"Synthesizing seemingly unrelated phenomena such as electricity, magnetism, and even optics was revolutionary in its time, but we have vastly expanded our inquiries into kinship to account for the most abstract materials, such as language. This *Guide* reveals with elegant simplicity the marriages of opposites conducted by artists and reformers in the social arena of the past century."

 —James Clerk Maxwell, author of *A Dynamical Theory of the Electromagnetic Field*

"To the Shasta daisy, the Fire poppy, the July Elberta peach, the Santa Rosa plum, the Flaming Gold nectarine, the Wickson plum, the Freestone peach, the Burbank potato, the spineless cactus, and the plumcot, you can now add *The Posthuman Dada Guide*. What I did with plants and seeds, this *Guide* does with ideas."

 —Luther Burbank, author of *The Training of the Human Plant*

"I called Luther Burbank an American saint in my autobiography, knowing perfectly well that every saint is part con man. The spineless cactus caused great joy in Washington, D.C., where it was greeted as the ideal cattle-feed. Luther created it by talking to the cactus to convince it to drop its thorns; that was the saint part; unfortunately, it had no nutritional value and cows did not benefit from it; that was the con man part. In the twenty-first century, I see no sense in distinguishing saints from con men, but

it is good to see the spiritual sense of existence
upheld by a devil such as Codrescu."
> —Swami Vivekananda, founder of
> Ramakrishna Math and the Ramakrishna
> Mission

"If I weren't on an astral plane busy with
the production of Angel Salt (a substance
indispensable for the correct functioning of
angel wings), I would draw on my previous
work with ur-language to praise this *Guide* for
keeping open the tunnel beneath the post-Babel
pandemonium in order to allow a few lucid
adventurers to travel unimpeded."
> —Aleister Crowley, painter, astrologer,
> hedonist, bisexual, drug experimenter, and
> social critic

"This book made me feel naked, and that's one
thing I know. I'm naked even now in a place I
can't describe. I'm so glad this book got to me
somehow. Congratulations!"
> —Josephine Baker, "Bronze Venus," "Créole
> Goddess," "The Black Pearl"

"I will tell you what really happened if after you
read this scurrilous book you let me punch you
hard. I read myself all the time but I rarely get
this worked up. Bring it on, mother! It's no great
feat to blow your nose in the handkerchief of
eternity. Keeping us alive is the only crime, and
this book does it."
> —Arthur Cravan, author of *The Surf on Q
> Beach at Night*

THE POSTHUMAN
DADA GUIDE

The Public Square Book Series

PRINCETON UNIVERSITY PRESS

THE POSTHUMAN
DADA GUIDE

TZARA & LENIN PLAY CHESS

Andrei Codrescu

Princeton University Press | Princeton and Oxford

Published by
Princeton University Press,
41 William Street,
Princeton, New Jersey 08540
In the United Kingdom:
Princeton University Press,
6 Oxford Street, Woodstock,
Oxfordshire OX20 1TW

Library of Congress
Cataloging-in-Publication Data
Codrescu, Andrei, 1946–
 The posthuman Dada guide :
tzara and lenin play chess /
Andrei Codrescu
 p. cm. — (The public square book series)
 Includes bibliographical references.
 ISBN 978-0-691-13778-0
 (acid-free paper)
 1. Dadaism.
I. Title.
 PS3553.O3Z46 2009
 813´.54–dc22
2008037893

British Library Cataloging-in-
Publication Data is available

This book has been composed
in Minion, Impact, and Bodoni
Printed on acid-free paper. ∞

PRESS.PRINCETON.EDU
Printed in the
United States of America

10 9 8 7 6 5 4 3 2 1

THE POSTHUMAN
DADA GUIDE

THIS IS A GUIDE for instructing posthumans in living a Dada life. It is not advisable, nor was it ever, to lead a Dada life. It is and it was always foolish and self-destructive to lead a Dada life because a Dada life will include by definition pranks, buffoonery, masking, deranged senses, intoxication, sabotage, taboo breaking, playing childish and/or dangerous games, waking up dead gods, and not taking education seriously. On the other hand, the accidental production of novel objects results occasionally from the practice of Dada. During times of crisis like wars and plagues, some of these objects can be truly novel because they sabotage prevailing sentiments. At other times, Dada objects are merely interesting, by virtue of an added layer of irony, an extra punch line, or a new twist to an already-consecrated object. In such times Dada objects amuse everybody, and since these objects are (mostly) made collectively, they are a strong community bond. Amusement (of oneself and others)

and the making of art communities are
the goals of Dada. Dada is a priori against
everything, including goals and itself, but
this creative negation is very amusing and is
meant to be shared. For one whole century,
Dada has delighted in uncovering and using
contradictions, paradoxes, and negations, the
most important of which are: 1. most people
read signs, Dadas *make* signs, and 2. most
people are scared of scary faces, Dada makes
scary faces. No one should go Dada before
1. considering whether one would rather be
a. amused or *b*. grim; one must weigh in the
balance childishness and seriousness; both *a*
and *b* have a history; both affect everyone in
the world; both are possible at any moment,
but the difference is that being childlike
(*a*) is pleasing to creatures lighter than air
(with or without wings), angels, St. Francis,
and Candide, while being serious (*b*) is a
weight, like the cross, and heavy as a lead ball
(see **hugo, ball**) and iron chains; and 2.
understanding that art is life and vice-versa
and Dada is against both, except on the road
to ecstasy when it stops for exceptions. It is the
thesis of this book that posthumans lining the
road to the future (which looks as if it exists,
after all, even though Dada is against it) need
the solace offered by the primal raw energy of
Dada and its inhuman sources.

If you have any doubt as to whether you
are posthuman or merely human, take a
look at the following parts of your body:
the city, the house, the car, the iPhone, the

laptop, the iPod, the pillbox, the nonflesh surround. If sixty percent of your body is now electronic or bioelectronic, living in space designed for efficiency, you will need Dada as a corrective to what will certainly be the loss of the modicum of liberty you still possess. The first Dadas lived in cities that contained the means for a thorough critique of the world: Zurich, Paris, New York, Vienna, Berlin, Bucharest, Prague, Zagreb, Budapest, Petersburg. They had virtual summations (libraries), revolution-planning centers (cafés), body-centering (or -decentering) loci (bordellos), hungry provincial student clusters (universities), geniuses (random selection), mass-media (printing presses, newspapers, the telegraph), the option of moving the body through space faster than the body could move on its own (trains, cars, carriages), models for imaginary worlds (cinema), the tools of propaganda (advertising, manifestos, podiums), memory (museums, statues, history books), sentiment (cabarets, songs, theater, carnivals), weapons (cobblestones), hope (money, God), social flexibility (learnable codes of manners, uniforms), ubiquity (the feeling that you know, or think that you know, everybody) and, most importantly, a sense that time was relative (some people had a lot of it and dreaded its immensity; others had only a little and dreaded its passing). The revelation of the *substance* of time preoccupied Freud, who saw it as a repository for repressed history, Carl Jung, who discovered (or thought he did) a

space inhabited by prehistoric *souffleurs* who dictated their nature to ongoing generations of human actors, Albert Einstein, who added time to the three known dimensions, Heisenberg, who denied time altogether, and a variety of artists who adopted one or another dimension of time (futurists, the future; simultaneists, simultaneity; Dada, all or no directions). These cities were concentrations of virtualities that offered the possibilities of creative reinvention of the world. Within these rapidly morphing intensities, the fixities of societal conventions that led inevitably to war became painfully apparent. The bright energies remaking human beings drew their force from everything and anything, but mostly from laughter. Nothing fixed by convention could withstand the Gordian-knot-cutting laughter of Dada, though resistance was not futile (see **lenin**).

Today, a century later, the merger of software and wetwear is ongoing and speeding up. Dada has nothing, or maybe everything, against doing well and doing good. Buy biotechs. The fondest wish of all well-wishers, and that includes many dadas, is that we will say hello to a green organism that is born by natural birth, will lead a carbon-footprint-conscious life, and will biodegrade without toxic waste. Planetary thinking in its most digestible form makes sense, and the future seems open to every individual initiative that is aware of the collective predicament. Living *aware* is the current desideratum, and if we

4

destroy non-renewable resources, we'll at least downsize or vanish with our eyes open. Dada is for all of that, but within (non)reason. For the majorities, profligacy is no longer desirable. In effect, desire is no longer desirable. If previous dada-minded people with nothing to lose (or so they thought!) could afford to be profligate, seminal, and ecstatic, this is no longer the case. Substitute "wishing" for "desire." Wishing accommodates acting, while desire is unpredictable. Posthuman life is based on the alleged awareness of all living connections, unlike the irrepressible and murderous peaks and valleys of human life in the past. The rational description of our posthumanity would have it that the societal mechanisms that were of such great concern to *thinkers* have been automated. Political structures larger than the family are projections of automatic economic systems. Borders are largely imaginary and will become wholly imaginary, soon to be replaced by aesthetic differences.[1] In other words, there will be privately constructed borders created by everyone everywhere, enforced by pocket nukes capable of eliminating entire cities or regions. Arbitrary moral systems will back up private aesthetic borders, making it imperative for everyone to receive the correct medication. Unmedicated people will not be allowed pocket nukes, which makes it necessary that they be naked and searched often by local militias of art students. In this environment, which is almost completely current, the simulations of

pleasure within zones of medicated liberty can be literally life-saving. These simulations will be a new medium (using all the media) for plotting escape routes and egress points that may or may not lead out of Eden. These potentially liberating simulations promise an escape into reality, but, reader beware, all realities adjoining present tightrope Eden may be virtual and not real at all. With that proviso, an alternative escape project called Dada is being made available here. Dada is the viral option to the virtual certainty. What the Dada life is will be explained in the following pages with a minimum of tedious reference, i.e., we will record only what can't be googled. In other words, only what hasn't yet been *captured*. Dada is the Western Now, a Zen that employs *fullness* instead of *emptiness*, so much fullness, in fact, that there isn't enough matter to fill its fullness, so it resorts to imagination in order to create ever more paradisiacal *objets*, better iPods made from shredded dreams.[2] Each imagination unit (IU) expanded here will be spent for your instruction, reader, but you will notice that each entry is constructed to self-erase as soon as it is understood, and to generate its own IU as soon as it disappears. The claim to the nongooglable is pretty huge and I'm making it lightly. The good available information googled either from Google or out of books written by Dada chiefs will be used here to its *utmost*, that is to say, used in order to extract or prolong the vital fluids, which are as yet ungooglified. (At least until this is

e-published). I know that Google, a mortal company, could go the way of Xerox, which used to be synonymous with copying, but in the grand collage that is Dada, past and future are equally usable. Look at the fragment from a newspaper inserted by Kurt Schwitters in his 1920 *Collage*:[3] the actual newspaper, with its oh-so-urgent events of the day, is long forgotten, but the section preserved in Schwitters's collage is immortal. I am not saying that this guide, a simple book, will outlast both Xerox and Google, but it is possible. If the 20th century has taught us anything, it is that we will forget everything except the box it came in. The substance of what it was, what it felt like, what could be usefully gleaned from it, was buried with the persons who felt and gleaned. Memoirs and history further dismember the past by articulating it: every articulated experience is as good as forgotten. Forgetting is a human specialty that was greatly refined by the recently deposed century. We've kept the wrappings, though: the styles, the anecdotes, the narratives (the sexy ones, not the academic), and we are using them to deposit new contents inside. The end of the 19th century put an engine in a horse, and, even though there was no more horse, literally speaking, the form of the mechanically-powered horse was marvelous to behold. Today, of course, there is hardly any need to remember why a mechanical horse needs to look like a living horse because most of us don't know what a horse is: even the horse-

form is being forgotten. As oblivion speeds up and facts store themselves in a memory stick, we are free to splash around in the funhouse of forms. Thank God for Dada, the engine of empty forms! This (or the next this) is a time to be human without the weight of history, beliefs, feelings, vendettas, or school grades. We are in a Dada state of grace. For the Dada Guide-users, you and me, there isn't even a point in the dated distinctions between "human" and "nonhuman," "remembered" or "forgotten," because the literature of those distinctions is ubiquitous and serves no purpose other than mutual accusation: those who think of themselves as "human" will claim that they have a "soul" and an indelible "history," while posthumans will claim to be part of everything and that everything has a soul, including the web they are presently setting to vibrating with their indignant thumping. This is a useless argument and if anyone feels uncomfortable about being called "posthuman," please call yourself whatever you want. My distinction is this: a posthuman is a human who has put nature (including herm own)[4] between parentheses. (Or convinced hermself that everything nonhuman is human and, therefore, human = nature. This used to be called "anthropomorphism," but lately it is known as a "user-friendly interface." In current popular discourse, nature has come to mean "nature," or "the nature channel," and thus is wilderness removed from it and its destructive *and* creative force neutralized. Putting the world between either parentheses

or quotes is an effective way to erase it, indifferent of how warmly we feel about it. We are replacing wilderness by self-reflection and are making huge (virtual) efforts to make the self-reflective sensorium look demiurgic and various like nature. If early in the 20th century only poets had the gall to conceive of themselves as "pequeños dios" in César Vallejo's phrase, now everyone feels entitled to a god-degree because the tools for faking it are part of every body (see **e-body**). Dada intends to open the doors at night to let the wilderness back in. Dada is a tool for removing parentheses and removing the world from between quotes with the forceps of inspiration. Sometimes this will call for disruptive spontaneous action, creating and holding TAZ (Temporary Autonomous Zones), actualizing dreams, running with gangs, living with animals, and making peace with weather. Sometimes it will mean going after parts of speech, like "like," or other rhetorical devices, but we will never discourage direct address, on the off chance that someone is listening. Historical Dada was a metaphor factory, but we will try to abstain and be as dry as a properly made Cabernet. Dada, like every living thing, has a problematic relationship with language, which is why it has employed it collectively, nonsensically, mystically, and in combination with other media, such as paint, pixels, bodies, couture, sex, sound, newspapers, advertising, and necromancy. Language has been slipping like a coarse blanket from humanity's

nightmare-racked body for centuries, but 20th-century dadas like Ludwig Wittgenstein and George Steiner (who were not officially Dada) and Tzara (who was, see **tristan, tzara**) revealed that it had been yanked off by Lenin, Stalin, Hitler, and Mao (big yankers) and by myriads of smaller yankers who use language to poke holes in reality and to put nature between parentheses. Big and small yankers (language-users) have been fueling their enterprise with portions of liberty, mine and yours. The motor for creating posthumans runs on stolen freedom.[5] Now there are two entities: language, lying at the foot of the bed, as freezing thieves with a yen for power crawl toward it, and a flesh body that is quickly becoming a metaphor for all that used to be called "human." The Dada project is to make the body warm by covering it with the blanket again and demeta-phorizing it. This project requires abandoning all the humanities' approximate definitions of "human," because "the approximate man" (see, again, **tristan, tzara**) turns out not to be a man at all. Or a woman. Those lovely forms have vanished and can now be found only as skeuromorphs in media, including writing. The vague yearning for the "not human" is now no longer vague, it is pure efficiency. We look nostalgically at waste: there isn't any. All is now open for Dada (as Nietzsche suspected) but not everyone knows how to live the Dada life, to press the "restore" button. In other words, nobody knows how to act when all knowledge seems available, and

claims to difference look like either reinventing the wheel or retrofitting the posthuman lump ("body without organs," Antonin Artaud) with dated forms. Mysticism and metaphysics are the popular forms of Dada now in vogue, particularly in science fiction, the New Age, Oprah, churches, mosques, and pagan-trancing moonlit groves. There is a lot wrong with those practices, namely, that they are all about the consciousness of humans on their way to perfecting posthumanity. Most of them pretend to worship or at least acknowledge the nonhuman, but it's only a cover, superstitious salt thrown into the eyes of whatever looks back at us, amused or annoyed, Nietzsche's abyss with eyes. Dada, too, is a form of mystical currency, but it likes to think of itself as too radical for narrative and parable, and too agnostic to take itself seriously. We will see. We need a guide that is at once historical and liberating. Or just hysterical and tonic.

Nothing illustrates better the difference between the human and the posthuman than a chess game that took place in October 1916 at the Café de La Terrasse in Zurich, Switzerland, between Tristan "all thought is formed in the mouth" Tzara, the daddy of Dada, and V. I. ("communism = socialism + electricity") Lenin, the daddy of Communism. These two daddies battled each other over the chessboard of history, proposing two different paths for human development. Dada played for chaos, libido, the creative,

and the absurd. Communism deployed its energy for reason, order, an understandable social taxonomy, predictable structures, and the creation of "new man." The Dada man was an actor and a peformer, a clown, and a drunken fool, a mystic. The "new man" was a well-behaved worker who would eventually be so well served materially that he would become posthuman, a being to whom all nature, refined and motorized, would pay homage. Dada was born onstage from satire, disgust, angst, disgust, terror, improvised materials, and channeled snippets of verse, while Communism came out of books of philosophy and economy, terrorism (with its technologies of disguise, conspiracy, and homemade explosives), and church-inspired forms for synthesizing dogma. Who won the game? After the collapse of Soviet-style communism in 1991, it looked as though Dada had. But if it had, why do the non-Soviet posthumans of late capitalism feel such despair? Could it be that late-capitalism posthumans have arrived in the leninist future without communism? And if they have, is the game still going on, and does Dada still have work to do? Are languages (including programming e-languages), print, reason, the fear of nature, and the impulse to vegetate still in charge? Is performance today mainly palliative, validated by reviews? Was that game of chess a win for Tzara or Lenin or a draw? Why did the two men sit down to play in the first place? Obviously, it was cold and there were snow flurries, and the café was

full of people of intelligence and feeling, and some shady drunks and thieves, but beyond that, did either of them sense a metaphorical gravity? I doubt it. Chess is the game of choice for people who must think in a crowd: chess is the quintessential "meditation in an emergency" (Frank O'Hara) for people forced by circumstances (overcrowding, prison, a chattering roommate) to seek solitude in a crowd. The laws of chess (they are not called "rules") have been designed over a millennial history to provide a maximum of thinking space within a small square, and a sense of movement and change by means of a number of symbolic figures. Even if Tzara and Lenin, alone or together, sensed the making of a metaphor, they would not have been interested because 1. it was other people's metaphor, and 2. they were both animated by passion about injustice. Tzara: "But suppleness, enthusiasm and even the joy of injustice, that little truth that we practice as innocents and that makes us beautiful: we are cunning, and our fingers are malleable and glide like branches of that insidious and almost liquid plant: this injustice is the indication of our soul, say the cynics. That is also a point of view; but all flowers aren't saints, luckily, and what is divine in us is the awakening of anti-human action."[6] Lenin: ". . . the development of capitalism has arrived at a stage when, although commodity production still 'reigns' and continues to be regarded as the basis of economic life, it has in reality been undermined and the big profits go to

the 'genius' of financial manipulation."[7] Tzara is talking about flowers, soul, the divine, and fingers, while Lenin explains how easily people are distracted and robbed while being handed "commodities." Both passages proceed from the basic acknowledgment of the existence of injustice, but Tzara welcomes its cruelty and pushes its contradictions to where it will cease to function within language and, it is hoped, life, because it's been sabotaged by poetry. Lenin has found the villain: sneaky, insidious capitalism robbing the workers while amusing them. There is also another difference: boredom. Tzara is fresh, Lenin is boring. Lenin is not boring just in retrospect, he was boring at the time he wrote that. As we know from Baudelaire, Boredom is the worst evil of all: "Among the vermin, jackals, panthers, lice / gorillas and tarantulas that suck / and snatch and scratch and defecate and fuck / in the disorderly circus of our vice, // there's one more ugly and abortive birth. / It makes no gestures, never beats its breast, / yet it would murder for a moment's rest, / and willingly annihilate the earth. / It's BOREDOM. Tears have glued its eyes together. / You know it well, my Reader. This obscene / beast chain-smokes yawning for the guillotine— / you—hypocrite Reader— my double—my brother."[8] Yes, but, *pace* Baudelaire, was Lenin *wrong*? Not really. At the start of the 21st century we are in an even better position to appreciate Lenin's insight into the nature of capitalism. He goes on to

explain, by means of tedious citations from German economists, exactly how prices rise as a result of the formation of monopolies, and the subsequent impoverishment of the proletariat. Lenin is setting up his chessboard minutiously, preparing for what will be his real intention: plotting in detail the coming revolution. In addition to setting up the board, he needs to cleanse the socialist movement, which agrees with him on the analysis of capitalism, which only reiterates, after all, what Marx explained in equally tedious prose decades previous. Lenin does not even bother with Marx's preoccupation with the alienation of worker from product. For Marx, this alienation brought about by automation must be combatted in order for communism to be built. Lenin couldn't care less about how workers feel. Let's make the Revolution, then automate everything, and, in the end, everyone will feel better.[9] Tzara would rather be the object of violent ridicule than the cause of a yawn. "Every act is a cerebral revolver shot—both the insignificant gesture and the decisive movement are attacks."[10] That's invigorating, but is it true? The man he's playing chess with will make sure that it isn't, for a century at least. He'll leave a trail of corpses from Russia to Japan to Europe and beyond, to prove Tzara wrong. Not *every* act is *cerebral*: some acts, like a *real* pistol shot, are repetitious, monotonous, mindless, set in motion by a barked order. Tzara, the revolutionary poet, is playing chess with

Lenin, a mass-murdering ideologue. The winner will win the world, a prize neither is thinking about in 1916.

Their projects were as different as their game, but the feeling that the world was unjust was in both of them like a root. We will go back and forth in time to check various moves and consider some possibilities. Although our sympathies are with Dada, we are not all that sure about the outcome of the game. You will notice that we have retained the alphabet and ordered the Guide alphabetically. This is also a book, so pages are conventionally numbered. This may very well be the last (necessary or unnecessary) book, so we scrupulously observed all the conventions we could remember, typographical, grammatical, anal, oral, and chronological. With a tip of the hat to the kabbalah, we are working against (and for) time and amnesia. The waters of oblivion are rising, memory is as fragile and thin as matter in a black-hole universe, but as Tristan Tzara said, "Dada is against the high cost of living." Lenin was against that too, but since he thought he'd found the villain, he was going to do something about it. We can't do anything about it, so we will make this cheap and painless.

1915, winter, Zurich: Jan Ephraim, the Dutch ex-sailor who rented Hugo Ball the Meierei restaurant for a cabaret, asked him the following questions: 1. are you going to make me money? 2. are you going to draw

them in? Hugo Ball, a serious German thinker, writer, magazine editor, war-resister, and metaphysically troubled person, at whose side, holding on to his arm, was the lithe and ethereal dance-hall pro Emmy Hennings, answered: "I think so. Emmy's dancing, my music, and the help of my friends will make the cabaret a success." This was the entirety of the interview. The interview, as a form, was becoming briefer and briefer as Europe plunged into war all around peaceful, neutral Switzerland. "An estimated 120,000 French soldiers were killed during that brief offensive (against the Hindenburg line, 150 miles from Paris), and a serious mutiny ensued. One of the most striking events of that dark time was the procession of a group of infantrymen through a town, baaing like sheep, to protest that they were like lambs being led to slaughter."[11] That spontaneous irruption of Dada performance posed a serious challenge to artists who felt that they no longer had the luxury of art. In Berlin, exhibitions of new art, including those of the Expressionists of Der Blaue Reiter (the Blue Rider group), became political occasions that sometimes turned violent. Art took the war personally, and artists even more so, especially artists in the warring countries. They flooded into Switzerland, particularly Zurich, a city that became practically overnight the center of the world's artistic avantgarde and world revolution. German, French, Russian, Polish, Italian, Yugoslavian, and Romanian artists and revolutionaries found their way here,

among them James Joyce, Vladimir Ulyanov (Lenin) and his circle (Karl Radek, Gregory Zinoviev), Franz Werfel, Else Lasker-Schüler, Rudolf Laban, Viking Eggeling, and the future dadaists: Hugo Ball, Emmy Hennings, the three Janco brothers (Marcel, Jules, and George), Arthur Segal, Tristan Tzara, Marcel Slodki, Richard Huelsenbeck, and Francis Picabia. Some of the refugees were already known for their art, or wanted by the police in their countries (sometimes both), while others, like the dadas, were about to find their mission. Café de La Terrasse and Café Odéon served as living rooms for the (mostly) desperately poor bohemians who gathered there for news, gossip, heat, and company, and the thin hope of picking up some employment. Finding money was an urgent preoccupation for the bohemians of 1915, just as it has been for bohemians in all ages. In fact, Zurich became a TAZ (Temporary Autonomous Zone), connected underground to all the bohemias of past and future: the fin de siècle Left Bank of Paris, old Bucharest, New York's Greenwich Village, Prague's New Town, San Francisco's North Beach, and all the poor historic neighborhoods of cities where rents were cheap, life desperate, shabby, and erotic, where bars and cafés outnumbered churches, and eccentricity was encouraged because entertainment distracted the locals from their stomachs. Zurich acquired a bohemia thanks to the war, an exceptional situation for this eminently bourgeois and liberal town, situated at the confluence of

German and Latin cultures. The novelty was startling for everyone, refugees included, who found themselves exposed to ideas and art that pooled here like a lake fed from the oddest springs.

For most of human history, excepting a slice of the 20th century, originality was not a requirement. In fact, it was something of a curse, a lowbrow by-product of perfection. To the extent that it was possible, the powerful did their utmost to standardize worship, occupations, and products. The sorrowful evidence of individuality made the necessity to standardize ever more urgent. The messy poor were the visible proof of the failure to standardize. The differences that enchanted the rulers of people were the perfect products of master craftsmen, and their quality resided in the skill of using the materials, not in the personality of the maker or the uniqueness of the product. The rich wanted the *best*, not the most original. In the early modern age, Byzantine icon painters learned how to copy *exactly* the work of their predecessors. In the West, the use of models by Renaissance artists was greeted with unease by all but the most perverted patrons. The idea that the Virgin Mary was actually the baker's daughter was subversively amusing, but never to be publicly acknowledged. Even the Flemish painting revolution that depicted average people with realistic delight made sure that a science of *copying* nature was discernible in the work, just in case the artists might

be accused of originality. The church called originality simply *heresy*. After tolerating the original visions of John of Patmos by agreeing that they were of divine origin and by no means original, the Church spent the following centuries rejecting visionaries and crazies. The poor did their best to imitate the masters' objects, but being unskilled, they produced instead rough approximations that delighted them beyond the apparent resemblance. In contemplating their work, the lowly artisans and their clients found qualities absent in "high" art. They found amusement, personality, difference, passion, *the imaginary*, in short everything that was carefully excised by perfection. They also found certain ideas that they hadn't intended to put in there, but that had appeared quite spontaneously while the artisans were carving a piece of wood, for instance, and following the grain instead of the model. Demotic craft became art; it also became of interest to the rich, bored by their perfectly crafted embodiments of approved ideas. The rich then commissioned their own artists to produce unusual objects, but try as they might, they couldn't. Precious materials and great skill simply prevented them from being original or even amusing. Only the poor could, evidently, make original art, either from clumsiness or from the liberties they took in parodying the objects of the rich. To make a long story short, through mass-production, everything useful or familiar could be manufactured perfectly. Only the art of the poor could not be mass-produced.

The poor could simply not afford to buy their utensils and objects of worship at the store, so they kept making original things that were much coveted by the rich. In the end, a solution was found in the establishment of a market for originality (the work of the poor), and mass-production (the making of profitable copies): the rich bought art from the poor, and the poor bought mass-produced copies with the profits. Maintaining the production of art necessitated keeping the poor poor so that they would keep producing unique objects, and for this purpose the rich introduced obsolescence—the mass-produced things broke after a short time—so that new ones needed to be bought, which kept the poor poor and making art. An imbalance was created, however, and the poor, who loved buying things a lot more than making them, became poorer somehow and became a rabble, living in slums. Poverty itself became art, but not to the poor. The rich who went slumming did so at some peril. In the great European cities, artists created bohemias. This story appears at first sight to follow mechanization, but this isn't the case. The "mass-production" is present in all recorded history: in the early Middle Ages, the copyists of incunabula were the "mass" producers. So were the painters of icons and the masons. Anything made well enough to be an indistinguishable copy was "mass-production." The "originals" existed only in the mind of God (or Plato's cave). Boring. How much spicier the poor! And how deliberately *original* some of them! They

amused themselves with pastiche, parody, deliberate mistakes, pratfalls, crude satire, filthy songs, and primitive images, things that lost their flavor as soon as they were removed from the streets and mounted inside palaces!

Bohemia is not modern: commedia del'arte flourished in the Middle Ages in the shadow of (or outside) the fortified city walls, and traveling theatrical troupes and minstrels subsisted by dancing, singing, and reciting. The entertaining class can be traced to the beginning of human communities in the East, the Middle East, and Europe; think Orpheus, Sappho, and Homer, Lao-tzu, Japanese Zen poet-beggars, Persian ambulant musicians, and troubadour troublemakers. Life outside the palace seemed more than drudgery, hunger, and war; the amusers of crowds were the agents of liberty, or, at least, the possibility of it, through stories and songs to escape into; they made it appear as if another world and life were possible; they made fun of proscribed morality with bawdy realism; they mocked the church and exalted sentiment, revelation, and miracles; they described unofficial earthly and otherworldly utopias; they humanized animals and made people more tender. They also made fun of court poets, "cultivated" language, empty formality, and "high" art, patronized by aristocrats or the church. Traveling artists brought joy, but also news and critiques of the unfair setups of society. Marseille at the end of the 19th century, for

instance, was a wild port where the tallest tales were heard by master colorist Panaït Istrati, a multinational Levantine Romanian writer and adventurer born in a Black Sea port himself, who wrote his life in a mixture of French, Romanian, Greek, and Turkish. This was the port from or toward which Arthur Rimbaud's "Drunken Boat" perpetually sailed, lured by the vivid and exotic life of lusty sailors and cabin boys wearing potato sacks or turbans, drinking from silver flasks and tin cups, a world convulsed by laughter and rage, sex, violence, and the sound of strings stretched over oddly-shaped gourds. Ports and slums teemed for centuries with singers, acrobats, bear-tamers, pirates with parrots trained to draw fortunes and lottery tickets from a glass jar, circuses, puppet and shadow theaters, beggars with a shtick, prostitutes with an act, and scam-artists belonging to a loosely constituted Guild. Even religious festivals approved by the authorities relied on this Guild's expertise, and it was precisely during these manifestations of mob-joy that authorities became most vigilant. Catholic Carnival, the feast of saying "farewell to the flesh" (*carne vale*), was an occasion for turning society upside down through the use of masks and mock reversals of the social order: the poor became aristocrats, the aristocrats objects of derision. Priests were shown to be demons, and the altar a privy. Carnival let loose all frustrations: resentment toward the wealthy, hatred of the "other," including Jews,

Protestants, priests, scholars, etc., a long and changing list, with the exception of Jews, who were a constant target for european satire and hatred, to the point where the ever-present Devil started to look exactly like the popular image of the Jew: goat-hoofed, bearded, curly-haired, redheaded, and horned.

The Jews had festivals themselves (see **jews**) especially in eastern-central Europe among the Hassidim, but they were inward-directed, making fun of human failings and chastising the lazy for lack of discipline in the study of the Bible; their plays and fables performed on crude wooden stages in muddy shtetls ended also in dancing and merriment, but always with an eye out for the gendarmes or the Cossacks. A new language, Yiddish, spoken in the Pale, had the uncanny ability of questioning *everything* under a mask of mild, though savage and often self-directed, humor. Yiddish lent itself to two great constants of Jewish life: commentary and storytelling. Commentary was the form of perpetual revolution born out of interpreting the Talmud: each syllable of the Bible was subjected to an intense meditation and reinterpretation for use by living Jews. The living Jews themselves, when outside the text, maintained their world with stories in which their humanity was gently upheld, and the absurdity of a world that rejected them was mercilessly revealed. Jews were deconstructionists who filled the vacuum left

behind by paradox with substantial narrative. Yiddish was the language invented expressly for performance in the unscripted world. Yiddish theater in the golden age of Avram Goldfaden (1840–1908) spilled out of the ghetto into the wine cellars and eventually the stage of Yassi, a Romanian city where over fifty percent of the inhabitants were Jewish. A singing, dancing world of improvisation, spontaneous rap, mockery, and masking sprung from an imagination fettered for centuries, giving birth to ironic and foolish characters mixing glee with anger as they smashed taboos. "Parody, grotesque humour, crude physicality, obscenities, swearing, and cursing in the purimshpil were part of the folk festive culture and a sign of normality in the life and culture of the Jewish people. The popular language shattered the solemnity of the ritual and of the biblical scheme, replacing them with parody and adding oral material such as sketches, jokes, satires and folk songs."[12] To give but one example, the Yiddish expression "Thank God my children are religious," stated quite seriously by pious Jews even now, had the audiences of 1882 roaring with laughter when a stage actor, rolling his eyes heavenward, said the same thing.[13] Jews laughed at their own prejudices, and defied them: women took the stage for the first time in Yiddish theater. With few exceptions, all women's roles until then had been played by men in drag. The title character of Goldfaden's most famous play, *Shmendrick*, entered the

language as the archetype of the gentle idiot. In 1883, three years before Tzara was born, Yiddish theater came to an end, as antisemitic laws were decreed in Russia and Romania. Between 1883 and 1914, two million Jews from the Pale emigrated to America and to Palestine, taking with them a fertile tradition of theater, song, and cabaret that flourished in a new context mostly on Broadway and in Hollywood. The immigrants to Palestine worked too hard to inhabit the desert to have much time for the stage, though they were surely consoled by the rude joyful songs of their youth after long days of breaking stone to plant trees.

The great Christian carnivals, on the other hand, were mini-revolutions, separated from the real thing only by the lack of weapons, discipline, and sobriety. In the 20th century, the colorful life of Marseille, like that of all great ports, began fading before the onslaught of uniformly packaged cargo. All the great cities started giving way to urban planning, zoning laws, noise ordinances, and police rule. The mass-productions of the industrial age looked capable of standardizing people at last. But not before two world wars dismembered the colonial empires. Zurich in 1916 was halfway there: orderly but tolerant; hospitable but not overly indulgent; cultured but not pretentious; a university hub renowned for its libraries; the home of Carl Jung; the temporary home of Albert Einstein; a city

that kept suspicious foreigners under discreet surveillance; a haven for homeless exiles, but not a charity center. The weather: breezy and pleasant in June and September; blustery, cold, and wet in Fall and Winter; hopeful and suicidal (owing to the föhn wind) in the Spring.

1915, opening night, february 5: The Meierei restaurant became a Kunstlerkneipe (cabaret). Hugo Ball hung a few paintings and drawings that the Romanian painter Arthur Segal (Aron Sigalu from Botoşani, Romania) lent him, etchings by Pablo Picasso, paintings by Wassily Kandinsky, Henri Matisse, Paul Klee, Arturo Giacometti, and Otto van Rees. Segal was a well-known artist who had exhibited in Berlin, Tokyo, Dresden, and Cologne. Hugo Ball's friend Hans Arp convinced him to come to Zurich from his home in Ascona to help decorate the Meierei. Segal was much older than the young Romanians who would soon arrive, but they all spoke Romanian and came from the same Jewish area of Moldova. Ukrainian artist Marcel Slodki made a poster for the new cabaret, named Voltaire in honor of the great skeptic. It was the first inspired "naming," a special kind of grace that fell on that street corner. The poster promised an evening of "Musik-Vortrage und Rezitationen im Saale der 'Meierei' Spiegelgasse 1." There remained only the matter of creating a program because it was going to be difficult for Emmy and

Hugo to entertain for the entire evening. As fate would have it (or Chance, which became a Dada god), Marcel Janco, a young Romanian architecture student desperately looking for work, entered the building while preparations for opening night were in progress. He offered his pleasant singing voice and paintings, as well as the services of his two brothers, George and Jules, and those of the poet Tristan Tzara, a twenty-year-old Romanian who was rooming with them and had just arrived from Bucharest. Before the scheduled opening, Ball was able to also enlist a Russian balalaika band. The opening of Cabaret Voltaire on February 5, 1915, featured Mme. Hennings and Mme. Lecomte singing Berlin Schlager; Tristan Tzara reciting and shouting poetry in Romanian, some of it obscene folk poetry known as "strigături," bawdy shout-chants that the horny shepherds of the Carpathians let loose when they returned to their villages after a long summer taking sheep from the mountains to the sea. Ball himself played piano, improvising music for Emmy's songs. The performers appeared onstage several times, making up new skits and bits of poetry that got louder and funnier as the drunker and drunker crowd prodded them on and participated with their own improvisations. Tzara read his own poetry in Romanian with instant translation into heavily accented French. In her memoirs, *Ruf und Echo*,[14] Emmy Hennings recalls that Tzara was the first to take the stage, a beautiful man-child who recited emotional words of farewell to

his parents, bringing tears to the eyes of the
many orphaned members of the not yet totally
drunk audience (standing room only) and
then read Max Jacob's poem "La Côte." The
small, dark-haired Romanian with the pince-
nez was followed by Emmy Hennings singing
"A la villette," a popular Aristide Bruant song,
accompanied on the piano by Hugo Ball. They
were followed by Marietta di Monaco, who
read the popular Gallows-songs by Christian
Morgenstern (the favorite black-humor
poet of the trenches),[15] and also poetry by
Gottfried Benn and George Heym. They were
followed by the six-piece balalaika orchestra
assisting Ball in the playing of "Totentanz,"
the Death Dance, another wartime hit. Hugo
Ball then read poems by Blaise Cendrars.
Emmy Hennings performed again, to a
much drunker and more emotionally fragile
audience, and then betook her sweaty body
from table to table lasciviously distributing
pictures of herself. Suddenly, nonsense noises,
whistling, and shrieks were heard behind
the curtain, and the lights went out. A green
spotlight revealed four masked figures on
stilts, each hissing a different sound: sssssss,
prrrri, muuuuh, ayayayayayay. The figures
alternated their sounds and began a crazy
dance. While the grotesques flailed and
stomped, one of them tore open his coat
to reveal a cuckoo clock on his chest. The
audience stomped and shouted, and soon got
into the act, rhythmically joining in by making
the sounds, too. At a frenzied point when the
shouting reached its most feverish pitch, Tzara

reappeared onstage dressed in tails and white spats, shooed away the dancers, and started to recite nonsense in French. The performance ended with Tzara unrolling a roll of toilet paper with the word "merde" written on it.[16]

The first dadaist performance at Cabaret Voltaire sounds quite well behaved by today's standards, comparable to, let's say, the first Beatles concert. No one had any idea what had been opened here and what was going to come through this opening in the decades to come. There are two notable things about this first evening at Cabaret Voltaire: 1. the first part of the program tugged at the strings of everyone's heart by fairly conventional means: the songs Emmy Hennings sang, the poems of Morgenstern, and the "Totentanz" were the straws of sentimentality and black humor that everyone in the audience hung on to as their brothers and kin were dying in the huge slaughter around them,[17] and 2. the second part, bizarre as it was, connected to forms of carnival and absurdity familiar to europeans since the Middle Ages, and was in keeping with the ubiquitous and helpless fury of that audience of students and refugees. The first evening followed a time-tested formula: set them up (soften them up), get them drunk, and pull the rug from under their feet (go for the gut). This is the simple formula of all art, but especially theater. The new elements were the masks designed by Marcel Janco, the sound poetry of the masques, Tzara's seemingly nonsense recitation, and the art on

the walls, but these novelties were flawlessly woven into the structure of the performance, and few, including the participants, suspected just how much novelty they held. None of the performers were novices: Emmy Hennings had sung in cabarets from Berlin to Budapest and Moscow; Hugo Ball had published poetry, written essays, acted, and promoted artists and writers in Berlin; Arthur Segal, as noted, was a renowned painter; Marcel Janco had already co-edited the avantgarde journal *Simbolul* (The Symbol) with Tristan Tzara (signing with the pen-name S. Samyro) while the two of them were still in high school in Bucharest. Tzara and Janco (Iancu in Romania) were seasoned avantgarde writers and essayists by the time they arrived in Zurich. They had both taken part in a literary revolution *avant la lettre* in Romania. Tzara and Janco brought with them nearly a decade of experimentation, innovation, avantgarde battle scars (fighting a conservative, nationalist opposition) and the knowledge of Balkan cultures deeply invested in vivid folk traditions rife with supernatural creatures, ritual masking, pre-christian fairy tales, drinking songs, bawdy skits, and mystery plays. The musical and poetic mosaic of the Balkans combined the sounds of the Turkish tanbur, the Hungarian tsimbal, Gipsy violins, Mongol drums, the long Romanian horn *cimpoi*, and the Jewish klezmer. The pre-christian Romanian tales featured the waters of life and death and magical winged horses, while Jewish dybbuks (spirits who could be angels or demons, depending on context) and

fable-telling tzaddiks (wise men) posed acute moral dilemmas, not all of them grave, some of them crazy-wise, bitterly self-mocking, or gratuitously funny. Tzara and Janco knew this balkan (or levantine) folklore intimately, and were able, in Swiss exile, to draw a wealth of forms and ideas from it, to renew the wells of Western culture, nearly dry from centuries of intellectual formalism. The first night at Cabaret Voltaire was a meeting of Berlin and Paris highbrow and lowbrow art with novel eastern european forms of terror and clowning. Both the Germans and the francophile Romanians were conscious of working for an art revolution that was taking place simultaneously for at least a decade before the convulsing of Europe in the First World War. The antennae of the Decadents, the Symbolists, the Expressionists, the Fauves, the Cubists, the Futurists, the Constructivists, and their political counterparts, socialists and anarchists, had been picking up the future, and artists rushed to recast the forms and values of a world headed for big trouble. Despite their best efforts, european civilization ("that old bitch gone in the teeth," Ezra Pound) was made void by the slaughter. Once the slaughter began, art had a tough new job, and new combinations were in order. In Zurich, the satirical mysticism of the east europeans met fighting hard-core Berlin activism. Reinforcements arrived the second week in the form of Richard Huelsenbeck, who came straight from Berlin and the train station to Cabaret Voltaire to shout his

negergedichte (negro chants) that very night,
accompanying himself loudly on a drum:
"boom boom boom boom drabtja mo gere,
drabatja mo *boooooo*." Hugo Ball recalls that
Tzara suggested that Huelsenbeck, Janco, and
Tzara "recite (for the first time in Zurich and
in the whole world) the simultaneous verses of
Mr. Henry Barzun and Mr. Fernand Divoire,
and a simultaneous poem of their own
composition."[18]

The "poème simultané" was subsequently
orchestrated for as many as twenty voices
in at least five languages, reaching choral
dimensions. The innovations in poetry
performance also included "bruitism," an
infernal mix of mechanical noises and human
voices making up loud nonsense words, heavy
on consonants like *z* and *r* and *s* repeated
zzzzz, rrrr, sssss, until both performers and
audience experienced rhythmic trance. Drums
were the favorite instrument, accompanying
Huelsenbeck's "negro chants," but Ball's piano,
used as the original percussive instrument,
took center stage as well. At times, the frenzied
audience became violent and started smashing
the furniture and each other, a state of affairs
that didn't sit well with Jan Ephraim, the
proprietor. He warned the dadas to tone it
down, but the sound innovations went on,
hand in hand with stunning visual props,
costumes and masks designed by Marcel
Janco and Hans Arp. The use of all kinds of
materials in collage and assemblage, a practice
intiated by Picasso and Braque, became

sartorial sculpture and masks. The cabaret organized a Russian evening, with readings from Russian poets and music by Scriabin and Stravinsky, and then a French evening with poetry by Apollinaire, Max Jacob, Jarry, Laforgue, and Rimbaud. In addition to paying homage to fellow avantgardists in Russia, France, and Italy, each evening brought more spontaneous and explosive surprises. More young artists from warring countries appeared at Cabaret Voltaire, looking to express their rage and contempt at the madness in "civilized" Europe. In the Cabaret's first publication, on May 15, 1916, Hugo Ball defines its activities as a reminder "to the world that there are independent men,—beyond war and nationalism—who live for their ideals." He also announces that "the intention of the artists here assembled is to publish an international review. The review will appear in Zurich, and will be called DADA Dada Dada Dada Dada."

Another lightning stroke of grace: the word Dada. This stroke of lightning, just like the original Word of God, ended up the subject of great and lasting misunderstanding. See **dada, the word**, wherein the facts and speculation surrounding this concentrated drop of semantic revelation is hermeneutically filleted.

Inevitably, the necessity of publishing arose, and in June 1916, the anthology *Cabaret Voltaire* appeared, publishers Hugo Ball

and Emmy Hennings, contributors Tristan
Tzara, Marcel Janco, Richard Huelsenbeck,
Apollinaire, Arp, Cendrars, Kandinsky,
Marinetti, Modigliani, and Picasso. A series
of illustrated books of poetry edited by Tzara
followed, a series titled Collection Dada.
Then between 1917 and 1921 Tzara edited the
magazine *Dada*, which ran to seven issues. The
second issue contained work by Arp, Birot,
de Chirico, Kandinsky and many others. And
in 1919 Tzara co-edited a one-shot magazine,
Der Zeltweg, with work by Arp, Giacometti,
Schwitters, and others. The story of Dada
publications is long, but the speed of the
development of the movement in a short time
is phenomenal. Not only are the principals
innovating live onstage, but they now face
the challenge of transcribing such things
as Huelsenbeck and Tzara's collaboration
"Pélamide":

> a e ou youyouyouyou i e ou o
> youyouyouyou
> drrrrdrrrrdrrrrgrrrr
> stucke von gruner dauer flattern in meinem
> zimmer
> a e o i ii e ou ii ii plenus venter

and so on, a challenge for the typesetter, but
also an invitation to collaboration that the
typesetter may well have taken advantage
of. Among the Dada first principles was
Collaboration, the art that was taken up with
gusto in the 20th century by many poets and
artists and reached its second peak after Dada
in the works of the New York School poets

of the 1960s and 1970s. The Cabaret Voltaire performances are foundational, and the first publications have become scriptural, in exactly the sense that human ritual imitates the acts of the gods at the moment of creation, and then hold the first accounts in literal awe. The difference is that the dadas were consistently antiworship and antiscriptural; their work was intended to self-erase while disposing of a good deal of inherited wisdom. Mostly this didn't happen, because their followers, like the mistresses of writers who've been asked to burn their manuscripts and correspondence but instead hold on to them even more, disregarded the founders' instructions. On the other hand, art and writing in the 20th century would have simply sunk into the boredom of "modernism" (as it is threatening to do now) if the Surrealists, Abstract Expressionists, Beat writers, concrete poets, New York School poets, and the numerous dada-inspired groups in Europe and the United States had not continued the original Dada work. The renewal of the dada cut-up poem by William Burroughs's and Bryan Gysin's experiments of the 1950s proved that the original *souffle*, the living breath, was still there. The gods of Collaboration worked for the writers and artists and musicians of the New York School exactly as the dadas had intended, by creating a community of artists having fun first, and then, only then, making some sort of useful (sellable) objects from it. If. Maybe. Somehow. Hopefully. After the original flush of youthful generosity that

dispensed its genius without thought for the
future (there didn't seem to be any in 1916,
there was none for its victims, including
Jacques Vaché and Apollinaire, and Dada
was against it, anyway), the inconceivable
happened: the future showed up. The scraps
of butcher paper with collaborative poems
and drawings on them became subject to
the future's primary drive: the market. This
market, the art market especially, is driven
by scarcity: the less work there is, the dearer
it sells. This inexorable and, by now, banal
law was understood by Marcel Duchamp and
Andy Warhol, but precious few other artists.
Had the dadas been presented with such a
thought in 1916–1921, the presenter would
have been laughed at, spit on, and, possibly,
boxed. The gratuity of the art act looked as
inexorable to them as the law of scarcity was
for the market. On the other hand, a lively
trade of work among artists was in progress
from the very beginning, and both Tzara and,
later, André Breton, survived by selling their
friends' art.

In June 1916, Jan Ephraim was fed up: he
evicted the dadaists from the Meierei. In its
brief existence, the cabaret experienced the
three ages of man: a quasi-innocent childhood
(conducted by very young old hands who
were excellent at pretending innocence!), a
political youth driven to quasi-activism by
producing loud noises and decency scandals,
and a scriptural middle-age that had been
in the making all along by Monsieurs Ball

and Tzara. Tensions within the group also became apparent as the first ugly shoots of the nationalism that the entire group rejected began to sprout, timidly at first, then in great bursts of hostility. The French-Romanian (Tzara, Janco) dadas and the German (Ball, Huelsenbeck) dadas began to quarrel over the origin and copyright of the word "Dada." Arp served as a bridge between the two, siding with the French in his guise as poet and painter *Jean* Arp, and with the Germans when *Hans* Arp, painter and poet. This foundation-crack would widen in the coming decades, with unexpected consequences. In addition to the appearance of nationalist tensions, there was a sudden mystical conversion that gave the movement the look it had never sought: that of early Christianity or socialism, with their rifts, fissures, cracks, and heresies.

On July 14, 1915, the first Dada soirée away from the Meierei was held at the Waag Hall in Zurich. This evening included the entire Dada repertoire, showcasing the reading of manifestos by Arp, Ball, Janco, Huelsenbeck, and Tzara, and ended in a near riot. Huelsenbeck read a "declaration" that was a send-up of *The Communist Manifesto*, in which he proposed replacing the slogan "Workers of the World, Unite" with "Workers of the World, Go Dada." Dada, he declared, means nothing, and it is thus the most meaningful nothingness. In retrospect, the workers of the world should have listened

to Huelsenbeck. Fifty years later in Paris, the Situationist slogan became "Workers of the World, Disperse," and more than two decades later, in Moscow, huge crowds marched under the banner "Workers of the World, We Apologize!" If Lenin was in the audience, as he was often reported by various (unreliable) witnesses to have been, this is when it might have occurred to him to have all avantgardists deported or shot. (As it was, it took Lenin an entire five years after the Bolshevik Revolution to figure out what to do with intellectuals, namely, put them on a boat and exile them, using the tsarist model he himself had been a victim of; after Lenin's death in 1924, Stalin experienced no dilemma: he had ideological deviants, including artists, shot.) Tristan Tzara, in tails and signature monocle, read his play-manifesto, *La première aventure céleste de M. Antipyrine*, a work of such vigorous eloquence it is as fresh today as the day it was written. (This is a kind of miracle few written works perform, being kin to the incorruptible bodies of saints that refuse to rot.) Monsieur Antipyrine (named after a headache remedy) offers Dada to the world as revolution, therapy, a new art, an antiwar movement, and, above all, a warning against making out of Dada a new guide to living. (Mhhhmmm.) It begins by proclaiming that "Dada is our intensity: it erects inconsequential bayonets and the Sumatral head of German babies; Dada is . . . against and for unity and definitely against the future; we are wise enough to

know that our brains are going to become flabby cushions, and that our antidogmatism is as exclusive as a civil servant . . . that we cry for liberty but are not free; a severe necessity with neither discipline nor morals and that we spit on humanity . . . DADA remains within the framework of European weaknesses, it's still shit, but from now on we want to shit in different colors so as to adorn the zoo of art with all the flags of all the consulates."[19] An internationalist credo, indeed. Happily, the liberty that Tzara declared unachievable was achieved by the liberties his language took. The language of the manifesto dissolved with a grand gesture the borders between genres and freed future generations from the necessity of repeating the obvious. Happily, Dada did not remain within "the framework of European weaknesses" because it thrived in New York and then it became the prevailing form-generator of the 20th century. The historical declarations of Monsieur Antipyrine (who refused to think of them as "historical") were not the only epochal event of the evening. Hugo Ball appeared onstage as "the bishop of Dada," in a costume designed by Marcel Janco: his legs were inside blue cardboard tubes, he wore a high scarlet-and-gold cardboard collar that moved like wings when he shook his head, and a striped blue-and-white high top hat. Emmy danced while inside a cardboard tube with a grotesque mask on her face. After the recitation of his sound poems "Karawane" and "Gadji beri bimba," and halfway through the performance of his "Lautgedichte," Ball

found that a voice was welling from within himself, a priestly, lamenting voice intoning a funeral mass. The frightened performer could not stop himself, but when he finally did, all the lights went out.

In Paris, simultaneously, there are fireworks. Simultaneity is also being discovered simultaneously by painters, poets, philosophers, and scientists in Paris, Vienna, Berlin, Bucharest, New York, and, possibly, Timbuktu. Simultaneity abolishes time in one fell swoop like the *I Ching*, the Chinese book that works simultaneously in the present, past, and future. Happy birthday, French Revolution. Hugo Ball is finished with Dada. He leaves with Emmy Hennings for Lago Maggiore and experiences a powerful conversion to the Catholic faith of his childhood, encouraged by Emmy, whose faith has never wavered, not even during the dreadful times when she sold her earthly body for money for food. Hugo Ball begins writing a profound and complex mystical work,[20] while Emmy tries to hold body and soul together.

With Hugo Ball's defection to God, Tristan Tzara began to turn Dada into a truly international movement. He sent Guillaume Apollinaire in Paris a copy of *Cabaret Voltaire*, and Apollinaire asked for more to distribute among his friends in Paris and New York. Marcel Duchamp, who saw his copy in New York, recognized "the spirit of Jarry, and long

before him, Aristophanes—the anti-serious attitude, which simply took the name Dada in 1916."[21] Simply perhaps, but the name had magical powers. Tzara corresponded with Apollinaire, Duchamp, Picabia, Marinetti, and Breton. The famous Duchamp-Picabia collaboration called *Tableau Dada* by Marcel Duchamp and *Manifeste Dada* by Francis Picabia was published. *Tableau Dada* displays the *Mona Lisa* with a mustache drawn on her, and the letters LHOOQ underneath, which sounded out mean *Elle a chaud au cul* (her ass is hot to trot). Picabia's dada manifesto contrasts Cubism, "la disette des idées," with Dada's absolute nihilism, "Dada, lui, ne veut rien, rien, rien, il fait quelque chose pour que le public dise: 'nous ne comprenons rien, rien, rien,'" which was a pretty loose rendering, if not a downright mutation. Picabia sounds a little exhausted here, but then it's hard to imagine anyone on the scene in either Zurich, Paris, or New York who wasn't. The dadaists hardly slept, and many of them traveled constantly looking for a new scene, or employment, or rest in a world at war when just reading a newspaper could make one's nerves snap. The constant bombardment of ideas would have been even more exhausting if they hadn't had a stage to discharge their physical energy on. Even Lenin, who was a graphomaniac leninist, used an immense amount of physical exertion on podiums in smoky halls, lecturing in detail on the intricacies of imploding capitalism and colonialism, on the French Revolution, on the Russian Revolution of 1905 and the mistakes

made then, all by the way of exhorting the
rather placid Swiss workers to revolution. A
revolution in Switzerland seemed possible to
Lenin, though not to many others. Switzerland
had all the revolution it needed, and in the
mind of even the most staunch socialist, the
public parks, free libraries, reduced power
of the church, and system of taxation were
evidence of its success. Infuriating. Zurich
in 1916 was proof of Nietzsche's dictum
to the effect that wherever the force of the
spirit is increased, there is a corresponding
increase in intensity of ideas in all of society.
Another atmosphere, made not from air, but
from thoughts, circled the Swiss burg, thick
with smoke and insomnia. If the dadas, the
leninists, the radicals, and all those watching,
observing, and reporting on them were not
enough, Carl Jung was also there, as were
Sigmund Freud and Albert Einstein. What
would happen if a single Tzara aphorism,
perhaps, "Dada is a virgin microbe,"
encountered one of Jung's archetypes, "the
white goddess," let's say, while running
simultaneously into a couple of sentences
of Freud's *Interpretation of Dreams*, such as
"I here insert the promised 'flower-dream'
of a female patient, in which I shall print in
Roman type everything which is to be sexually
interpreted. This beautiful dream lost all
its charm for the dreamer once it had been
interpreted," and then bump into a barely-
born new idea of Einstein's about time and
space, perhaps the one that Tzara reputedly
told Picabia and Breton that Einstein had
personally told him: "If you look into infinity,

what do you see? Your backside,"[22] and then *en passant* run into Lenin's "Give us the child for 8 years and it will be a Bolshevik forever"? What would happen is insomnia. If the intellectual air of Zurich in 1916 was heated to such a degree, an (al)chemical combination would have been inevitable. The combination produced in a short time the energy that powered the coming decades. Still, there is no excuse for Picabia's thrice-repeated "rien," because it shows at that moment a profound misunderstanding of Dada. It's like an exorcism: say it three times and it will go away. When Tristan Tzara said, "Dada means nothing," it meant, for those really listening, that Dada *meant* nothing. For everyone else, ignorant of the value of nothingness, nothing meant nothing. I wonder if Picabia's wariness did not broadcast something never discussed then or since: the possibility that having been uttered, Tzara's declaration reserved for poets the work of language while condemning everyone else to *making* art, in a trade between unrewarded utterance and remunerated matter. Tzara and the language(s) of Dada reserved the mystical path, while art was condemned to be a *market*. This would explain the impotent fury of artists trying to kill art while producing enough of it to make a living. Duchamp may have understood this well, because he gave up making artifacts and wrote mysterious little poem-notes instead. When Picabia clicked his Dorothy-heels, this wasn't yet a possibility: the roller-coaster of ideas and publications hurtled on. Theater,

poetry, print, and revolution burst forth in a cornucopia of forms still not exhausted after a century of reruns, neo-neo reproductions and reinventions, hundreds of books, and exhaustive research.

Dada entered the DNA of the 20th century through a radical negation that stayed fresh long after its seemingly successful competitor, communism, bit the dust. The anti-ideology of dada won over ideology and inspired other artistic and political movements that were short-lived to the extent that they compromised with ideologies: surrealism, existentialism, the theatre of the absurd, situationism, concrete poetry, Fluxus, happenings, abstract art, and pop art all became *historical*. Not Dada. There are, of course, many histories of Dada and, as noted, many dada revivals, but nobody can figure out why Dada won't rust. What's more, what's still live in some of the movements inspired by Dada, whether surrealism, happenings, Fluxus, abstract, or Pop, owe Dada that still-ticking *je ne sais quoi* and *je ne regrette rien*. The paradox, of course, is that those movements die to the extent that they become acceptable, while Dada stays both alive *and* unacceptable. Dada has no style, no taste, and no taste for taste, and, after its meager possessions have been divvied up by museums and collectors, all that is left is what Dada *means*. (Which is *rien*, nothing.) No art in its right! Mind (i.e., for sale) can possibly *mean* what it says. Therefore, Dada is not art. Precisely.

And Dada continues to appeal to the young because it refuses any distinctions between life and art, between forms of art, or between humans and their creations, and, what's more, it *means* it. The stem cell of Dada ("the virgin microbe") contains every possibility of revolt, destruction, and self-destruction; it is by definition *anti*: antiauthoritarian, anti-institutional, and anti-art, antianything, like Marlon Brando's answer "Whaddya got?" to the question "What are you rebelling against?" in the movie *The Wild One*. Dada has causes, *all* of them, and is against them *all*, including itself.

The timing of Dada's birth was right. Everything that is solid melted into the air, as Karl Marx and Friedrich Engels's best line in *The Communist Manifesto* had it, and there was no certainty left standing. Both Lenin and Tzara were keenly aware of the possibilities of the vacuum opening before them. Lenin wanted to shape it into a new world order. Tzara wanted to seed it with creative ideas that would sprout anarchically to give birth to whatever they would. These two philosophies of the vacuum of 1915–1918 describe the subsequent history of the 20th century. When that vacuum opened, sucking in the old empires, life, in its simplest form, questioned the uses of human beings and their art again, as it had done many times, in less technological ages. This latest interview by life was complicated by the sophistication of killing tools. How beautiful was a tank?

How big a cannon? What did *numbers* of corpses mean? Very few "serious thinkers" considered these questions seriously. The aesthetics of tools meant nothing to socialists who thought that they should be used to rectify the social order. They meant nothing to professional artists who had carved out a niche entertaining the bourgeoisie. Even those artists sensitive enough to notice that reality could be viewed using other senses than the one trained to photograph first impressions didn't do more than sigh over their discoveries. Yes, light changed the perception of landscape: energy could be *seen*. Yes, life was tragic and its pathos could be made to stir the emotions through vivid expression. But for the first time since the Renaissance, some artists began to notice that something had changed in *the nature of reality*, rather than in the perspective of the artists. Picasso and Braque introduced newspapers into their still life paintings and discovered the preeminent expression of the 20th century, *collage*. Marcel Duchamp, the protodaddy of Dada, exhibited his first "ready-made" *Bottlerack*[23] in 1914. Francis Picabia repainted a mustache on the *Mona Lisa* after Duchamp's first mustachioed *Mona Lisa* was lost. Among philosophers, only Nietzsche channeled the unsettling message that the gods were angry about the way humans were handling nature. Most everyone else, artists and philosophers included, viewed war and social upheaval as a struggle for power and, as an afterthought, a fight for justice. The effort of "thinkers"

was strategic: they wanted to know where the levers of the social mechanism were located so that they might use them to equalize, overthrow, or stabilize society. Artists were looking for new *perspectives*. Monarchies and the military seemed to be the only sincere admirers of the sophistication of the tools of war, an admiration unclouded by philosophical or artistic doubts. Between the "thinkers" and the army circulated only a free-floating class of mystics or charlatans. A steady number of spontaneously-born mystics (out of the ashes of heretics burned by the church) floated between social classes, feeding fragmented communications from the beyond to the families of dead soldiers (the Ouija board was invented in this First World War) and hinting at occult practices that influenced the microcosm and macrocosm in one way or another. As a group, mystics were remarkably consistent, being the only professionals to have survived every attack by philosophy and technology since humans first became self-conscious. Whether genuine or fake, they imparted a real sense of the possibilities of the projection of human thought and imagination. Photography, film, and long-distance communication, fast machines, and mass-persuasion by advertising made a special case for the occult. Even before Freud introduced oedipal doubles to every person, the 20th-century family appeared suddenly to be the result of a daddy, a mommy, and a *destiny*. The king, the army, and the church understood that the order

of a *collective* destiny must be maintained at all cost, before every individual got the idea somehow that herm had a unique one. Artists were struck simultaneously by the urge to rethink everything, as if a huge curtain had been pulled aside revealing an elsewhere, a multidimensional beyond. Europe looked suddenly like a painted backdrop, or perhaps it was the curtain itself. For all that, most artists still believed in art, except for the dadas, who did *not*. *Au contraire*, they believed in desecrating the Church of Art, so useful still to everyone else, if only as a place to store and package the suddenly revealed "beyond."

Marxists denied flatly the existence of the beyond, or any churches that went with it, clearing the room for the concentrated activity of social revolution. Other "system" manufacturers situated all that could be known within consciousness itself, or its proxies: language and observation of nature. Not so fast, said Urmuz, a Romanian who saw the world upside-down, disinflating and moving à la Alice in Wonderland in Bucharest 1909. Tristan Tzara, Ion Vinca, and Marcel Iancu, adolescent poets in prewar Bucharest, saw the tenuous hold of "reality" on language just as Urmuz had; they felt on all sides the weighty presence of a vast invisible world called by Freud "the unconscious." Ugh. There is a universe next door! Not so fast, saith also Wassily Kandinsky, who saw past cubes into the Abstract. Hold it right there, said Picasso, who made it cubic first and

then stuck newspaper adverts in it for shape and volume. *Attenzione!* hollered Marinetti. *Charme, charme!*[24] shouted Tzara, in French, *il y a une autre chose dans la chambre*, there is something else in the room! It resides in every object and it denies the existence of every object; it resides in every thought and it contains its opposite; each word has two meanings, one of which is the opposite of the other; there is a positive and a negative charge in everything that erases everything. Nothing exists, no matter what cumbersome dialectical apparatus you bring to the world: there could be no hegelian dialectic if there isn't enough energy to survive destruction.

And yet there was energy, plenty of it. The cannons were booming, the people were rising, the artists felt the invisible in their own flesh like barbed wire and sex, something called the 20th century was beginning; the world was changing, reality itself was no longer being questioned. A new, fast reality was asking the questions instead. The tools (of perception, of destruction, of building) were ascendant. "To paint the face of the pince-nez—blanket of caresses— panoply of butterflies—*behold the life of the chambermaids of life*. To lie down on a razor and on fleas in heat—to travel like a barometer—to piss like a cartridge—to make blunders, to be idiotic, to shower with holy minutes—to be beaten, to be always last—to shout the opposite of what the other says—to be the editorial office and bathroom of

God who every day takes a bath in us in the company of the privy emptier—*that is the life of dadaists*."[25] Tristan Tzara, writing this, could not have seen the effect of his words in the future, though he suspected, in the last decade of his life, that he *might* have. Still, I'll hazard that he could not have known how the vital adolescent disorder of his proclamations would end up as rigorously sensical as a washing machine. He was "only" trying to produce scandal, the chief occupation of all avantgardes. On the other hand, he was totally serious. He could not have heard, though he'd already thought it, William Burroughs in 1964 claiming that "language is a virus." Tzara did say, "The thought is made in the mouth," a place notorious for germs, and a favorite hostel for viruses. Controversial still, but only in a boring sort of way, is the idea that humans are offices or bathrooms for God. A decade or so hence, after another horrific "world war," the act of God taking a shit inside one's self was quite real to the surrealist Antonin Artaud who conceived the Theater of Cruelty. Not the "theater of indignity"—he was way past that, as were most people fresh from the trenches and the famines—but the "theater of cruelty" that, no matter what the disposition of the actors, was still *theater*. The "theater of war," that was "theater" too, but among the many performances, sublime, tragic, ridiculous, pompous, or comedic, there were some stages where an action of total negation *was* going on. The controlled anarchy of Carnival turned into the Paris Commune,

which nearly destroyed the joy of Carnival, but Pierrot did come back to life, as did obscene song, blasphemous folklore, pagan dance, Devil worship, the poetry of horny shepherds, and feminine moon societies. The architectural project of 19th-century city planners was to contain Carnival and rid the public space of medieval complexity, but the sewers of Paris and neighborhood resistance here and there preserved enough fool's space and cobblestones for sudden irruptions of the absurd. In 1915, the cabaret stage was one arena outside the military machine where the tools of war were questioned under a different spotlight. Here, a *diseuse* like Emmy Hennings could note, with thanks to Freud and George Grosz, the lengths to which a murderous cannon might go to compensate for a general's malfunctioning penis. In the cabaret, screaming could be made to sound expressionistically silent à la Edward Munch, and silence could scream. Languages were wellings on the skin of sound. The church of the impious concentrated in a reduced city space the subversive aspects of carnival, festival, and circus, and with Dada it did so by means of all the art mediums: language, music, dance, painting, drawing, and nudity.[26]

Neither Hugo Ball nor Tristan Tzara nor the Janco brothers, or Richard Huelsenbeck, or Emmy Hennings, or Hans Arp, or any of the occasional Voltaire performers, knew that they had begun work on an alternative reality that would erase the world being constructed by

Lenin. The only trouble with Dada then and now is that despite its liberating influence, it was and it is *work*. Unlike leninism, Dada promised nothing, no utopia, but also no end to strife, no rest. The work of Dada is interminable, consisting inevitably of change. If Tzara and his fellow dadaists had been motivated by anything other than being, they would have promised something at the end of Work. Something, anything: immortality, a better society, an escape, a half-life after death, a lazy pantheism. They promised nothing, but in so doing they discovered the secret of putting the "people of the future"[27] to work, so that that they might reinvent Dada every time they felt the unbearable pressure of "reality" closing in, the boot of *techne* on their neck.

To future humans in the grip of inevitable crisis, Dada has answers every time: it creates time by agitation, humor, self-humor, and revelation of absurdity. Dada is a time-making device, a balloon-popper, and an udder. What does a posthuman need? Time. Udder time. Any kind of time. Dada is charged with creating an antiworld, a communication that exposes the fallacy that language exists in order for people to communicate with one another. Birds communicate just fine without words. Dada is against communication. Words are part of the substance out of which Dada makes worlds, not in order to communicate, but to dis-communicate, to disrupt, to make time where the communication was interrupted. Giant California redwoods make

their own weather: they catch a cloud, seed it, and then it rains on the one tree that captured the cloud. A tree like that is no metaphor. Neither is a poem that captures the cloud of your attention and draws it unto itself. The job of poetry is to carve its own time out inside the maelstrom of posthuman time-suck. It does this by dissolving the ligaments of linearity and making counterswoosh, but not necessarily by making such neat sentences. Still, it builds the words in a way that provides shelter from the machinery of one's body, especially the crowded, buzzing e-body. All words are Dada if they are correctly misused.

assumed name, pseudonym, pen-name: Today, the "world" is a pseudonym that stands, maybe, for the world. "Reality" is doubtlessly a pseudonym for reality. All words are in fact pseudonyms of themselves, and if they are sufficiently pseudonymous, they become symbols. The internet is almost entirely pseudonymous or anonymous. In the last decades of the 20th century and the first of the 21st, there's been an increasing trend for musicians, designers, and writers to use a single name (Madonna, Prince, Adonis) or, even beyond that, to adopt a graphic symbol for identification (the artist formerly-known as Prince). The trend to be an instantly recognizable trademark is partly the need to be recognized by a world with an increasingly shorter attention span, but also a desire on the part of public artists to disappear into the collective, to become No One, or Everyone. A

circle is being closed: Odysseus was the first
"No One," the name by which he answered
when the angry Cyclops asked for his name. A
roll-call of notables is a roll-call of
pseudonyms: Voltaire, the godfather of
Cabaret Voltaire, was François-Marie Arouet;
Lewis Carroll was Charles Dodgson;
Apollinaire was Wilhelm Albert Vladimir
Apollinaris de Kostrowitsky; Man Ray was
Emanuel Radnitsky; Blaise Cendrars was
Frederic Louis Sauser; Marcel Duchamp was
Rrose Selavie (*eros c'est la vie*); Paul Eluard
was Eugène Grindel; Hans Richter was
Morton Livingston Schamberg; and Picasso
was the outlandishly baptized Pablo Diego
José Francisco de Paula Juan Nepomuceno
María de Los Remedios Cipriano De la
Santisima Trinidad Martyr Patricio Clito Ruiz
y Picasso. The art-people pseudonyms came
about for a variety of reasons, only some of
which were conspirative, but the pseudonyms
of revolutionaries were wholly for eluding the
police. Lenin (Ulyanov, Jacob Richter), Trotsky
(Bronstein), Stalin (Djugashvili), Tito (Broz),
Pol Pot (Saloth Sar) were covers that became,
with success, trademarks. Romanian poets
were particularly keen on changing their
birth-names—Tudor Arghezi was Ion N.
Theodorescu; Ion Barbu was Dan Barbilian;
Ion Vinea was Eugen Iovanaki—but it is
among the Jewish authors that pseudonyms
have a weight greater than euphony and poetic
concealment, among them Tristan Tzara
(Samuel Rosenstock), Benjamine Fondane
(Benjamin Wechsler), Ilarie Voronca (Eduard

Marcus), Felix Aderca (Filip Brauner), Gherasim Luca (Salman Locker). It is easy to understand why the Jewish Rosenstock changed his name to Tzara: in a country of antisemites, the best cover is a non-Jewish name. But it goes deeper: Tzara also means "land," which is the one thing Jews couldn't have. They were hired to manage the estates of the boyars, but they could not own land. (This might seem remote, but as close as the 1970s in a country as distant as the United States, Jews couldn't own oil leases; they could sell pipe to the big WASP boys, but until Jimmy Carter's U.S. Trade Representative Strauss told the Texas boys to change the rules, they drew the line at owning oil-land.) Tristan Tzara's first pseudonym was S. Samyro, which was apt for a symbolist, but too wispy for the fierceness rising in him: in 1915 he became Tzara, meaning land, country, the thing that nationalists and the traditionalists held most dear. This is what soldiers died for: their tzara. The defiant poet didn't stop there: he changed his first name, too, to that of the archetypal lover of Europe's most cherished saga, though it is possible that he named himself after Tristan Corbière. By abandoning his given name, he was free to become someone else, a new person who birthed himself and was his own mother and father, and the citizen of his own country. "Rosenstock" wasn't his name, either. Jews had been ordered to take German names in 18th-century Austria-Hungary by Maria Theresa, who saw herself as a reformer. She reasoned that integrating Jews into the

empire by renaming them would integrate them, at long last, in the world that hated them. Of course, Jews couldn't take just any name, because they might have named themselves, God forbid, after regular Austrians, becoming the doppelgängers and worst nightmare of every run-of-the-mill antisemite. She had the fantasy and horror fiction writer E.T.A. Hoffman, who loved mountains, colors, and dimensions, draw up a list of names, and so was born a freshly named people of rose quartz (rosenstein), pink mountains (rosenbergs), stones (steins), mother-of-pearl shells (perlmutters), who were little (klein) or big (gross) or white (weiss) or black (schwartz). Overnight, the Jews became parnassian symbols, their names ready for a symbolist poem, like verses written in colored ink on multi-hued paper by Al. Macedonski, the extravagant Romanian symbolist who dispensed (false) jewels to his followers. This romantic outburst of sympathy nearly destroyed the Jewish community in Europe. During the millennia of exile, Jews had kept only two possessions: the Bible and their Jewish names. They now lost half of their secret treasure. The damage was repaired somehow by giving every Jewish child at birth a secret Jewish name, but after a century of secularization, this became merely a quaint custom, an empty sound at the core of one's official identity. The German names bestowed on Jews by the Austrian empress did not help the Jews of eastern europe, whose German names still marked them as foreigners. On the

contrary, their new names, drawn from a restricted list, made them easier to identify outside their communities. The shtetls of the Pale where the Rosenstocks came from held on closely to their Jewish identities: under the cover of their new names, the pious students of each village studied Hebrew and renamed themselves. A dedicated branch of the Hassid movement brought back the Hebrew language, too, along with a fanatical and literal insistence on each word of the Torah. Tristan Tzara effectuated a multiple escape by changing his name: he left the fundamentalist ghetto for the secular world, reinvented himself in Bucharest as S. Samyro, and then became someone whose name declared both his defiance of the law (he didn't have to own land now, he *was* the land) and his intention to challenge traditionalists on every front: poetry, loyalty, patriotism, reasons for war. Tzara thus joined the revolutionaries of the 20th century, literary, artistic, or political, who had assumed new names. Tzara abandoned his first symbolist pseudonym shortly after he chose it, because he abandoned Symbolism. The solemnity of the symbolist façade crumbled without appeal after the *Bizarre Pages* of Urmuz, and the Cubist and Futurist rearrangements of reality reached him. Suddenly, the world was no longer to be deciphered because it was Baudelaire's "forest of symbols," or even Dante's "selva oscuro." The world was certainly a dense forest of symbols, just as Dante and Baudelaire had

intuited, but things were their own symbols, not stand-ins for another reality. Symbolism was nothing but mechanical Platonism, a movement that had somehow misunderstood the mystery of the material world as an order to inventory it and double each thing by an occult *something*. The glee that must have seized young S. Samyro at the thought that he didn't have to do that must have been great, like learning that there was no assignment. School was out. He could now goof around, joke, play pranks on the elders, tell filthy stories, and sing bawdy songs. If only there hadn't been a war looming. And that Jewish thing. And the hard-to-avoid injustice of it. Freeing oneself from Symbolism wasn't quite enough when there were social issues pressing, backed by centuries of european "culture." "Tristan Tzara" was closer to the mission he felt obscurely, but even that name wasn't quite enough, and Tzara would write in the future under other pseudonyms. The dadaists wrote under multiple names, publishing or acting simultaneously as different people (with opposing philosophies, at times), and in so doing opened the way for the rich play with names and identities that later 20th-century artists used for fun (and branding), and, a short time after, because they *had to*, identity-shifts (including shifts of race, gender, and human to animal and vice-versa) having become mandatory. At the start of the 21st century, artists misunderstood Rimbaud's dada discovery, "*je est un autre*," as an order *to*

be another, just as poets at the start of the 20th century mistook Baudelaire's "forest of symbols" for an assignment. The difference in our time being that now, thanks to the internet, *everyone is an artist,* and everyone feels charged with the task of becoming another(s).

Professional revolutionaries in Europe since the 19th century used names as conspiratorial covers, but artists changed their names to erase their origins, whence prohibitions had come, to become free of parental and ancestral terror. Or alternatively, to display it in all its crippling glory. Or maybe to just disappear, from sheer boredom. "Tzara says that he had always dreamed of losing his own personality; he was ... dreaming of becoming impersonal and of renouncing the arrogance of the belief in himself being in the center of the world."[28] If at the beginning of the 20th century, a pseudonym was de rigueur for an artist, Tzara took it a step further by changing countries as well, becoming an exile, like the revolutionaries hunted by the police. Exiles, voluntary or involuntary, were instrumental to the literature, art, and politics of the 20th century, with both brilliant and horrific results. In abandoning name and country, Tzara could answer like Odysseus—"I Am No One"—when the Cyclops asked, but the Cyclops kept asking, a harsh interrogation that took a long time, long enough for No One to find enough other No Ones to deliver

a resounding NO strong enough to fight
nazis, Europe's chief and upcoming fixed
identity freaks. The desideratum of any artist
is freedom, and finding it involves being
born again. For the purposes of this Guide, I
suggest that you *read* it as *someone else*. Yes,
reader, take a *reading pseudonym*: you will be
astonished by how interesting it will become,
without the intellectual baggage of whatever-
your-name-is-now. Only writers had such
privilege until now (and first-generation
Americans who came through Ellis Island
and were renamed by tone-deaf immigration
agents), but starting with this text I am
making it possible for you to take on a new
reader's name. The first assignment I give
my students in writing classes is to choose a
pen-name. Those who ask why are not poets.
Mostly they don't ask, because they know
that the person who'll write poems will need
to be free of the name they carry like a sack
of potatoes on their backs and hear called
out in derision or displeasure by parents and
teachers. I have never asked them, however,
to read their assigned texts under the cover
and freedom of a pseudonym. It occurs to me
that reading under an assumed name makes
all literature *forbidden* literature, which is the
desired effect. One is not really reading if there
is still a self-conscious reader. What used to
be called "the suspension of disbelief" is more
difficult now when everyone is surrounded,
penetrated, and constructed of text that
writes with light on and through a person.

A pseudonymous reader might just slip like a spy through the net and lose hermself in words.

americanization: Richard Huelsenbeck, Dada drummer, became Charles R. Hulbeck, New York psychoanalyst. Marcel Duchamp, a.k.a. Rrose Selavie, shocked and delighted *tout* New York by exhibiting "ready-mades," including the famous *Fountain*, a men's urinal, submitted under the name R. Mutt to the 1917 Salon des Independants. Duchamp's work had been in vogue ever since the 1913 Armory Show that introduced modern art to America. A sex threesome between Duchamp, Madame Duchamp, and Mina Loy became very public when all three created works to commemorate it. New York had a tonic effect on the modern European artists who began to live there as if they had found, at long last, the elusive bridge between art and life. For many european artists, life in New York became art itself, preferable in its lived multidimensions to the patient making of objects, a painstaking medieval occupation. What's more, the New World offered artists an unvarnished view of the value of self-manifestation and the possibility of opening up new markets of the imagination, markets that were as real as the markets opened by the brash American capitalists whose first markets had also been works of imagination. The process of abstraction was still visible and active within the reality of America in ways closed to the senses for centuries in Europe. Best of all,

the possibility of play was wide open to the intense seriousness of the europeans who had theorized about it. Duchamp claimed to give up art for chess and played chess for decades. He played often with Man Ray, the American dadaist who was a great success in Paris, just like Duchamp, the dadaist Frenchman who was all the rage in New York. For two decades Duchamp played chess in Washington Square Park with anyone good enough to take him on. He declared the death of art, such an alluring and lovely obituary that hundreds of artists sprang out of the lofts and the studios of Soho and Greenwich Village to prove him wrong.

The English-born partly-Jewish poet Mina Loy (Loew), who had been the mistress of Futurist F. T. Marinetti, was *Look Magazine*'s "Twenties Woman" cover girl, and the poet William Carlos "In the American Grain" Williams was madly in love with her; he wrote a play that called specifically for the lead male actor (himself) to kiss the lead actress (Mina Loy). He couldn't bring himself to kiss the beautiful poetic genius that was Loy until the actual performance, when the warned audience began rhythmically clapping and chanting, "Kiss her, man! Kiss her, man!" So interesting was Mina Loy's party-filled New York life that she became profligate in the dispersal of her brilliant work, scattered in respectable avantgarde magazines, but never collected and critically discussed. If Mina Loy had shown more interest in the disposition of

her poetry, she'd have surpassed in influence Ezra Pound and T. S. Eliot, and healed with her cosmic yet bitterly ironic verse the rift that subsequently opened in American poetry between the poundians and the eliotians, a rift that only grows larger as time goes by.[29] Ironically, Pound and Eliot lived in Europe, a place with infinitely fewer opportunities to live intensely every moment, and so they had much more time to pay close attention to their literary products, while Loy, who was more subtle and powerful, traded her literary legacy for the all-consuming allure of the American present. As noted, Mina Loy lived with Marinetti, and she wrote her own "Feminist Manifesto" (1913), under futurist influence, but she savagely satirized the macho futurists. In a letter dated 1914, Mina Loy wrote to Mabel Dodge Luhan that she was "in the throes of a conversion to Futurism—but I shall never convince myself—There is no hope in any system that combats 'le mal avec le mal' ... and that is really Marinetti's philosophy."[30] She was a feminist, a dada, and a poet, but Dada New York took her away from poetry in the opposite direction from Tristan Tzara, who left Dada Paris for poetry. In other words, it was possible for Tzara to transition from the performative flamboyance of Dada theater to the monastic solitude of the page, but Loy remained a Dada *refusenik* for the rest of her life. In New York she made collaged lamp shades from scraps of materials found in the streets. When her great love, the Dada

poet and boxer Arthur Cravan, disappeared in Mexico, she lost all interest in art and withdrew into a silence that lasted until she died, past even the phenomenal success of her *Lost Lunar Baedeker*, republished by Jargon Press in 1982, edited by Roger Conover.

Francis and Gabrielle Buffet-Picabia were in New York between 1915 and 1918, publishing, exhibiting, and going to parties. Picabia's series of "object-portraits" appeared in Alfred Stieglitz's magazine *291*, one of which is a picture of a spark-plug entitled *American Girl*. The early dadas in New York were joined in the 1920s and 1930s by other European avantgardists, a wave of refugees that remade American art and put New York on the map as the new world-center of creative activity: André Breton, Hans Arp, Max Ernst, Hans Richter, Josef Albers, Moholy-Nagy, Mies van der Rohe began writing, publishing, exhibiting, and going to a lot of parties. New York was awash in new galleries, ground-breaking exhibitions, art and literature magazines, new manifestos, polemics, and parisian-style scandals. The atmosphere of New York in the three years before World War One, and the years immediately following, was charged by dada, a fertile dada that gave birth to art and social liberation ideas that did not consider themselves in the least dada. European Dada absorbed American jazz, African-American sound and style, spaciousness for increasingly large gestures,

comix, violence, architecture, advertising, and a cornucopia of forms of anonymous design and object-proliferation. For the cramped students of text coming from the *mansardes* of Europe, America offered space, and everything got bigger: canvases, appetites, drunken binges, orgies, exhibits, statements, magazines, and clothes. In 1921, *New York Dada* appeared in English, with Duchamp's object-collage *Belle Haleine, Eau de Violette* on the cover, a magazine redolent of hot jazz, cocaine, and sex, containing, among other things, a "faked photograph by Man Ray and the portrait of a Dadaist whimsy, a woman whose whole life was Dada, the delirious spectre of Dada mingling with the crowd in one of its monstrous transformations. Baroness Elsa von Loringhoven [see **baroness elsa, von freytag-loringhoven**], "who made objects in the manner of Schwitters, became famous in New York for her transposition of Dada into her daily life."[31]

For one thing, there was more free stuff on the street in New York than anywhere else. Mixing modern junk with old materials (newspapers and tin cans with paint) was limited in Europe by size and quantity. Things that were too big to fit in a Parisian studio could not be constructed on the street, plus people didn't waste so much. Shortages, famines, and wars, and the memory of revolutions and refugees, still occupied the european mind, even the avantgarde european

mind. New York, on the other hand, was all modern and filled with as much modern junk as you could carry, all free. The spaces were immense, inside and outside. You had to empty yourself of old fears and stinginess if you were going to be Dada in New York. You had to think bigger, be more expansive, more extravagant, more generous. The relationship between european artists and America went back to the beginning, when America was only a european fantasy, a New World full of wonders. New York and America were always in the sights of the european avantgarde. The American Revolution inspired the French Revolution; the French Revolution ended in the bloody poetry of the Paris Commune; the Paris Commune was the formative experience of Arthur Rimbaud's adolescence; Rimbaud was the "rediscovered" tutelary figurehead of Surrealism. Throughout these transformations, two imaginary Americas continued to operate, 1. the disappointing America of a revolution that ended in consolidating a democracy based on a triad of mutually alert powers that drew strength from checking and opposing one another, unlike the French Revolution, which ended first in the beyond-good-and-evil bloodbath of the Paris Commune, and then in Napoleon's tyranny. The disappointment of artists in the success of the mercantile American Revolution was due to the avoidance of Chaos. Since the late 19th century, Charles Baudelaire and the Symbolists had been hoping that the

self-disgust that they personally felt would have cosmic repercussions. They wished for an end to the dialectical opposition between good and evil, a condition that the Paris Commune mob transcended briefly. The America so keenly observed by Alexis de Tocqueville was much too optimistic for Baudelaire in even its worst contradictions, so he found an antidote in his masterful translations into French of the romantic and reactionary work of Edgar Allan Poe. Poe, the anti-Whitman, held out the vision of another America, 2. a blood-drenched, mystical, Goth America that did (and *does*) exist, a laboratory for the irrational and the poetic. That poets should wish for Götterdämmerung during the hangover is not news, but transferring even part of this kind of self-destructive wish to America is interesting. There wasn't much for Europeans in the American Imaginary that supported a dystopian view of the New World. The Native American tragedy was still thought of as the "Indian wars," a series of conflicts and a web of alliances with colonial powers, that would take a very long time before it would be called "genocide." The violence of American cities was still glamorous. Blaise Cendrars, during his first visit to New York, rhapsodized about the fact that the hotel he was staying in was robbed at gunpoint the day after he arrived. This was, he thought, the "real America," the hard, violent, noir, stylish America that was in every way the opposite of soft, effete, bourgeois Europe. Cendrars and

many dadaists and surrealists admired boxing, the sport Americans had taken to new levels of brutality.

America was an ever-present attraction for even the most anti-capitalist radicals. In 1916 in Zurich Lenin thought that if the revolution failed in Russia, he would go to America, like Trotsky, the architect of the lost revolution of 1905. Trotsky was in New York at the very moment it occurred to Lenin to emigrate; was on Second Avenue, ordering latkes with sour cream and applesauce from a gaunt waiter at the B&H Kosher Deli. The waiter will work there until the age of ninety, when he will die, in 1967, but not before he'll be asked hundreds of times by dadaist hippies what Trotsky had for lunch. By 1967, the top one percent of a rebellious generation will wear Trotsky's face on their tee-shirts. Lenin's face will be on worn on red berets by a grim minority. The rest of that vast and rebellious generation was Dada. Walt Whitman's dada line "I am human, I contradict myself" became glaringly obvious as the contradictory, dual, energy-making machinery of the universe showed through the façade of "reality" thanks to LSD. Music made buildings. The Yippies, a political American dada group, threw money from the visitors' gallery at the New York Stock Exchange and briefly interrupted capitalism from its relentless march. By the turn of the millennium, in the year 2000, the B&H was still a kosher deli,

run by the Puerto Rican cook who inherited it from the Jewish owner. Allen Ginsberg, American poet, was getting matzoh ball soup from the B&H for his lover Peter Orlovsky, who had a cold, in 1968, when a young Romanian poet intercepted him to ask what he was *doing*. "Getting matzoh balls for Peter's cold," Allen, the Yiddische mama, answered, giving the young Romanian a dizzying telescoping view through the years, a veritable *chute dans le temps*,[32] brushing in passing Emma Goldman's generous bosom and the beards of Jewish prophets. In his great "Howl," Ginsberg wrote about poets throwing potato salad at "lecturers at CCNY on Dadaism,"[33] and that was a guide to the appropriate dada gesture for the young poet who, years later, at about the age Ginsberg was then, would write a Dada Guide, thereby earning Allen's posthumous rage and fully expecting to have potato latkes thrown at him. And in "Kaddish," the great lament and remembrance of Naomi, his mad communist mother, Ginsberg salutes, in passing, Trotsky, his Lower East Side neighbor, and looks back on the century's cruelty, American communism, and Naomi's madness. And the dadas of New York whirl in a merry-go-round above the skyline, full of mirth, buffoonery, energy, raining down pamphlets. Almost one century since that April evening in 1916, the dadas show no signs of slowing down the production of rebel forms issuing prodigiously from those few months of mad invention. It's as if they opened the *other* mouth of Chaos, the one that never tires of its splendid rage. And then

there is the *other* mouth of 20th-century hell, opened by the well-behaved people of the world marching like ants to slaughter. "One must have a bit of Chaos in oneself to give birth to a dancing star," said Nietzsche, and the dadas keep giving birh.

american woman (the): Peggy Guggenheim, Nancy Cunard, Gertrude Stein, Mina Loy. European dadas admired the American Woman, that new, fiercely independent (often rich) figure who ranged atop a horse with a gun in the West (Annie Oakley) and fashionably flaunted convention in New York (Peggy Guggenheim). The American Woman, but mostly Peggy Guggenheim, ended up saving the lives of many dadaists and surrealists when she paid for their passage from Europe to America to escape from the Second World War. Peggy was an art connoisseur and lover of artists and anarchists, who were, like her pooches, dear to her in a completely unselfish way. In the 1920s she provided anarchist Emma Goldman with shelter near Cannes, a forlorn place back then. In exchange for shelter, Goldman, whom J. Edgar Hoover called "the most dangerous woman in America," entertained Peggy and her guests when they arrived by motorcar in the middle of the night drunk on champagne and high on cocaine. On the eve of the war, waiting in Portugal for passage to the United States, bored out of their wits, Peggy Guggenheim and writer Kay Boyle exchanged husbands. They were briefly amused. Back home, Kay Boyle wrote leftist psychological

novels, while Peggy, prodded by Duchamp, assisted at the birth of Abstract Expressionism by supporting Jackson Pollock. She married Max Ernst, who, freed from money worries, went junking through the secondhand shops of New York, often accompanied by André Breton, to buy trinkets to put in his art. The junk shops of New York provided many of the materials of art for the rest of the 20th century and, in so doing, proved to be alchemically apt. The junk, once turned into art (often barely or not at all) became absurdly expensive, so absurdly that Duchamp, sensing the depth and hunger of this market, could do little but quit the racket altogether. After displaying a urinal in a museum, what was there to *say*? Nothing really, though much was said. The point was to *make* stuff. If Peggy Guggenheim's husband, Max Ernst, could make gold out of tin, why not do that? The most impoverished of the bohemians, however, rejected that cheap alchemy. Jackson Pollock *painted*, an expensive activity without money, and his integrity caught Peggy's attention, who took him as a lover. Now she had both the playful alchemy of Ernst and the sullen integrity of Pollock. What more could she want from the 20th century? She died in her Venice palazzo, the owner of the last privately owned gondola in the city, and was buried in the garden alongside her five beloved dogs.

While Peggy Guggenheim presided over the avantgarde, as befitted an American aristocrat, the Anglo-Saxon world was busy providing

an artistic alternative called Modernism.
Modernism had many daddies, one (Jewish)
mommy (Gertrude Stein), and one half-
Jewish British-born poet-muse, Mina Loy.
Ezra Pound, T. S. Eliot, James Joyce, and
William Carlos Williams are the daddies of
modernism, the chief claim of which is that it
is a *non-Jewish* avantgarde. The inconvenience
of Jewish *mamele* Gertrude was partly made
up for by the fact of her formidableness, so
formidable a formidableness that even the
nazis left her and Alice B. Toklas alone, at
a time when Jews were being deported to
the death camps. (Picasso, the communist,
intervened on their behalf with the German
High Command, which must have harbored
superstitious culture germs.) Modernism
was a (mostly) antisemitic avantgarde and
anticommunist to boot, which made it shun
Dada in favor of Futurism. There were few
differences between Futurism and Dada
in 1916 when both Marinetti and Tzara
aspired to the same revolution. The year
1916 is comparable to 1968 in the U.S., when
libertarians Newt Gingrich and John Clark,
shared the same pamphlet-covered table on
the Tulane University campus. A decade later,
Newt Gingrich led the right-wing Reagan
revolution, and John Clark wrote textbooks
on anarchism and further elaborations of
the ideas of Bakunin and Emma Goldman.
Some such abyss must have opened in the
1930s between the communist Tzara and the
fascist Marinetti. Macho modernism, unlike
the feminine avantgarde, had little use for the
American Woman, who was too independent,

too sassy, but maybe not too rich. Ezra Pound's manner of dealing with Margaret Anderson or Marianne Moore, for instance, was to correct their taste by creating lists of modernity and, while they were thus occupied, to use their resources to promote modernism. The avantgarde, perenially in need of money for survival (and, later, passports and passage), thought that the rich American Woman was an indispensible part of the enterprise. Tristan Tzara: "The poor are against Dada. They are very busy with their brains."[34] Thinking of oneself as poor obliges one to steal from oneself, thereby robbing yourself of the wealth of the imagination, the true riches of the world. The "no money" part is so much more gracefully solved by elegant, beautiful, rich American women who believe in freedom. There was a certain revulsion toward the rich European woman, who came by her money as the result of widowhood and witchcraft (synonymous in most cases) and could support an artist's work only if he became her husband and turned his art to profit. This ingrained prejudice is not without foundation: in the 16th century wealthy European widows were accused of witchcraft so that the king could confiscate their property. American wealth was not associated with witchcraft in any way, and the American woman was seen as an equal because of her work on the frontier. Of course, between the gun-toting frontierswoman and Peggy Guggenheim there was a serious gap. In truth, there was only one Peggy Guggenheim, and some mini-Peggys.

Gertrude Stein and Djuna Barnes pursued
an entirely different course, and their money
is hardly ever mentioned because it did not
act so publicly on the fate of artists. The
American Woman loved Marcel Duchamp.
All women loved Marcel Duchamp, and he
loved them back. Mina Loy loved Arthur
Cravan. Tristan Tzara made love to American
women in Paris, but he never married one.
He joined the Resistance in France and
became a communist. Huelsenbeck made it to
America on his own, and he psychoanalysed
the American Woman, though it does not
appear that he liked women much. Hugo
Ball and Emmy Hennings lived in ascetic
seclusion on a Swiss mountain and pursued
Catholic mysticism. Until recently there were
no American women saints. Now there is
Mother Seton.[35]

andré, breton (1896–1966): Breton so
looked forward to Tristan Tzara's arrival in
Paris, he could barely contain himself. They
had been corresponding since January 1919,
with Breton insisting more and more urgently
that Tzara come to Paris, but months passed
before Tzara actually arrived. André Breton's
inspiring friend, Jacques Vaché, committed
suicide at the end of the First World War,
and the disconsolate young poet was looking
to use and to understand on a larger scale
the discoveries he and Vaché had made
about poetry. Together they had discovered
Rimbaud, Lautréamont, and Apollinaire, and
everything they had believed in until then had

crumbled. The traditional values of family, church, and state were receiving massive blows from artists suddenly awakened by brutality to imagine a different world. Poetry pointed the way to something else, to an elsewhere, to a sense of the marvelous, to magic, to otherness. The activities of the dadaists in Zurich, but especially the manifestos and writings of Tristan Tzara, excited Breton to a pitch of fever. He believed that Tzara might be the reincarnation of Vaché, that he was the messiah of the new way in the arts, and not just the arts. Paris in 1919 was an explosive playground of art and new ideas. The Cubists had already ascended to the modern pantheon, and younger artists were quickly creating new movements. Writers seized by the new spirit looked to the coming century in wonder: they knew, obscurely, that anything inspired that they could make in this place and at this time would be automatically valued by the future. They had the sense also that there was a great deal to be made and thought because there had been a great breach somewhere in the fabric of what everyone took for "reality," and other worlds were pouring in at an astonishing rate. Guillaume Apollinaire coined the word "surrealism," to describe the fusion of new arts, in a review of the ballet *Parade*, which had a script by Jean Cocteau, scenography by Picasso, music by Erik Satie, and choreography by Massine. Apollinaire created his own surrealist play, *Les Mamelles des Tirésias*, staged in June 1917. Breton and Vaché attended the performance

and helped push it to a full-blown scandal
that erupted when, after an interminably long
time, the curtain rose and a fat woman took
off her blouse and pulled out her breasts, two
gas-balloons, and flung them at the audience.
Vaché, dressed in his military uniform,
allegedly fired a revolver. This performance
seemed to Breton very much like the doings
of Cabaret Voltaire, and the idea of spectacle
produced collectively in inspired freedom
joined poetry forever in his mind. Dada gave
birth to the surrealist movement that Breton
would later make his fenced-in theoretical
kingdom, but first Dada had to establish itself
in Paris. Tzara's eagerly expected arrival was,
at first, a disappointment to Breton, who
had imagined someone more dashing, taller,
someone with Jacques Vaché's good looks.
The welcoming party of Breton's friends,
including Paul Eluard, Louis Aragon, and
Francis Picabia, were not terribly impressed
either. Picabia was actually indifferent to the
moment of arrival itself, since he'd already
met Tzara in Zurich and they got along
famously. Descriptions of Tzara, a "small"
man with a monocle, speaking French "with
an accent," "timid," etc., abound in the letters
and journals of Breton's intimates, who found
their homoerotic messianic expectations
dampened. This first impression, though
persistent in literature, and proof, if anything,
of Parisian snobbery, was dispelled when
Tzara's phenomenal energy and brilliant
inventiveness set everyone in motion. In
addition to the many Dada spectacles and

scandals that followed, Tzara turned out to be a remarkable French poet, whose use of the language, uninhibited by the taboos of his native tongue(s), renewed it like a fresh spring. Tzara made French his personal playground, and the astonished litterateurs of Paris couldn't wait to climb aboard its variety of fun-rides. Breton recognized his immense talent, as did other French poets and critics, and while the stories of theories and quarrels dominate the anecdotal literature, something more profound and now forgotten had taken place: a major French poet had begun transforming French literature, a poet who was the embodiment of Rimbaud's *l'autre*, the other, a Romanian Jew whose first language was not French, whose given name was not Tristan Tzara, and whose radical impertinence was without equal. At first, Breton adhered to Dada completely, bringing his great talent for friendship and organization to bear on a multitude of activities. They published together the magazine *Litterature*, and produced events that included some of the Voltaire discoveries, such as poèmes simultanés, cut-ups, absurdist paintings, performances of poetry by Picabia and Duchamp, complete with theatrical props, and befuddling nonsense lectures. Their most notorious manifestation attracted a huge crowd to the Grand Palais, after the dadaists announced that Charlie Chaplin had joined the dadas and would speak about it. Chaplin knew nothing about it, and when he didn't show up, there was a riot. Paris was an

easy playground for Tzara because it was a
city steeped in art where everyone expected
the shocks of the new with a not-unpleasant
frisson of dread. The problem for the dadas,
as soon became apparent, was that the *frisson*
proved more and more difficult to produce,
because the public quickly became bored.

The expectation of the new and its companion
shocks would become synonymous with art
for the rest of the century, not only in Paris,
but everywhere. In the future that the dadaists
had now unleashed by addicting it to ever-
novel perfomances, there were going to be
unending attempts to offend public taste and
morality. The saving grace for the coming art
was that the dadaists did not exhaust it: the
majority of people on earth still clung to the
inherited values of religion, state, and family,
values that are quick to (re)assert themselves,
even after such earthshaking events as the
successful revolution in communist Russia
where Stalin proclaimed that "the family is
the basis of society," firmly quashing futurist
attempts to undermine it with free love.
Likewise, all dictatorial ideologies in 20th-
century Europe, including Futurism's own
Mussolini and Nietzsche's deformed baby,
Hitler, claimed that the first societal order was
the integrity of the family and respect for the
church (*Kinder, Küche, Kirche*). As early as
the mid-19th century, the threat to the family
was removed from *The Communist Manifesto*
by the First International, which voted to
remove the second demand after "Abolition

of Private Property," namely, "Abolition of the Family," which the founders saw as an extension of private property: man owns woman, parents own children. Thanks to these non-negotiable power agreements, the dadaist provocations continued and continue to be safely outrageous. I saw the *Paradise Now* performance of the Living Theatre in Detroit, Michigan, in 1967, before a truly outraged audience, unused to being told to burn their money and passports, and take off their clothes, as the actors were doing. At the *Paradise Now* perfomance in New York in 1968, the audience was more radical than the actors. When they challenged the audience to "Burn your Passports," there was a shout from the crowd, "Let's burn the fucking theater down," and several determined local anarchists started setting fire to the curtains, causing a frenzied panic. The Living Theatre in the 1960s had learned from the dadas, the surrealists, the situationists, and the anarchists. By 1967 everything dada and/or surrealist was in the performance tool-kit of a new insurrectionary spirit. In 1967 in Detroit, radical activists founded a Rumor Bureau that specialized in launching false rumors, one of its most successful being that the cover of the Beatles' album *Abbey Road* proved that Paul McCartney was dead. This rumor made it around the world in three days, way before the internet. With the invention of the internet, the whole world became a target for such subversive enterprises as "Encyclopedia Disinformatica," which specializes in almost-

true facts such as "Antigone was Hamlet's mother," and the truly subversive RTMark. com, which mimicks corporate websites and tai-chis them; one of their jujitsu/tai-chi moves nearly torpedoed the World Trade Organization (WTO) and Toys "R" Us. Why, a sane person might ask. For the hell of it, a dadaist might say.

Tzara, for all his brilliance, just wasn't serious enough for Breton, who was a serious man. He had waited patiently for Dada to run through its repertoire of old and new tricks, in the hope that something would emerge from the mess to point the way for a fundamental change in art and society. For Breton, as for the French public, the idea of repeated hoaxes and pranks did not appeal. Sooner or later, as the Parisian man-about-town told his wife, after a long and disappointing evening spent in the arms of his mistress, New Art, "there has to be something serious about it all. Man cannot live on laughter and jokes alone." But Tristan Tzara had said plainly, and meant it, "Dada is against the future." The future was everything for Breton: secretly, he was a romantic who believed in utopia, a faithful husband of the old values that he rejected more because he failed to believe in them than because they were bankrupt. He was certain that another world waited to be found and that world was utopian in a lovely fourierian way that did not reject all the colors and pleasures of his Catholic childhood. He had glimpsed this u-topos in poetry and even in

many Dada events, but those glimpses had to be brought under a rigorous system, they needed to be made into practical tools for the *Surrealist* revolution that would bring it about. As Breton saw it, Dada had to evolve into an ideology of struggle against reality for a purpose, into Surrealism. He set to work defining and refining the revolutionary tools, by gathering around himself a dedicated group of followers ready to experiment in order to create a science for bringing about a utopian *elsewhere*. Breton found his first tool in the practice of reaching into *the unconscious*, by means of freudian analysis and free-association. Reaching into the unconscious and bringing treasure from its depths involved many techniques: *écriture automatique* (automatic writing), hypnosis, self-hypnosis, occult chants, spiritism, theosophical and alchemical formulas, old magic, reviving forgotten heresies, and whatever else science had repressed or discarded since the Enlightenment. In the First Surrealist Manifesto (1924), the enemy was redefined: "We are still living under the reign of logic, but the logical processes of our time apply only to the solution of problems of secondary interest. The absolute rationalism which remains in fashion allows for the consideration of only those facts narrowly relevant to our experience. Logical conclusions, on the other hand, escape us. Needless to say, boundaries have been assigned even to experience." The goal was also distinctly different from the children's

games of Dada: "For the time being my intention has been to see that justice was done to that hatred of the marvelous which rages in certain men, that ridicule under which they would like to crush it. Let us resolve, therefore: the Marvelous is always beautiful, everything marvelous is beautiful. Nothing but the Marvelous is beautiful." Not quite as profoundly unarguable as Keats's "Beauty is truth, and truth is beauty," Breton's affirmation is nonetheless . . . marvelous. By making an adjective into a noun, Breton sought to solidify the last traces of "beauty" (known formerly as "good taste") by restoring to it the magic eroded by logic, science, academism. All good, except for the tendency of former adjectives such as "marvelous" to slip back into their adjectiveness when not improved constantly by a guardian of its nounness. When the care and watering of the marvelous, through dreams, poetry, esoterics, mysteries, caballahs, and ancient sources, slacked, the noun, left on its own, hears the siren song of its adjectiveness and regresses. Perhaps it cross-dresses. Like a dog left at home while his owners are at the Opera, it cannot resist peeing on his mistress's lingerie and his master's monogrammed cigarette-case, while admiring himself in the mirror and barking, "How marvelous!"

Dadaist dreams will not suffer either freudian, jungian, or lacanian interpretations. Tzara employed a technique of "experimental dreaming" in his 1935 poem-essays "Grains

et Tissues." Deliberate dreaming as "directed dreaming" or hypnotic suggestion was widely practiced by theosophists in the 19th century, but Tzara stripped the prose from oneiric transmission and employed only those dream essences that refused to make "sense." Dada's attitude to dreams was no different than Calderón de la Barca's "la vida es sueño," (life is a dream). There isn't any point in *analyzing* dreams if everything is a dream: the analyst could be no one but the upholder of authority and of the "reality" the dadas meant to escape from.

Tzara was quite startled when André Breton set dreams apart as a separate reality that needed coaxing and order, a reality that only people with "dream passports" (i.e., Surrealists) could travel in with impunity. Breton set up a *nation* (that bogeyman!) of dreams, ruled by Surrealists (with help from the eminently bourgeois Doktor Freud). Of course, Breton didn't set out from the very start to found a Republic of Dreams with him as president, but the impulse was in him. There is a nation-builder (or empire-builder) inside every Frenchman: the only cure is mescaline (see **michaux, henri**). When André Breton decided to break from Dada and Tzara for reasons that were partly personal (he quarreled with Tzara, as he did with most everyone, eventually), and partly because of his feeling that Dada was beginning to go nowhere with its "shocking" spectacles

because Parisians were no longer shocked, he seized on "dreams" as a chief means to disengage. Breton's earlier incursions into the "unconscious" led him to try to add a poetic dimension to Freud's *Interpretation of Dreams,* by considering dreams on their own, as an alternative reality. This dream-reality did not necessarily need to be subjected to interpretation and used in search of a "cure," but would, on the contrary, be affirmed and substituted for reality, which was, after all, only an agreed-upon convention of the power structure. The "reality" organized by society's manipulators might be replaced by dreams in a way that would point to psychic liberation. Breton's ambition was to bring the "unconscious" into the open with all that it might contain, demons, perversions, and vices. All that had been suppressed for millennia by the power-brokers who designed "reality" would be purposefully released, bringing about a "revolution of the spirit," and not only. Breton found a tactical ally in Freud, whose approach to dreams was methodical and rigorous, qualities that Breton found appealing. In order to access the world of dreams, Breton quickly found two "mediums": Robert Desnos and René Crevel, young poets who competed with one another for Breton's affections, and raced each other to be first to surrender to hypnosis and to channel the netherworld of dreams from which they spoke without remembering later what they'd said, in the presence of André

Breton and his circle. Competition became so intense between the two that the simple sight of the founder of Surrealism sent both of them into a trance state whence they started babbling uncontrollably, indifferent to place or circumstances, even on a public street. After his initial adoration of Freud, who personally rejected his doctrine, Breton made an effort to de-oedipalize dreams, a surrealist initiative that found its late but best expression in *Dialectique de la dialectique*, the manifesto of Romanian surrealists D. Trost and Gherasim Luca, in which they situated "non-oedipal erotism" at the base of actions of "negation of negation" and "the dialectic of the dialectic," apparent paradoxes that went a long way toward establishing a new philosophical understanding that blossomed in Gilles Deleuze and Félix Guattari's 1972 masterpiece, *Anti-Oedipus: Capitalism and Schizophrenia*.[36]

1916, early morning, chess tables still not set up, it's snowing, the café won't be open for another hour. The sleepy waiter thinks: People who don't win the lottery have an odd familiarity with the winning numbers. There they sit, in the cafés, looking at them in the newspapers . . . they look extremely familiar . . . very close . . . 7 . . . 11 . . . 1916 . . . 2008 . . . 2018 . . . very, very close.

a dream, april 12, 2008: There is a lot of cocaine in the next world. At the big party, there is a mirror in the middle of eternity, a wheel of the damned on which the heads

of the great and the small bend in constant *davening*. Everybody who's anybody (in this book) and everybody who's nobody (in other books) is here. In this world, it's the leap day of the fourth year and there are a lot of executions because laws don't apply on the invisible day. The executed go to the party after forty days and nights of confusion.

The spontaneity and sexy freedom of improvised revolt in Dada gave way to the grim work by Breton and his followers to find the secret keys to another world by employing the severely maintained Marvelous. There was little fun in this enterprise, but then the world in the 1930s was no fun either. Something evil was back in the world again, the same evil that Tzara had fled from to Switzerland. In such darkening times, the occult, vampiric, perverse researches of Surrealism seemed a lot more apt than the lighthearted provocations of Dada with its absolute refusal to make sense, or even to make alliances with people who made sense. Surrealism was all about alliances, about group politics, about Breton's enforcing Surrealist *discipline*. The absurd had metamorphosed from an occasion for freedom and laughter into a solemn academy guarded by surrealist dogs. We were mistaken in the previous paragraph: the Marvelous was not a dog, but a parrot in a gold cage guarded by dogs. We apologize. During the war, Breton took his show to New York, where surrealist activities increased, but not in the direction Breton would have liked. After the war, back

in Paris, a bitter Breton presided over the disintegration of the movement and watched it pass not into a utopian elsewhere, but into that most dreaded of things, *the museum*!

André Breton, who never felt at home in America and refused to speak English, gathered a number of American followers, but group discipline could not be enforced in New York as it had been in Paris. There were too many circles of interest and friendship, too many restaurants and not enough cafés, too much involuntary surrealism everywhere. Dada had thrived in Zurich on the variety of people from different countries and the clash of differences, and it continued with renewed vigor in New York, but Breton hated disorder. He had an instinctive conspiratorial streak that demanded purity and enemies, an "us" and a "them," an attitude that was the opposite of Dada's, which encouraged mélange, mixing, creolization, confusion (of sexes and races), pseudonyms, identity exchanges, destruction of borders, and promiscuity as opposed to war. New York *was* Dada, and its energy was uncontainable by theory. Breton without theory was not conceivable to Breton, but the theory-mocking New World welcomed Surrealism warmly, nonetheless. The American Surrealist magazines, *VVV* and Charles Henry Ford's beautifully produced *View*, celebrated Surrealism and made generous room for its polemics. Breton's best-known polemic was with Salvador Dalí, who was experiencing enormous success with the public and was taking Surrealism mainstream,

a place Breton abhorred. Still, there was little he could do about it: what Americans liked, they paid for, and Dalí was becoming hugely rich as well as famous as a Surrealist. It was all Breton could do to keep copyright of a word that was becoming synonymous with Dalí. One of the things he *could* do, and did, was to encourage the enemies of Surrealist art who, in his view, were exponents of the Surrealist spirit, though not of its visual style. Abstract art, in its savage, native form, uncompromised by the endless quarrels of the europeans, burst onto the scene and moved the center of the art world definitively from Paris to New York. The Second World War unfolding in Europe also created a political divide between the "Americans" of New York and the artists who'd stayed behind in Europe to fight the nazis. The once-upon-a-time core Surrealists Paul Eluard and Louis Aragon wrote non-surrealist, patriotic, rhetorical poems that became anthems for the French during the war. Tristan Tzara and René Char followed Eluard and Aragon into the Communist Party and took an active part in the Resistance. There was hardly any time for the French poets to follow the intrigues of Breton and his followers in New York, but controversy had a life of its own. Even Dada, innocent and not-so-innocent Dada, became a matter of bitter dispute between the anticommunist Huelsenbeck and the communist Resistance fighter Tzara, though it wasn't until after the war that Tzara could counter in any way the charges accumulating across the ocean. Tzara had attempted, without success, to

embark for America before the war, but Peggy Guggenheim didn't help him. Like another great Romanian artist and Surrealist in France, Victor Brauner, he was left behind. Both of them were Jewish and starring personalities of the art that the fascists and nazis hated. Without the possibility of going to America, they were obliged to stay behind and fight.

armand, inessa (1874–1920), "daughter of French actors and the wife of a well-to-do Russian, broke with her husband and joined the Bolsheviks. She met Lenin in Paris in 1910 and soon became, under Krupskaia's tolerant eye, both his mistress and his faithful follower."[37] She was a proponent of "free love," a doctrine Lenin argued against, believing it to be a purely theoretical matter. In Switzerland, however, separated from Lenin by only a short distance, Inessa's feelings for him cooled considerably, leaving Lenin, alone with Nadya in Zurich, to suspect that praxis may have entered the theory. *Dear Friend! Your last letters were so full of sadness, and these aroused such sorrowful thoughts and stirred up such pangs of conscience in me that I simply cannot compose myself.*[38] Lenin had feelings!

audience: that which one provokes either to participation or to self-destruction. Dada realized the former, Lenin the latter. What to do with the audience would preoccupy every member of the Zurich art and ideology squad for the rest of the century. For the dadas, a nonparticipant was like a policeman, the

sober guy at a drunken party, taking notes. A celebratory, participatory audience was de rigueur because Dada, like Carnival, mocked spectators, made them feel like parasites, and reserved the right to attack them physically and by any other means. They meant to induce collective delirium, joy, hopefully, but rage if there was no choice, and to drive the maddened collective to either an orgy or arbitrary destruction, "arbitrary" being the operative word. "Nonarbitrary" destruction was what the political mobs had been doing forever and what, unbeknownst to the dadas of 1916, they were going to do to much more sinister effect in the coming decades. The (self-)contradictions of dada and its varieties of grotesque emotions and symbolic images of anarchy hoped to render mob fury impotent, much as boxing drew angry energy to the sport rather than generalizing violence. Lenin was an agitator. For him, as for the thousands of commissars who followed in his deliberate and well-defined footsteps, the purpose of an audience was to constitute the body of a mass-meeting that could be turned into a multiheaded dragon of fury. The collective mass of spectators could follow the directions given it by the rage of the commissars. The "masses" were invented and exalted by marxism and leninism because they were the perfect instruments of revolution and power for leaders who could convince them of their "historic" importance, their destinies, their purpose, and their targets. The masses didn't exist before the writing of *The Communist*

Manifesto. Before that there were mobs, outraged citizens, crowds, gatherings, mixtures of people with various interests and different backgrounds, who came together briefly for a festival, a riot, a *fronde*, a revolt, even a "revolution," though not in the sense that marxists gave it. A "revolution" before Marx and Lenin was the highest achievement of a mob, but one that it couldn't hold on to. Every "revolution," once past the euphoric stage of burning the palace and chasing out the rulers, devolved back into the fists of guardians of order who rearranged society in order to return it to its previous owners. The writers of *The Communist Manifesto* would never have believed it, but the Russian Revolution of 1917 was going to be no exception. Lenin's marxist revolution was the first revolution to maintain the rhetoric of the "masses" and to transform mobs into "masses" through sustained propaganda and enforcement, but power was never returned to them. After Lenin's party took Russia, the audience for the inspirational communist speaker, from Lenin to the lowliest commissar, was never again allowed to forget that it was a mass (of sheep), and that they had a "historic" mission. At first, the leninists experimented with audience participation in the form of a "dialogue with the masses," in which questions were allowed (directed) and answers given by the political speaker; later, they introduced "self-criticism," a public confession of sins against the "revolution" or "the masses," a ritual followed by the granting of penance (extra work, exile,

jail, or death). The "dialogue with the masses" was ritualized: questions provided in writing in advance by the commissar were returned to him out loud and he answered them. "Self-criticism" became voluntary confession before the police. By the time of Lenin's death in 1924, the audience of bolshevism was a quasi-military mass held in place by terror. The nonparticipatory, mute audience created by Lenin embraced the freedom of dada and anarchy with delirious gusto in 1991 when bureaucratic state communism finally bit the dust in Russia. Crowds had waited eighty years to speak, and when they did, they cried NyetNyet! NoNo! Or, DaDa! YesYes.

The natural progression of attitudes toward the "audience" in the West followed Dada. The New York School poets of the late fifties, inspired by Frank O'Hara who was inspired by Mayakovsky, collaborated among themselves, and also with painters and musicians. In the 1960s a plethora of publications appeared quickly, thanks to the cheap and messy technology of the mimeograph machine (Viva Gesttetner!), and poets were suddenly everywhere, as were painters. Andy Warhol's Factory began mass-producing paintings, prints, films, and music. We even had the War in Vietnam as the necessary background for this Dada resurgence that was a renaissance, it felt so so new. Theater became participatory in the 1960s when the Living Theatre asked us to burn our money, passports, and clothes. In 1968 at St. Mark's Church in-the-Bowery,

locus of poetry and anarchist militancy, I went to see a play by Amiri Baraka, formerly LeRoy Jones, the author of the poem "Black Dada Nihilismus." This was the first appearance on the "white" scene of the poet who had become a Black separatist and Muslim, and had not spoken to his avantgarde friends in years. Every one of those friends and hundreds of curious spectators jammed the hall. After a long wait, the lights went out, and the darkness descended for what seemed like hours. Just as the uneasy audience began wondering whether something ominous might be at hand, gunshots rang out. The gunfire intensified and some people, sure that they'd been shot, started screaming. A few matches were lit and a dim light slowly made its way into the room, and the stern faces of Black male actors appeared everywhere among the spectators, repeating the greeting word, "Alafia! Alafia!" After the unease, the terror, and the return of the light, the actors were greeted by a great sigh of relief. Baraka himself appeared after a while and launched into a dada attack on white society, capitalism, and decadent art forms. It was a relief. And *so* dada. The late Fifties, the Sixties, Seventies, and Eighties in the U.S. saw Dada multiply its activities tremendously through collaborative Happenings among painters, poets, and musicians in New York lofts, the absurd but precisely choreographed improvisations of the Fluxus group, and spontaneous rallies that used dada provocation to make political points. For my generation, dada became a

way of life, synonymous with life. Everything
we did at certain times contained a radical
negation, a dada attitude that had its most
creative delightfulness in the punk and
postpunk explosions of the 1980s. After
postpunk dissolved in alcohol, cocaine, heroin,
and AIDS, the ever-needy market rushed
to paw through the mounds of discarded
forms left behind by dead dadaists. Today,
almost everything you're wearing or thinking
that gives you the slightest bit of subversive
pleasure comes from a dead dadaist. Janco's
costumes for Huelsenbeck, for instance, have
been recycled by fashion so many times,
there are now *real* bishops wearing them. The
recycled trash the dadas made part of their art
has came back several times as high fashion.
Idiosyncratic typography, a major dada
delight, filtered through to Macy's and back
to MOMA, and then back again. It isn't just
design, though, a shaky notion at best, since
the dadas made deliberate efforts at changing
styles, so that they could be said to have none.
The *recycling* itself was dada, insofar as they
were the first urban rats to realize the mind-
boggling waste of the modern world and its
potential uses in dramatic (and stationary)
art. The armies of the homeless collecting
trash at the end of the 20th century waited
patiently for a new dada art-squad, but when
it appeared, it collected its own trash to wear
on the street. In the early 1980s in New York,
when punks and postpunks dressed to kill (or
be killed), armies of fashion photographers
from *Vogue* and *Paris-Match* descended into

the streets of the Lower East Side to find
the next "look." And so they did, and so did
dada go on, and still the homeless wait, with
shopping carts full of treasure.

**baroness elsa, von freytag-
loringhoven** (1874–1927): Celebrated in
Berlin and Munich in her youth, the baroness
bridges the fin de siècle decadence of Stefan
George's circle, German Expressionism, and
New York Dada. She is also one of the few
european artists who went beyond New York
into America, in search of adventure and
inspiration. Notorious for her affairs with
both men and women, her prodigious sexual
and artistic energy was legendary, but her
complex personality and hard-to-defne art
had to wait a long time for rediscovery. It
finally came with a 1996 Whitney Museum of
American Art exhibition, Making Mischief:
Dada Invades New York. And the 2002
publication by MIT Press of Irene Gammel's
biography, *Baroness Elsa: Gender, Dada, and
Everyday Modernity*. The Dada baroness was
the genitor of street performance, fashion
Dada, body art, and warholian networking.
Her life is an anthology of daring and risk
taking, from her start at age twenty as a
model for Henry de Vry's living pictures in
Berlin at the Wintergarten, a much-admired
form of art pornography, to being a chorus
girl at Berlin's Zentral Theater, a muse and
lover to several artists and writers (including
Djuna Barnes), a poet, a playwright, a
novelist, an American immigrant in Sparta,
Kentucky, a dadaist in New York, a free-speech

defendant, a jailbird, and the subject of
numerous paintings, poems, and unending
gossip. One of the odder chapters of Elsa's life
was her residence in the Kentucky railroad
town of Sparta, where she settled with her
husband Felix Paul Greve, who had faked his
suicide in Germany to run off to America
with Elsa. In Sparta, bored out of her mind,
the baroness sneaked off to Cincinnati by
train to model nude at an art school. Greve
emigrated to Canada in 1912, leaving his wife
without resources in a strange country. He
changed his name to Frederick Philip Grove
and began a successful career as an English-
language Canadian writer of popular novels
about the settling of the wild American
frontier. Elsa finally borrowed and earned
enough money to make her escape to New
York in 1913, where she connected quickly
with the circle around Marcel Duchamp
and met William Carlos Williams, who,
like every poet or artist who knew her, was
charmed and overwhelmed. In New York in
1919 she could sometimes be seen going to a
party wearing a birdcage on her head and a
self-designed costume that permitted risqué
glimpses of her lithe, Amelia Earhart–type
body. Like Mina Loy, she scoured the streets
for discarded objects to use in her art. She
mailed to Marcel Duchamp, from New York
to Philadelphia, the famous toilet that became
The Fountain, now on permanent display
at the Philadelphia Museum of Art. She
exhibited drawings, paintings, and sculpture,
including a sculpture-portrait of Duchamp
called *Limbswish*, made of a metal spring

and curtain tassel. Her poetry, published in *The Little Review*, was a constant source of scandal. *The Little Review*, edited by Margaret Anderson and Jane Heap, published the baroness's most outrageously dadaist, sexually charged work and would soon go on trial on obscenity charges for serializing James Joyce's *Ulysses*. Her poetry sparked one of the most heated debates about art in the 20th century, a forum titled "The Art of Madness" in 1919. This debate was the American avantgarde's most glorious moment, before the Pound-led faction charged off in another direction. The european dadaists moved with only a few skirmishes toward Surrealism, while the Americans made common ground with the more Futurist-oriented continental tendencies and pushed, in the tradition of Whitman and Emerson, for a native, widely ranging, freely breathing art. The baroness moved with equal ease between the different worlds, her body a statement *avant la lettre* of all the ideas the fired-up poets might come up with. Her extravagant costumes, poetry, art, and unabashed sexuality made her in a short time the most celebrated New York dadaist, but her high-mindedness and fondness for outrage ended up alienating many of the French expatriate artists and writers she frequented, and her constant need for money made even her most ardent fans uncomfortable. To everyone's embarrassment, she became a sort of bum, an eccentric street-person who reminded everyone how crazy Dada could *really* be, and a collection was

taken to get her enough passage money back to Germany. In Germany, her old friends from the Expressionist circles shunned her, but Djuna Barnes, to her credit, did not turn away her old friend. In 1928, her beauty and youth gone, her lavish imagination ignored, her genius art ideas discarded, she drank herself to death, and her obituary notice appeared in *transition*, the chief publication of the American modernists, where T. S. Eliot's *Wasteland* and Ezra Pound's poems appeared. Even in death, the Baroness Elsa connected with one of the vital modern movements that she'd helped birth by being close to William Carlos Williams, Margaret Anderson, Jane Heap, Hart Crane, and Berenice Abbott. On the other hand, no one was entirely comfortable with The New Woman, as the press dubbed her, as they did Mina Loy. Both Elsa's and Loy's art made the male-dominated avantgardes uneasy, and few writers, including Pound and Williams, came to the defense of *The Little Review*. The defense of *Ulysses* fell to the brave women poets and editors who went before the courts and the public with a fully articulate defense of freedom of expression. When Pound did finally speak up for James Joyce's novel, he did so under "the pseudonym of Emmy V. Sanders, hiding behind female skirts."[39]

boxing: Arthur Cravan, French dadaist and amateur boxer, astonished his comrades when his challenge to the American Jack Johnson was accepted. Johnson was the

European boxing champion and made his living staging exhibition matches. He was in flight from the United States where he was wanted on the Mann Act charge of transporting a minor across state lines for sexual purposes. The underage young woman he had been consorting with was but one of a string of girls seduced by Johnson, who had a reputation for prowess. Jack Johnson, who was Black, thought that racism was at work and was not going to return to America until he was assured of an impartial jury. In the meantime, he wandered bored from France to Spain and countries in-between, knocking down one challenger after another. Arthur Cravan, born Fabian Lloyd, was the nephew of Oscar Wilde and the publisher in 1913 of an avantgarde magazine, *Maintenant*, written entirely by himself, and the author also of an infamous fake interview with André Gide, who was, ostensibly, "dazzled by my height, my shoulders, my looks, my wit." In 1914, Cravan received the adulation of the avantgarde when he published a vitriolic attack on the painters exhibiting in the Salon des Independants: "M. Delaunay . . . has the face of an inflamed pig . . . Unfortunately for him, he married a Russian . . . I don't say I wouldn't fuck Madame Delaunay just once . . ." and so on, followed by attacks on Marie Laurencin and others. The pugnacious Cravan fled the war in France to Switzerland, living on money he made by selling a fake Picasso. When he ran out of cash, his mother agreed to pay his passage to New York. On the way,

waiting for a ship in Barcelona, he challenged Jack Johnson to a fight. He managed seven rounds before Johnson knocked him out, but his legend among artists *was* a knockout. According to Breton, he told Leon Trotsky, who was on the same ship to New York, that he preferred "crushing the jaws of a Yankee gentleman in a noble sport to letting his ribs be crushed by a German."[40] Jack Johnson returned to the U.S. to face the music and served a sentence in Leavenworth Prison. In New York, Cravan continued to make trouble, getting arrested for taking off his clothes at a lecture, preceding by a few decades a similar act by Allen Ginsberg at Columbia University in 1967. (Years later, Ginsberg told me that he was still known by a lot of people as "the poet who takes his clothes off at poetry readings." He laughed and said, "I did that *once*. I'm sixty years old now! What kind of fool would I be to take off my clothes in public!") Cravan's reputation for wildness was not diminished when he married the great beauty Mina Loy, whose looks and poetry had already conquered New York. Cravan and Loy vagabonded through Mexico and South America where he made a living boxing and writing for newspapers. His myth grew even more after his unfortunate disappearance aboard a boat he had built to take him and Mina from Mexico to Buenos Aires. William Carlos Williams, in love with Mina Loy, described the scene with a great deal of pathos. He has Cravan leaving in his boat and the pregnant Loy left on the shore.

Some people speculated that Cravan didn't drown, as was likely, but that he assumed another identity (a favorite Dada game) and became the mysterious B. Traven, author of *The Treasure of Sierra Madre*. The disconsolate Loy went back to New York, where she lost her appetite for the risky games of love and art. About Cravan she wrote: "His life was unreal, or surreal, in that he never *was* the things he became. For instance, he became *champion de Boxe amateur de la France*."[41] Cravan's life and art were a Dada continuum, whereby he made boxing the second most important recognized sport for the dadas, the first being chess. The dadas and the surrealists excelled at *new* games, the best known of which is *le cadavre exquis* (the exquisite corpse), a collaborative means of writing a poem or drawing a picture in such a way that no one will know what anyone else contributed until the very end when the sheet is unfolded and the collective mind of the collaborators becomes visible. Like most stories of the dadas, Cravan's life holds as many tales, fables, myths, and mysterious connections as the story of any one life can, particularly when the protagonist of that life set out to lead an oversized, extraordinary one. Cravan's life and art are indeed masterful, and the Guide advises, "Don't try this at home," but then, neither did Cravan. What he did make was a *cadavre exquis*, an exquisite corpse, that X-ray of the collective mind, the X-ray, certainly, of an age.

cafés: Refuges from cramped quarters, nosy landladies, and dreadful toilets. Also, the

European living rooms where strangers are (mostly) welcome. Birthplaces of conspiracies, publications, and bohemian artistic-political ideas. There is a vast literature of cafés: Paris in 1900 had two thousand cafés, one thousand of which had been frequented for at least one absinthe by Baudelaire; among the cafés of the early 20th century, Aux Deux Magots inspired an entire raft of books, one of which is eight hundred pages thick and contains the brief biographies of all its waiters; one of its tables was sold at auction in 1987 for a great deal of money because of the asses that sat at it and the ideas that the discomfort of those asses caused to the brains to whom they belonged. Paris cafés, thousands of them, were in permanent contact with thousands upon thousands of cafés in all the cities of Europe, and it was possible, throughout all of the 20th century, for a brooding person starting in Paris to travel between cafés in major capitals via a *pneumatique*, and arrive the same day in Moscow, still holding his half-full Pernod glass from Paris. The first Dada café in Paris was Certâ in the passage de l'Opéra, with its yellow curtains and unmatched cane chairs, made famous by Aragon's book *Le Paysan de Paris*. Breton, Tzara, and Aragon adopted it because they were sick of Montparnasse and Montmartre, the bohemian standards of café life. "Certâ was the first of the Dada and Surrealist cafés, those legendary venues, those homes-away-from-home where, every evening, the chosen ones would assemble." Louis Aragon found the voice of the cashier so alluring that he called just to hear her say,

"None of the Dadas are here, monsieur."[42]
It is now said that with the banning of
cigarettes and the increasing costs of overhead,
French cafés are disappearing to make
room for cheaper American chains. The
mushrooming of Starbucks in the U.S. has not
so far produced many intellectuals because
American houses are too big. Will they reduce
ideas in Paris or, *au contraire*, stimulate
philosophy through sheer hatred of their loci?

In a small country like Romania where
geniuses are precocious and still living at
home, cheap cafés are where minds are
formed, and Capşa, the most expensive café
for a century, is where reputations were both
born and killed. On the subject of cafés, our
only contribution is the banal explanation
that the cheaper the café, the greater its
creative atmosphere, and the more expensive,
the greater its irrelevance. This Guide
contains references to only a few cafés, the
most important of which for our purposes
is Café de la Terrasse, Zurich, Switzerland,
1915–1917, where Tristan Tzara, daddy of
Dada, plays chess eternally with Vladimir
Ilych Lenin, daddy of Communism. Lenin is
a Russian exile biding his time until he can
lead a revolution that will set the 20th century
on a course that could have resulted in the
extinction of the human race. Tristan Tzara,
a Romanian exile, is in neutral Switzerland
to avoid being killed in the First World War
raging everywhere else in Europe. Tristan
Tzara is not biding his time; he is having fun

inventing an art revolution right here and now
in Zurich, the Dada revolution, a movement
that will radically alter the 20th century
to continue into the 21st, surviving both
communism and the possible extinction of
the human race. At this moment, however, as
the antitsarist Lenin opens with his usual E-4
King's pawn, nothing is known of the future.
Lenin is a writer of obscure commentaries on
the work of Karl Marx and Friedrich Engels,
living in abject poverty with his wife Nadya
at 11 Spiegelgasse, a few doors away from the
noisy bohemian nuisance of Cabaret Voltaire
down the block at 1 Spiegelgasse. He meets
regularly with his fellow exiles, Karl Radek, a
Polish revolutionary, and Gregory Zinoviev,
his best friend, and often passes the night
arguing tactics with a variety of contemptible
Swiss socialists and political exiles with half-
baked ideas. He spends his days in the well-
run libraries of Zurich, writing up essays
on dialectical materialism, instructions to
comrades in Russia and Europe, editorials
filled with rage at the socialists of Western
Europe's dying democracies, and, occasionally,
a half-pleading, half-philosophical missive
to his mistress and comrade, Inessa, who
lives only a hour or two away in Clarens,
Switzerland, but has not come to see him even
once in the entire year. The Swiss annoy him
with their orderly habits, their maddening
routines, but he admires their precision,
punctuality, scrupulousness, and is grateful
for their so-called neutrality, which is sheer
cowardice. In fact, everything that is not

war is cowardice. To exist without conflict
is something Lenin cannot comprehend.
The cosmos is a raging battle of opposing
pinciples, a field of carnage forever recycled
by a series of temporary victories that advance
the struggle of consciousness, leaving behind
the weak. In the library, he requests materials
that are brought to him in silence by efficient
and unobtrusive librarians. Libraries are the
single stable fact of his exile, an axis that runs
through his life, beginning in the hushed
decorum of the British Museum Library
where he wrote at desk 06, the same one used
by Karl Marx to write *Das Kapital*. At desk 06
Lenin was known as Jacob Richter, a German
national. In Zurich, he frequents La Terrasse
to play chess after a hard day's work, but it
isn't for pleasure only. The café teems with
agents and counteragents, spies, and his own
people, who, for safety reasons, he does not
acknowledge but with whom he manages,
nonetheless, to communicate. Lenin cannot
imagine a world without honest libraries or
without noisy cafés. Lenin cannot imagine
the Soviet Union. Playing chess with the very
public and well-known mischief-causing
Romanian poet makes Lenin feel safe. All eyes
are on Tzara; nobody pays much attention
to the Russian revolutionary whose shiny
pate can be seen reflected in the ostentatious
monocle of Monsieur Tzara. "To masquerade
as a conspirator, or at any rate to speak French
with a Romanian accent and wear a monocle,
is at least as wicked as to be one; in fact,
rather more wicked, since it gives a dishonest

impression of perfidy, and moreover, makes the over-crowding of the cafes gratuitous, being the result neither of genuine intrigue nor bona fide treachery—was it not, after all, La Rochefoucauld in his *Maximes* who had it that in Zurich in Spring in wartime a gentleman is hard put to find a vacant seat for the spurious spies peeping at police spies spying on spies eying counterspies . . ."[43]

chess: Chess is inhumane. It also mirrors civilization; that is to say, it mirrors our perceptions of time. It also combines gambling, which is a kind of hostile attention to fate, with calculation. It fosters the illusion of learning and improvement aided by a comfy deity called Excellence. The Masters of chess are a transcendent class that gives hope to every player. The Masters embody a Knowledge that, unlike the mystery gods, can be accessed physically by going to tournaments, or any time by turning on the computer. It is possible that chess, at its inception two-plus millennia ago in either China or India, began as an oracular board used for divination, a paleo-Ouija. The early pieces could have been the most delicate bones of a just-eaten beast, or those of a captured enemy. Ritual drunkenness by the oracle-keeper, or of the spectators, may have led to a bit of gambling, and to consequently incorporating dice into the setup. Rules will have come about both in order to keep the house advantage, and to pay at least formal obeisance to king and country, hoping that by

such homage the game would remain sacred, therefore untaxable. The Golden Horde was crazy about chess: the Mongols, like most nomads, loved this portable game and played it for centuries. At times, it mirrored military tactics. The Arab caliphates at the height of their power worshipped chess. The Mongol and Arab games were played fast, each player making as many moves as he could at the opening of the game, indifferent to the opponent. If one of the players failed to move as fast as the other, that was too bad. There was no rule about taking turns. Waiting politely for the opponent to make a move was unheard of in early chess, when the game was a joyful rush to victory in the initial moves. Protracted war was boring to warriors: there was no joy in waiting out the enemy, plotting methodically, designing tactics. Early war, like early chess, was about the rush, about thinking on your feet, about heading to death in one exultant sprint with your vigorous young comrades. J. C. Hallman, who wrote the *The Chess Artist*,[44] quotes Vincenz Grimm, a Hungarian chess-player who visited Syria in 1865: "For the first time that I played with an Arab and invited him to commence the game, he made with incredible rapidity 10 or 12 moves one after the other without in the least troubling himself about my play. When I asked in astonishment, 'When does my turn come?' he rejoined in just as much astonishment, 'Why are you not moving?'" In Europe, chess changed and became slower and more stately;

it incorporated notions of chivalry and fair play, and the pieces themselves mirrored the medieval courts. The King acquired a cross, to represent the Crusading King. Tactical thought, silence, and deliberation entered the game as played at Europe's medieval courts. During the Renaissance, chess got sexier, like everything else. Played by flirting young courtiers, it became charged with carrying sexual innuendo across the board: surrendering became voluptuous. Eventually, slow chess began to bore the europeans, whose societies started to change and speed up. The revolutions that began in the 18th century had their effect on chess, but it took the 20th century and America to truly speed up the game.

Tzara and Lenin play fast now, several games in a row, at a speed the La Terrasse riffraff isn't quite accustomed to. Four hundred years of deliberate moves have seen only incremental changes in timing, but this appears to no longer be the case, and it confuses the kibbitzers. Chess, like society, is starting to move at the speed of machines, keeping time to the shouts of futurists and dadaists, cars, and airplanes. The advent of one-minute chess played with a digital clock late in the 20th century could already be glimpsed in the rapid moves of the two players. One-minute chess, simultaneous games, and blindfolded chess have already been played, but the future is full of them, like ticking bombs. Chess

has its detractors already, even among its admirers, who suspect it of being addictive and leading to insanity. Lenin is impatient: revolution is all about timing and the time is now. Lenin is one-quarter Mongol (Kalmyk) and one-quarter Jewish. Tristan Tzara is one hundred percent Ashkenazi Jewish, but there is a persistent question about the origin of the Ashkenazi Jews in Eastern Europe, about whether they are partly or wholly Khazar (a Mongolian people who converted to Judaism in the 10th century), or direct descendants of Abraham. In any case, it is Lenin who most clearly embodies warring Mongol impatience with Jewish thoughtfulness and reasoning. The revolution must be conducted like a Mongol attack, a swarming of the enemy, and so it is. The Bolshevik attack on the Winter Palace in St. Petersburg in October 1917 is the Mongolian chess opening: a handful of armed and angry Bolsheviks seizes power from the weak Duma and takes control of Russia. What happens *afterwards* is tactical, and Lenin has given it only a little thought, trusting that every situation that will arise after the revolution will be solved given the context and the situation, if one acts according to the principles of dialectics, which is History. Tristan Tzara desires most earnestly to overthrow reality, not just art, and to this end he would rather play anarchist chess, moving pieces situated at random on a board occupying any number of dimensions. He is nonetheless fascinated

with the limitations of the game because
there are infinite possibilities within these
limitations, a paradox much like the study of
the Torah, the reading of one verse numerous
times so that it loses its apparent meaning and
becomes pure sound, referencing something
primal and unknown. He waits like a junkie
for the moment when the high hits and
the apparently banal turns magical. At that
moment, the mechanical movements of
the head moved by reason become abstract.
Abstraction is freedom and, amazingly,
abstraction appears most accessible through
the narrow gate of rules. Each square is a
mouth opening into Chaos and each piece,
once moved, changes the entire universe, like
words rearranging the cosmos. This is way
beyond Lenin's play. Lenin wants to win and
he stubbornly insists on the rational unfolding
of the plan of History, a process that is as
objective and solid as the wooden chess pieces
on the board. The wooden knight in his hand
is real, it exists beyond him, but it must move
two and one squares because that is the Law.
History has Laws that proceed from objective
reality. The Laws of Chess have on occasion
accommodated politics. Benjamin Franklin is
said to have lobbied for the taking, not just the
surrender, of the King because he did not want
to play a royalist game. A republican game,
he thought, would make the King a citizen, as
mortal as a pawn. Lenin decided something
similar when he ordered the Tsar and his
family killed. I doubt if Franklin would have

gone so far: abdication and removal from the board would have satisfied him. For both Tzara and Lenin, chess is fascinating beyond metaphor. Chess is the Bible of war. Jews were enabled by their portable religion, the Bible (the Book), to keep the faith. They idled the time between pogroms and expulsions by studying the Bible. Chess enabled nomad warriors to while away the time between battles by playing chess, a game of divine origin that was a transcendent mirror of war that validated their campaigns. Fundamentally different languages attend the players: Lenin is validated by the logic of the board, Tzara by its possibility of transcendent egress. Lenin has his hand on the knight when he realizes that his opponent is none other than the Tzar. Tzara. He pulls on the reins and the knight leaps forward.

Lenin is not, on principle, in favor of speed. He is methodical, deliberates every point to a maddening degree, and is slow to act, but timing is, of course, of the essence, and timing, more often than not, involves speed. In his haste to checkmate the Tzar, he makes an almost fatal blunder in the next move but stops just in time, and his hand retreats to stroke his bald pate. Patience. He is also one-quarter German and one-quarter Russian.

In the still middle of the game, there is a point of absolute silence, a dead zone or a meditation place when nothing can be

done, none of the players move, meditation turns into tense sleep. The next move will determine the outcome of the game, but right now, right here, on Center Island, in neutral Switzerland, there are no Winners and Losers, only the Game. The Game has abandoned all its metaphors, it is naked and very much itself. Among the lost metaphors of the Game is chess itself, or rather its succeeding designs, as gods, saints, pawns, kings, queens, bishops, and knights fade into the past. The three-tiered rule of royalty, church, and the military is breaking down even as Tzara and Lenin play on, and the kibbitzers sense it because what they are waiting for, whether they know it or not, is the birth of Chess Theory. And class struggle. And the atom bomb. The idea of classes and masses advances from Lenin's hand, just like the iconic statues of the Soviets will have it for the next six decades, but even they give way to speed already, as modern art is making the world look unrecognizable wherever there is no Lenin statue.

There is still a Lenin statue in Kalmykia. After the death of communism and leninism, Kalmykia's dictator, Kirsan Ilyumzhinov, a bona fide Grand Master of Chess, conceived of the idea of lifting his desert people in Southern Russia from poverty into 20th-century affluence by means of chess. Like a Pharaoh using the entire country's resources, he built Chess City in Elista, the capital, to host a World Tournament of Chess. The

teaching of chess was made obligatory for
all school grades, and chairs of chess were
established at the university. He intended,
as he told a journalist,[45] to make chess "the
religion" of the Kalmyk people. The Kalmyk
religion is Tibetan Buddhism, and the Kalmyk
lamas are appointed directly by the Dalai
Lama, who visited Kalmykia in the 1990s.
For six decades of Soviet rule, Buddhism was
dismissed as superstition, but the religion
revived with great fervor after the USSR
dissolved. Ilyumzhinov's effort to replace both
communism and Buddhism with the religion
of chess was met with derision, but that
response was quickly silenced by the brutal
suppression of critics. Lenin's birthplace, after
the death of leninism, rose from the ashes
as a dictatorship of chess. One wonders how
many of Lenin's passions, fetishized in social-
realist art for decades, will come to life from
his corpse. Not too many, I hope. On the
other hand, chess has its own power to induce
visions and hallucinations. The dictator of
Kalmykia, Ilyumzhinov, went to see Bobby
Fischer, the American world-champion who
was a fugitive from American justice, living
in exile. Fischer was wanted under the flimsy
pretext of having defied the U.S. embargo of
Serbia during the Balkan wars in the 1990s,
but the real reasons for the hunt were his
unpalatable anti-American public rants about
the 9/11 conspiracy, the Jewish conspiracy,
and a number of other conspiracies. Fischer
was probably the world's most accomplished

Jewish antisemite, unless one counts the obscure führer of the New York chapter of the American Nazi Party who committed suicide when the *New York Times* revealed that he was Jewish. Fischer was also the darling of visionary dictators like Ilyumzhinov who hoped to entice him to become a Master-in-Residence in Kalmykia. It didn't work out. Chess had most certainly driven Fischer mad, as it had Ilyumzhinov and many lesser luminaries throughout history, but the law of repulsion operates here: mad people repel each other. No madness is like another, even if it is rooted in the same paradox.

collage: the pre-eminent expression of the 20th century. Picasso and Braque introduced newspapers into their paintings of random objects whose forms were more important than their "objective" models. A whole universe of the 20th century's new objects came into view, especially the newspapers and their advertisements. Tzara brought it home:

> To make a dadaist poem
> Take a newspaper.
> Take a pair of scissors.
> Choose an article as long as you are
> planning to make your poem.
>
> Cut out the article.
> Then cut out each of the words that make
> up this article and put them in a bag.
> Shake it gently.
> Then take out the scraps one after the other
> in the order in which they left the bag.

Copy conscientiously.
This poem will be like you.
And here you are a writer, infinitely
original and endowed with a sensibility
that is charming though beyond the
understanding of the vulgar.[46]

Tristan Tzara cut up various texts onstage
during Dada events in Paris, pulling words
out of a hat and solemnly reading them, first
to the outrage of the audience, then to their
amusement, as the value of shock diminished.
The first performance of a cut-up text came
before a French audience so traditional that
they thought it was impolite to as much as sit
down during the reading of a poem. (Each
poem being, apparently, a sort of national
anthem. Ah, the religion of art!) Poets never
read their own work, either. Actors performed
the poems, a custom that lasted well into the
Sixties in Romania, where actors from the
National Theater read on television poems by
"poets from literary journals."

In 1964, an old eminence from the National
Theater in Bucharest recited one of my
earliest poems on television, prefacing it
with "This is a poem by a sixteen-year-old
poet from Sibiu," and then proceeding to
massacre it in a way that, even at that tender
age, almost made me abandon poetry forever.
The consequences of that misreading of my
juvenilia before the nation were numerous.
In the first place, I found it hard to believe
that the plainly stated intentions of the poem

(with a tad of symbolism here and there) could be interpreted as anything more than what they declared, which was something to the effect that my young soul experienced the reverberations of the church bells in my medieval hometown as messages from another world. The old actor was moved to a different interpretation. His stentorian declamation *condemned* the sounds of the bells as carriers of *nefarious* messages from the defeated past. My mother was, at the time, being courted by an army captain I loathed. When I came back from school, I knew that he'd been in the apartment because the stink of his boots made me want to throw up. It turned out that this captain, who'd read some of my poems, let it be known around the garrison that he wrote poetry, and he had passed around some of my poems as his own, including the one just read on TV. When the old actor told the national audience that the author was a "sixteen-year-old," a scandal broke out. The captain was demoted and my mother broke up with him. Who says that poetry makes nothing happen? Happily, the solemn recitation of poetry by actors before bored populations has ceased long ago. We have come so far from the days of solemnity attendant on the presence of a poem that we now receive daily the automatic blessing of a dada poem via our e-mail. Poetry readings are everywhere and the poets themselves are the terrible actors of yore. Dada poetry is ubiquitous: the pulses of internet spam are surging around the dams and walls

erected by spam-assassin software, networks, and government, and producing eerie poetry. At first, I thought that avantgardists had targeted me personally for their guerrilla poetry, but realized quickly that there was way too much of it and that even the most automatic generators of word-salad could not make as many strange combinations as stuffed my mailbox every morning. Tristan Tzara would have been proud of this one:

> eerily perplex bookie cynthia aggression
> discretion bravado culture ghostlike introvert
> cybernetic christy bulgaria comedian condition
>
> jigsaw rome sketch romano cortex
> inflater sri hopkins nausea dirt
> laser bonanza charcoal orthopedic cellular

There are poets who'd give their left foot for a poem like that, because it has everything that a poem requires: density, impenetrability, a dark sort of music, and nearly perfect fodder for critics. "Jigsaw rome sketch romano cortex" would make Wallace Stevens's day, not to speak of your average Language poet working in the cellars of aggressive nonreference. What's even better is that this spam poetry is involuntary, necessitated by the spammers' need to get some product across border-controls, but involuntary or not, the stuff is compelling. Aside from its intrinsic hermeticism, this poetry is symptomatic of our present state of fragility vis-à-vis the

common tongue. We are vulnerable to all its aspects because we can never be quite sure if what we are hearing is not a highly specialized message. We may be missing out on a great sale just because the message speaks dada. The need to sell something, anything, has reached the frenzied pitch of art: entrepreneurs have stumbled into the secret of the postmodern brain in their rush to add banality to our oversaturated and overextended consumer selves. And the strange thing is that it works. Everything from porn to nonexistent WMDs can be sold to us because we are perfect receptors for dada poetry, made pliable by a relentless history of nonsense and nonstop pitching. "Eerily perplex bookie cynthia" is us.

communist bestiary (the birth of): Playing chess with Tristan Tzara in Café de La Terrasse in Zurich, Lenin almost touches one of his pawns, then his hand retreats to stroke his bald pate. It is October 1916. So many ideas boil in there! His brain is a basin full of maddened snakes furiously eating each other. The Kadets government will oppose his return to Russia with everything in its power, short of offering Germany a separate peace. This *is* their only power, as Zinoviev, impatient to leave, never fails to remind him. Lenin knows that power resides now in the timing of either party's response to the war, but one has to conduct the negotiations in such a way that nobody will suspect the leninists of being in collusion with the German General Staff. Any hint of suspicion and the Kadets will label

them unpatriotic. The eternally inert, dogged, and stupid peasant masses of Russia will keep throwing bodies into the fight until there is no one left at all. Nothing but the wind whistling through rows of houses built from the bones of the dead by crow-like nomads wandering the steppes. Bones like driftwood, that's going to be Kerensky's Russia! Lenin's hand leaves his pate to come forcefully down on the pawn to push it with energy and determination to its one allowed square. No, Lenin does not underestimate the pawns, and he is not moved by their eventual disposition. Millions of them could be sacrificed in a tactical move as far as he is concerned, but it has to be the right move, the wise move, the dialectically useful move. Damn them all. If only the Swiss could be induced to forcefully eject him and his comrades on the grounds of inciting sedition, of trying to overthrow the fat cow of its government. That has to be the way, and so, without much effort, Lenin creates the rudimentary rhetorical bestiary of the next seventy-five years of the Soviet regime: snakes, hyenas, dogs, and crows will be the basis of all attacks on the future enemies of the Soviet State: capitalist hyenas, deviationist snakes, speculator crows, and rabid nationalist dogs are born in a single flash of leninist thought. In the long metamorphosis of Lenin from man into icon, all his thoughts, not just his words, will become the sole preoccupation of a professional Soviet class dedicated to interpreting, translating, and launching his ideas and intentions via print and other media

until they lodge firmly in every citizen's brain. The purpose of this exegetic project will be to implant the very brain of Lenin inside the brain of every Soviet man, woman, and child, until *the new Soviet man*, created by the new communist society, will be able to think automatically like Lenin. Eliminating all inequalities will involve partaking fully in the Lenin mind. The current present Lenin loses the pawn to Tzara's knight, then Lenin sacrifices his bishop. We will shoot all the priests anyway. For a while, the game is his, riding high on anticlerical sentiment until the Cabaret Voltaire poet tears down one of his rooks. A wide hole gapes in his defense, but it will take a while for the hyenas of imperialism to find it and aim for the heart of the ideology, because quite inexplicably, only a few years hence, Lenin will become a dead god and Tzara will become a communist. The fog of history swirls about the thick forest where purely imaginary animals howl pitifully, not for blood, but for the pain of trying to escape from metaphors.

creativity: "Dada is the creative activity par excellence." *Dada Almanach*, 1920. Therefore all writing referencing Dada must also be creative, or else. Without any knowledge of Huelsenbeck's radical statement in 1920, the education market in the U.S. in the 1960s began to produce "creative writing" workshops in which all writing was permitted, except for dada writing, which was thus saved for the lucrative and the

gratuitous. The only viable Dada is banished Dada. On the other hand, art, philosophy, languages, anthropology, geography, and physics departments began deploying Dada in a myriad of academic strategies, first in the deconstruction of old systems, then in the uses of chance, probability, games, subatomic behaviors, and performance. At the beginning of the 21st century all the arts and the humanities, and quite a few sciences, speak Dada or, at least, French theory inspired by Dada. All, with the exception of "creative writing" programs, which continue to speak in complete sentences, a.k.a. "yawns." Alexander Zinoviev, the namesake of Lenin's friend Gregory, who grew up in the apparatchik luxury of the Soviet philosophical academy, escaped to England in the 1970s and wrote a new history of communism, entitled *On the Yawning Heights*, concluding that decades of Soviet life were dedicated primarily to achieving unbearable boredom, instead of the "golden heights of communism" promised by the founders. "Creativity" as the buzzword of the emerging professions, including literary writing, has strayed far from its roots, meaning "to make from nothing" (as in God made the Word and the Word created the World, all of it ex nihilo). Our current usage no longer includes demiurgy or ex nihilo. "Creativity" may well be one of those words that must be abandoned as irredeemable at the growing garbage dump of language destroyed by advertising and politics. The list of such words is long, but it includes nearly

every word used by politicans, professional inspirational speakers, preachers, and degreed poets, with the possible exception of conjunctions and some adverbs. Popular culture senses first the decay of misused language and does its best to satirize it, shake it up, change its functions (from noun to verb, for instance), and, generally, sound it out for truth and laugh it off for hollowness. Any genuine hip-hop song (a zone corrupted also by commerce, alas) is worth more than any carefully workshopped "poem" in a "creative writing" program.

dada, bucharest: All nations were created by writing, but most of them were created by very few founding documents, usually only two, a declaration of independence and a constitution. Romania is the only country I know that was founded by the writings of many writers, principally the poetry of Mihai Eminescu and then by a number of literary critics and (mostly) poets, who wrote a plethora of founding documents. The job of this nation then became an unfolding commentary in writing about previous writings, creating not a history but a continuous commentary, a history of commentary. This exegetic activity is not an accretion of precedents, like British common law, but an ongoing series of ruptures from the immediate past. A nation born in the late 19th century from the breakup of the Ottoman Empire, Romania had a rich menu of identities before it, and it chose

the . . . Belgian model! Almost. It became a parliamentary monarchy with a Belgian constitution and a German king, with illustrations by René Magritte. Actually, the surrealism present at the founding was not lacking in native exponents. At the beginning of its national literature, writers invested in the Levant, in diversity, mélange, and the humor of the various peoples contained within its borders, people who were mixed not only in the present, but also in its founding epic, *Tziganiada*, by Ion Budai-Deleanu, the hilarious and touching epic of Gipsies in search of a state. *Tziganiada* is Romania's *Don Quijote de la Mancha*, except it is about a whole mixed-up people in search of an ideal, instead of just one Spaniard. This epic was met with instant derision by the Romantics, who didn't have long to knock down the hybrid proposition of the epic before they were themselves overthrown by Symbolists, followed in short order by post-Symbolists, Absurdists, and Surrealists, each one a successive wave that came with its own opposition of traditionalist enemies. The rapidity of its intellectual boxing matches and their quick deployment by newspapers (the golden age of print coincided with the birth of the country!) made it necessary to keep up with everything or one risked remaining stuck in a passé mode that would just not do if one belonged to the thin layer of society that met regularly in cafés and salons to offer opinions. The peasants, of course, didn't read, so their occasional stabs at social mobility through

the use of choice malapropisms became great objects of satire. Given speed, opinion, instant satire, and the coexistence of every modern idea half-knocked-out by another idea, Romania's intellectual landscape resembled Piranesi's ruins, out of which came something even the most forward-looking Parisian avantgarde had not expected: Dadaism. Romania is the world's most postmodern nation: it is still a generative arena of word combat that runs through its rhetorically-cursed history to bloom into our posthistory where it is possible to be finally seen, like a lush tree appearing suddenly in front of your car doing 200 mph on the highway of modernity. It is said that a reputable German linguist concluded that Romanian was going to be the Esperanto of the 21st century, but I haven't been able to trace this linguist: he may have been active between 1900 and 1912. In 1912 the avantgarde magazine *Simbolul* was published in Bucharest by high school students Samuel Rosenstock (signing S. Samyro), Marcel Iancu, and Eugen Iovanaki (Ion Vinea). While the future Tristan Tzara was composing the verses "They go on, and on / lazily rowing / On life's sad filthy river / Drawn on forever by the sight / of blue horizons / and sunsets / woven of shiny gold / they row toward the seas / the chimerical seas,"[47] a Symbolist pastiche in which deluded people row toward the unachievable, delirious crowds of real people in Bucharest were seeing soldiers off with flowers and brass, soldiers on their way to crossing the Danube to conquer

Bulgaria's capital city, Sofia. Having become a modern nation with an army, Romania now needed a war to be taken seriously. Bulgaria, just across its Danube border, looked like easy pickings since the Ottomans, the Greeks, and the Serbians were at war with it already. The Bulgarian army defeated the Greek and Serbian armies in Macedonia, but the Bulgarian government called for a peace treaty to be signed in Bucharest on August 10, 1913. In the wake of the peace treaty in Bucharest, Romania annexed an area of Bulgaria stretching from southern Dobrogea to northeastern Bulgaria, bringing even more ethnically diverse people within its borders. This "diversity through war," practiced in the Balkans, was not colonial conquest as understood by the major European powers, but rather a territorial readjustment brought about by the Western powers' own rearrangements. Like a spectator watching splendid mannequins being outfitted for the evening by a tailor (Mr. History), Romania gathered the leftover scraps to make its own, rather improvised, suit from the elegant remnants. Of course, these scraps were not free, they cost a great deal in blood, but Mr. History is nobody's fool. The kingdom by the Black Sea benefited greatly from the European power-games, especially after the First World War when it acquired Transylvania (and its population of Hungarians, Saxon Germans, and Szekelys) and Bessarabia (with Russians, Ukrainians, and Jews). In 1912, S. Samyro, soon to become Tristan Tzara, keeps writing: "the servants bathe the hunting dogs" and

"the light puts on gloves."[48] The Emancipation of the Jews begins in 1913 and continues through 1919. In 1913, Romanian Jews are still foreigners and Gipsies are slaves, but the cooking is already postmodern, fusion cuisine before its time: Greek stuffed grape leaves in a cabbage variant called *sarmale*, cold fruit soups of Slavic origin, Turkish kebobs, Austrian stews, German dumplings. Corn replaces wheat, and *mamaliga,* or polenta, replaces bread, to become the staple food. Following closely in the steps of its food innovations are culinary archaeologists, writing treatises about each incremental change.

Mon May 19, 2008, 15:41:34 UTC 2008
BUCHAREST (REUTERS) — From parading an elephant through the streets to wrapping a condom on a finger or posing as Jesus, Romanian politicians are finding new ways to woo voters ahead of municipal elections on June 1.

In the Black Sea port of Constanța, a bulky candidate for mayor, nicknamed "the elephant," publicized his campaign by walking the animal through the town centre. "It eats peas," the candidate Victor Manea said, poking fun at the current mayor of Constanța, whose last name, Mazăre, means peas in Romanian. The election for thousands of city mayors and county council members is an important gauge of the popularity of Romania's centrist government ahead of a parliamentary election this year. Hence the eye-catching stunts. A candidate from the western city of Arad has printed banners showing himself sitting behind a long table, together with 11

colleagues, in a depiction of the Last Supper. His message is he "believes" in his team. Banners in central Romania display images of a finger with a condom wrapped around it. The candidate for city hall in Bistriţa, Gelu Drăgan, hopes to show he will protect voters against ever-present corruption.

And in what a Romanian blog called "eggvertising," a candidate for the Navodari sea resort stamped his name on eggs to be sold in super-markets. Their sell-by date is set for a week before a potential run-off on June 15.

Many voters, angry about Romania's dilap-idated infrastructure and poor public services, are not impressed. "I feel harassed," said Ileana Zamfir-Berca, a 49-year-old accountant from Bucharest. "These people will do anything to get into power but just because they are walking an elephant doesn't mean they'll repair roads."[49]

Romania's loping forward into modernity had its nativist enemies who employed the same versatile rapidity as the modernists to create a traditionalist ethos. A benign, pastoral mode of writing in use since the European revolutions of 1848, when the Paris-and-Vienna-educated sons of the aristocracy had returned home filled with national ideals, continued its search for patriotic archetypes. Old Slavonic church texts lent their cadences to this nation-building-in-a-hurry. A native resistance to "foreign" ideas exalted the virtues of rural society, its observance of natural rhythms, religious and secular rituals, its forbearance and sense of "eternity." The

poet Lucian Blaga proclaimed that "eternity was born in the village," and generations of autochthonic nationalists before and after Blaga stood by that sentiment. The pastoral idylls, bucolic sentiments, and folk researches with the same agenda resisted imports, despite the ease with which they absorbed them. The educated Romanians spoke French, and the French newspapers were available at Bucharest cafés. In 1909 when F. T. Marinetti's Futurist manifesto appeared in *Le Figaro* in French, Romanians read it simultaneously. Symbolism provided a convenient vehicle for the meeting of opposites: the young editors of *Simbolul* used it to welcome the modern, while the traditionalists employed it to exalt the native. Both these directions merged in the poetry of Tudor Arghezi, a vital spirit who absorbed the French Symbolists *en passant*, and then gushed forth in an original idiom the elegant brutality of a poetry that was at once earthy and mystical. Arghezi brought together the genuine elements of traditionalism with the spirit of modernism in a one-man burst of vitality. A former monk, factory worker, and watchmaker, Arghezi was a well-rounded man of letters, like most Romanian litterateurs of the first half of the 20th century; he wrote literary and art criticism, and political essays, and he published newspapers, beginning with *Cronica*, in 1915, and then, in 1927, *Bilete de Papagal*, a literary-political journal that consummated the marriage of poetry and journalism, announcing the birth of a new kind of writing, ranging from pamphlet to

sheer abstraction, the sound of the coming century. The synthetic force that united aesthetic enemies in Arghezi did not last long. By 1915, the Romanian avantgarde was growing up quickly, following in the steps of the absurdist writer Urmuz, the pen-name of the lawyer Demetru-Demetrescu Buzău, whose stories appeared in 1909, immediately after his reading of the Futurist Manifesto. His *Pagini Bizare* (Bizarre Pages) echoed instantly with the young and continued to reverberate with Romanian writers well into the 1930s when Eugène Ionesco wrote the founding plays of the Theater of the Absurd. Urmuz committed suicide in 1923, with no explanation except that he had intended to die "without any cause." This fragment from *Ismail and Turnavitu* became a kind of holy writ for young writers: "Ismail is made up of eyes, whiskers and an evening gown, and nowadays he is in very short supply in the market . . . Ismail never walks alone. Yet one may find him at about half past five a.m., wandering in zigzag along Arionoaia Street, accompanied by a badger, to which he is closely bound with a ship's cable and which during the night he eats, raw and alive, having first pulled off its ears and squeezed a little lemon on it."

Urmuz and his high school friend, the actor G. Ciprian, were fond of reading the *Bizarre Pages* out loud in the cafés. The Romanian knack for comic performance found its master in playwright Ion Luca Caragiale, a genius of the spoken language and a merciless

social critic. In his plays, the thin layer of opportunists making up the political class of Romania's new Belgo-German parliamentary monarchy receive full credit for absurdity. The Bucharest audiences of the early 20th century were convulsed by laughter at the mirror Caragiale held up to them, and Dada may well have drunk from the rich comic springs of Caragiale's absurdist brilliance. Caragiale himself was a new type of Romanian, an entreprencur who tried, and was unsuccessful in, any number of ventures, including the running of a bar in the train station at Ploiești. As a businessman, he was the Romanian version of Mark Twain, whom he resembled as a writer as well. His death was like one of his plays, a tragicomic performance. Self-exiled to Berlin from disgust with Romania, he had a hard time feeding his family, partly because he drank and gambled, but also because he felt homesick and ill. In his absence, he became very famous, practically revered at home, but before he could return to collect his accolades (and maybe some rewards) he died penniless in Berlin. The Romanian state prevailed on the widow to bring home his body to be buried in the heroes' cemetery in Bucharest. The widow and his children made the trip to Bucharest with the great writer's body, but once there, he was refused burial by the cemetery's groundskeepers because he did not have his "burial papers" in order. The distraught family took the body back to Germany where he was interred in a poor people's cemetery. Romanians like to sigh

and blame such horrors on accursèd "fate,"
but such absurdities happen with distressing
regularity, making it reasonable to suspect
some specific local configuration deep in
the psyche, rather than the resigned work of
fate. By the time Tristan Tzara began writing
his 1915 proto-Dada poems, collected in
Primele poeme (1934), the literature of the
absurd had already presented its revolutionary
credentials to a culture still fighting over the
local products of poets inspired by French
decadence and Symbolism. Tristan Tzara,
Marcel Iancu, and Ion Vinea's *Simbolul* was
followed by a series of short-lived journals
that propagated the ideas of Futurism,
Constructivism, and Cubism, fresh from
Italy, Russia, and France. These journals were
generous to experiment, youth, and outrage,
and had names that shouted modernity:
HP75, *Integral*, *Pula* (slang for penis, approx.
"dick"), *Punct*, *Urmuz*, and the longer-lasting
Unu (One), edited by an army officer writing
under the name Sasha Pană. (He would
eventually become a general, and a historian
of Romanian Dada and Surrealism, a perfect
dada story.)

The avantgarde of Bucharest manifested its
absurdist, theatrical, and shock-filled activities
here first, because everything that Europe
at large suffered from was exaggerated here.
Bucharest took to Parisian, Viennese, and
Berliner art and style fashions with lavish
devotion made stronger by the resistance
from the nativists. Prince Vibesco, a Bucharest

dandy who appears in *Les Onze Mille Verges: Or the Amorous Adventures of Prince Mony Vibescu*,[50] Guillaume Apollinaire's pornographic novel, begins to walk in an exaggerated manner on the fashionable streets of Bucharest, rolling his buttocks obscenely, and claiming that this is how all the dandies of Paris walk now; the fad catches on in Bucharest, and soon it conquers Paris as well, by dint of the novelty of being imported from "exotic" Bucharest. The rich in Bucharest wanted modern houses in the Cubist style, and Marcel Janco, whose dadaist reputation enhanced his appeal, returned from Zurich and Paris in the late 1920s to build many of them. From the mid-1920s to the mid-1930s the avantgarde expanded to architecture, art, fashion, and music. The modern sculptor Constantin Brâncuşi, who lived in Paris, became a national hero. George Enesco's music was worshipped. Everything "modern" was more modern in Bucharest: Cubism was more cubic; abstraction was more abstract; women were more fashionably dressed than Sonia Delaunay and modeled more eagerly than Kiki. Gherasim Luca, the Surrealist poet, out-dada'd Tzara and out-cubed Picasso when he theorized and started producing "cubic objects" by cutting up well-known images by classical painters into squares, and rearranging them at random. Luca's "cubic objects" pulled collage into the as-yet-unknown future experiments with pastiche and quotation, hallmarks of the postmodern. The enemies of the avantgarde, the traditionalists and

pastoralists, had to hit back with greater intensity: they enlisted to their aid the myth of the "noble" Romanian race (the spawn of Dacians and Romans), and constructed race theories that preceded and helped Rosenberg, the chief racial theorist of the nazis. (Being first was always important to Romanians in artistic areas, just as it became crucial for the Soviets later to boast of having been the original inventors of all modern marvels, such as the lightbulb, non-Euclidian geometry, etc.) As the 1930s headed toward darker days, the modernist simplicity of Janco's architecture began to acquire ornamental expressions of national hubris. Modern simplicity gave way to "art deco," and absurdist writing and experimental literature and theater were transformed into carriers of "myths of origin," idealized folklore, and sanitized ritual, a process of falsification that made for an easy transition later from these fascist pieties to communist kitsch. In the decade from the mid-1930s until the end of the Second World War, a Bucharest ready to embrace experiment and new trends from abroad became the seat of a "national ethos" propagated by a new generation of "right-wing" intellectuals led by the talented young comparatist and novelist Mircea Eliade. This new nationalist movement had drawn just enough from the avantgarde to create its mirror opposite. There was even a forceful and brilliant dadaist of the Right, Emil Cioran, who raised negation to a new dark intensity. Frightened by the specter of what he had invoked, Cioran abandoned

Romania and its language and emigrated to Paris, where he became widely known as the luciferic nietzschean philosopher E. M. Cioran. (At least, that's how he simplified his life story, in the interest of keeping it legible to the Western public.) His French writing, rich in the ironies and paradoxes of a dizzying half century, remains one of the foundations of Existentialism. Kafka, Kierkegaard, Unamuno, Sartre, and Cioran span between them the time-arc of european consciousness in the first half of the 20th century, and the space-arc between the rise of the (absurdist) provinces and the fall of the great (illuminated) cities.

John Reed, the American journalist who covered Pancho Villa and Lenin's bolshevik coup, found 1920s Bucharest distasteful and decadent. The hard-edged journalist ridiculed the pastel officers with rouged and pampered mistresses, gorging on puff pastries instead of gunpowder and blood. Bucharest suffered from luxury and perversion, from extravagant carriages with velvet-clad coachmen, display windows glittering with jewels, cafés where political and cultural quarrels were settled over cognac and cash by mistresses, not state ministers. Political parties appeared and disappeared like the thick grounds at the bottom of Turkish coffee cups. Gipsies read fortunes and played addictive violin music that made one lascivious and light-headed. All this frivolity rested like a multitentacled vampire above a huge, backward peasant mass that lived in hunger and rags in villages.

The aristocratic vampire with its grotesque appetites sucked dry the energy of millions of wretched humans. One could look at it this way, or one could idealize the wretched peasants and see them as noble creatures full of the Roman virtues of their putative ancestors: simplicity, endurance, aesthetic genius, a sense of fairness to fellow villagers and animals, wise preservers of community resources, such as common grazing grounds, but also tough, lean, hard, dignified, ready to defend their communities and the honor of their women. Dressed in clean cotton, not rags, they hunted the wolves that preyed on their cows and sheep, and attended church on Sunday, though their beliefs were cosmic and pagan, pre-Christian and mysterious. One could look at them from Bucharest, as John Reed did, and see the peasants as victims of exploitation, or one could look from the villages, like Tolstoy, and see Bucharest as a Sodom in need of learning morality from the simple people. Neither of those visions was entirely right, but each hardened like fast-drying cement once they hit the public air in the newspapers and books. The pastoral ("sămănătorist") movement made a symbolic figure from the "pure" Romanian represented by the peasant, and a demon out of the bourgeois of Bucharest, a "foreigner," most likely a Jew, Greek, or Armenian. The tradesman was evil, an agent of capitalism, the foreign virus that robbed the people, speeded up time, and destroyed the ecologically balanced community of the village. It took

only four decades for the stock poetical images of the "laborer at his plowing" and the woods filled with Easter cheer to turn into the murderous fascism of the Iron Guard, a grouping of hoodlums with axes and hanging ropes who unleashed a reign of terror in the late 1930s. They butchered Jewish families in Bucharest and would have taken over the state if a slightly more ferocious King had not drowned them in their own blood, an inelegant but effective way to stop Romania from outdoing nazi Germany in racist fanaticism. And this was another thing about the colorful, Levantine capital of the country so many foreign commentators found either exotically endearing or exotically disgusting: it hid a constant threat of violence under the ribbons and the chocolates of its gilded cafés and whorehouses.

Nineteen years have passed since the collapse of state communism in a bloody "revolution" in Romania in 1989. The word *bloody* remains without quotes, but the "revolution" will forever stay within them, as an exemplary dada performance that involved, unfortunately, real corpses. In 1990, a full year after the televised performance of the "revolution," a group of older "formers" and their sexy young secretaries took a walk away from a party at Mogoșoaia Castle near Bucharest given by an advertising firm for a new Finnish vodka, to view two giant bronze statues hidden in the weeds by the lake; lying with their heads touching were two bronze

giants: Lenin, looking up at the blue sky, and the first communist dictator of Romania, Petru Groza. The elders stood at a respectful distance, contemplating the fallen forms of the men who had commanded most of their lives, but the staff had no such qualms. An elegant young woman climbed up and squatted on Lenin's face, pretending to pee in his mouth. (Or maybe she really did.) The other young people laughed, but a tremor like a sudden chill wind of terror and disgust seized the elders. Most of them left, heads hanging, like dogs unjustly punished. I watched their backs, feeling no compassion. Some of them had been "dissidents," but such subtle distinctions had disappeared, leaving behind only the fact that they had collaborated. Some of them had begun as sincere marxist radicals, but the miserable reality they accepted, and enforced for decades, was simple self-preservation. Some of them had saved people from interrogation, prison, or execution, but those acts were temporary, accidental favors returned. Lenin himself, implacable in matters of fighting the "class enemy," gave in to a few moments of human sympathy when he pardoned some of his old friends, sending them into exile instead of to their deaths. In the 1995 film by Theo Angelopoulos, *Ulysses' Gaze*, there is a documentary sequence following the journey on the Danube of an immense statue of Lenin that has been sold to a German collector. As the barge passes carrying the bronze body of the fallen god, the

peasants onshore kneel and cross themselves.
They are seeing something awesome, and no
matter how they feel about it, awesomeness
is awesomeness. The peasants of all lands
recognize power and they salute it, whether it's
good or evil.

Bucharest itself kept producing an extravagant
essence, indifferent to the prevalent ideologies;
it took to postwar ruins easily; it endured the
rise of communist beehives of inferior cement
that crumbled during major earthquakes;
it bore the megalomania of Nicolae and
Elena Ceaușescu, who bankrupted the
country building an enormous palace where
old churches and streets stood; it survived
postcommunist assaults by glass-and-steel
edifices for banks and advertising firms; it saw
the reconsideration and revaluing of what
remained of Janco's houses and modernist
architecture; it was amused by the whims of
the nouveaux riches raising temples of kitsch
in its suburbs; it is shaking off its hordes
of wild dogs and street children living in
underground tunnels, to emerge again as an
avantgarde art center, courtesy this time of
the European Union that Romania joined
in 2007. New cars are choking the city, and
they must die, before the people do, leaving
only dogs and street children, which would
be wonderful if the E.U. would allow it.
The E.U. has also outlawed knifing pigs for
Christmas ham in one's backyard; they must
now be humanely dispatched with injections

or electricty. The wild dogs, defended by
Brigitte Bardot, were quietly assassinated or
let loose in the mountains. The street children
are shipped into sex slavery in Italy and the
U.S. The Dadaists' favorite café, nicknamed
"La Motoare" (approx. "Gentlemen, start
your engines!"), displays on its walls vintage
photographs of Tristan Tzara, Ion Vinea,
Marcel Janco, and other avantgarde figures of
the 1920s. The young people who drink under
these images, and plot artistic revolutions
of their own, are barely aware who those
people on the walls are. The photographs are
unlabeled (or were, in 2005) and, as always
in Bucharest, one has to reinvent the wheel if
one has the energy, and realize that it's a good
thing because it will be a different wheel every
time. Posthumans must use wheels, but the
avantgarde must make sure that they move
clockwise.

personal note, bucharest, june 7, 2008,
lobby of the Romanian Writers' Union: The
Writers' Union is a 19th-century baroque
building fronted by art nouveau nudes, with
a columned interior rotunda, ornate gilded
ceilings, and upholstered leather doors; its
sumptuous halls have hidden openings unto
dingy subterranean offices where servants
sleep and wait for the bells that call them
constantly to duty serving the writers upstairs
their coffee, water, and puff pastry. This
building explains why Romanian literature is
so difficult to translate into modern American

English, a straightforward language. Unless the writer emigrates and changes languages, thus translating hermself.

personal note, sibiu, transylvania, Romania, may 28, 2008: the Piatza Mare (Big Square) is lit by the flames of Spanish fire-dancers costumed à la Ku Klux Klan shooting fires in all directions, a combination of New Orleans Mardi Gras flambeaux and a medieval auto-da-fé, or maybe Chinese New Year with a book burning thrown in. The grotesquely masked incendiary figures walk over the plaque in the square in memoriam of the demonstrators shot here in December 1989 from the eyes in the roofs of Sibiu. The Spanish actors, most of whom look as if they were born after 1989, would have been lynched even ten years ago by a frightened populace still jittery over the gunfire exploding in the square full of angry people shouting: "Down with Ceauşescu! Down with communism!" In 1989 that was history, in 1991 that was "still-fresh-history," in 2008 it's farce and carnival. Even all those cycles are recycled: in 1568 witches were burned in this square, in 1797 peasant rebels were tortured and hanged here, then there were parades, marches, religious festivals, and pageants every two decades in the 18th century. Every decade later, the victims returned as puppets. The cathedral from whose pulpit the preachers of 1568 called for burning the witches is now a museum, and the visitors write in the guest

book: "Magnificent! A jewel of a place, and the toilets are so modern and comfortable!" The toilets, excellent hygiene. The new dada Europe. NEXT!

dada, the word: the success of Dada, the "virgin microbe" and stem cell of 20th-century art, resides in the word "Dada," a four-letter word that has the same number of letters and no less significance for dadaists than the four letters (ACGT) of the DNA sequence. The identity of the Namer became a bitter bone of contention between the French and German dadaists, thereby re-creating, pathetically, the nationalism the dadas abhorred. Who found the Word first? Tristan Tzara or Richard Huelsenbeck? Who uttered it for the first time? Tristan Tzara's claim that he found it is backed up by its existence as the word *da* in Romanian and Russian, meaning "yes." The double affirmation DADA (YESYES) can mean, ironically, "Sure enough!" or "Yeah, right," or it can be indeed an overemphatic affirmation, overemphasis being something that even Voltaire would have surely derided, and his dada spawn even more so. Overagreeing with anything was the mark of the general stupidity of people willing to die for the overly emphatic clichés of nationalism. In that sense, Dada (yesyes) means simply NO. "Yeah, right" was definitely an interjection in keeping with the skepticism of the cabaret's patron, Monsieur Voltaire. "DADA proposes two solutions: NO MORE LOOKS! NO MORE

WORDS! Stop looking! Stop talking!" The command of "NO MORE WORDS" is footnoted by "No more manifestoes" (Tzara's Dada Manifesto of 1918).

Huelsenbeck claimed that he discovered the Word by opening the *Petit Larousse* and finding there the word "dada," a French word for a children's hobbyhorse, a toy. Present at the moment of his finger's pausing on the Word was Hugo Ball, who was consulting the *Larousse* for research on his opus *Zur Kritik der deutschen Intelligenz*. Hans Arp swears an affidavit that he was present at the birth when Tzara uttered the Word, namely, "on February 8, 1916 at six o'clock in the afternoon, at the Café de La Terrasse in Zurich."[51] In 1920, however, Huelsenbeck surrenders his claim to Hugo Ball, who, he now claims, was consulting a German-French dictionary as they were looking for a stage name for Madame le Roy, one of the cabaret singers. Huelsenbeck's first claim is in keeping with the idea of Chance, a dadaist credo, but it is almost too perfectly arbitrary. The second is irrelevant except to keep the Word within the German sphere. Why the fortuitous and arbitrary birth of a (supposedly) meaningless word should become so meaningful decades later to Richard R. Hulbeck, New York psychoanalyst, is a mystery, but not so great a mystery as why Tzara fought so hard for parenthood. Huelsenbeck, as Dr. Hulbeck, had shifted allegiance from the meaningless

universe of Dada to the wholly meaningful world of Sigmund Freud, a world in which there are no accidents. Coincidence and synchronicity hold together the freudian universe, making it understandable and, to the trained ear, meaningful and explicable. Huelsenbeck was not alone in turning into the opposite of what he had been in his youth. Tristan Tzara became a communist, another perfect inversion of Dada, an ideology that also claimed that there was an explanation for everything. Dr. Hulbeck, an American during the McCarthy era, was anticommunist. Tzara was anticapitalist and anti-Freud. Only the practice of violent negation remained with both men.

The mystery of Tzara's allegiance is solved when one considers that Tzara eventually renounced communism and returned to Dada, determined to give the movement a mystical makeover. In his manifesto of 1918, he had already written that "in Dada you have a word that leads ideas to the hunt," and he urges his listener to find its "etymological, or at least its historical origin . . . We see in the papers that the Kru negroes call the tail of a holy cow Dada. The cube and the mother in a certain district of Italy are called: Dada. A hobby horse, a nurse in both Russian and Romanian: Dada." In revisiting the Word after renouncing communism, Tzara recognizes again that Dada was a mystical movement from the beginning, so its Name matters a

great deal again. Naming a religion makes the Namer God. Turning back to the Kabbalah of his childhood, he now finds himself awash in significance. Tom Sandqvist quotes the Romanian poet, scholar, and publisher of the avantgarde, Nicolae Tzone, telling him that the Romanians have not one, but *two* saints named Dada, both of whom were martyred under the Roman emperor Diocletian, and one of whom is celebrated on his birthday of April 16, which is also Tristan Tzara's birthday (according to the old church calendar). Sandqvist goes on to say that "Michel Sanouillet claims that there is only one word in our cultural history enjoying the same privileges as the word Dada, namely God. And doesn't Kurt Schwitters say that 'Jesus Christ was the first dadaist,' just as Richard Huelsenbeck claims that 'Dada guarantees eternal life. Invest in Dada (Jesus saves).'" [52]

With so much at stake, a fight over the birthright was inevitable. We have to give it on points to Tzara. Dr. Hulbeck, analyzed by his friend Karen Horney, had no God but Freud, so for him it was mostly a matter of ego. There was also the matter of Dr. Hulbeck, Park Avenue psychoanalyst, defending his reputation and anticommunist credentials before the FBI agents who had been tipped off that the respected doctor had once been "a red commissar in Berlin." Proving that, on the contrary, he was the founder of an undisciplined art movement was far better.

"We never promised anybody anything; we looked for something undefinable, the essence, the meaning, the structure of a new life. And we became dadaists," said Dr. Hulbeck.[53]

For Tzara, it was a spiritual matter.

No one could have imagined in 1916 that Dada would become Dada™.

e-body: A person has a number of bodies. Persons of importance have a "body-double," but persons like us, who cannot afford them, create new bodies in the form of puppets and avatars. Having a "self-puppet" made of your own gestures and tics is a freudian objectification of "self" that worked well until the advent of Virtual Reality. Now, in Virtual Reality environments we can compose for ourselves a new body called an "avatar." The name is optimistically misleading, or maybe not: an avatar announces the coming of God's kingdom, it is a messiah; in the case of a virtual "avatar" to be used as a substitute for yourself in VR environments, the good news is that your projection may very well be immortal in God's kingdom, which is virtuality itself; the bad news is that your meat-body, poised at the controls of your eternal avatar, decays with time and turns into dust, unable to control any longer the movements of its own e-body. Antonin Artaud was haunted, before the internet, by something he called "the body without organs," which he envisioned as a flesh egg

composed of only brain and muscle that
controlled its extensions by rolling back and
forth to the rhythms of an invisible sea. This
egg is now real, and I and you are that egg.
Our avatars (you can have as many as you
want) sprout appurtenances from the essential
flesh-tuber of our meat-body (m-body).
The potato, a rhizome, was first offered as a
metaphor by Gilles Deleuze to explain the
proliferation of images of our body made
possible by projection and imagination. The
deleuzian potato appeared also before the
internet, and now both Artaud and Deleuze
have been vindicated: the only problem now
for the postvirtual body is to get hold of
enough imagination to project itself. (It takes
10 I.U. to operate an avatar chosen from an
already-programmed menu, but up to 100
I.U. to design a new avatar.) Rummaging
through the trash bins of style for bodies
to wear (out, and in public) is our chief
occupation today. Those who still work (in the
sense of expanding energy toward their own
subsistence) work as dumpster divers to find
styles to sell to virtual entrepreneurs.

emmy, hennings: the proto-hippie; the
exalting, ritualistic, ethereal Pan-Catholic
wife of Hugo Ball, credited with turning him
into a religious philosopher and wrenching
him from the smoky den of Cabaret Voltaire
that she cofounded with Ball and where she
performed as a singer and dancer, dressed in
a variety of costumes, including gauzy ones
that showed her boyish figure at its best. Some

of her costumes, designed by Marcel Janco and Hans Arp, have to be recycled for the inclement Swiss weather later when the couple lives in ascetic poverty in a former convent on an alpine mountaintop. In her memoir, *Hugo Ball Weg Zu Gott*, which phonetically translated means "vegetarians cut off Hugo's balls," but translated correctly is "Hugo Ball's Return to God," she describes the step-by-step journey of Ball, away from the blasphemous Voltaire, up to God, while shedding Hegel, Fichte, Diderot, Voltaire, Bakunin, and Kropotkin, like so many outworn potato peels or paper costumes. Emmy never did get Ball to take off the underpants of Schopenhauer and Nietzsche to come completely nude to the altar of flowers for the Virgin that she constructed on the stone altar of the old convent. She did succeed in causing him to renounce and attack Luther, who, being *inside* Ball, could never be quite destroyed, causing him to work harder and harder. In her *diseuse* incarnation, Emmy sang vulgar and not vulgar folk songs and songs composed by Ball, who accompanied her on the piano with original compositions. When Ball was dying from cancer, Emmy mail-ordered large bottles of Lourdes water that worked well, in her opinion. Ball died, nonetheless, on a melancholy, rainy day in September 1927. His only mourners, according to Huelsenbeck's moving account, were Emmy Hennings, himself and his wife, and Karla Fassbind, who owned Swiss hotels. In the end, the life of Hennings and Ball was a grand love story.

After Ball's burial, Huelsenbeck writes: "We didn't know what Emmy was thinking. They had to take off her wet clothes. She lived in another world, although her head, her hands, and her legs were there at the table . . . Her life was over. The man who had made her a madonna, who had made her philosophy his own, whom she had influenced so deeply that he lived her life as his own, had just been lowered into the humid earth. The fairy tale was over."[54] We might take away from this the following: 1. it is good to have a friend who loves you, but it isn't so great if this is a jealous love that conceives of your other love as a vampire, 2. it is good to give yourself over to your companion, as long as her particular insanity is metaphysical, and 3. you can hide on a mountaintop but you can't hide from *a*. history, *b*. the memoirs of your friends. Should you, reader, find yourself in the grip of a great love in the midst of a dramatic history that makes use, no matter how marginally, of your name and products, do not fight back: there is nothing you can do about it.

eros (women): The Surrealists, André Breton in particular, did not like women in any form, French or American, except as muses and objects of erotic amusement. André Breton made eroticism (a sexually ambiguous quality) a major philosophical tenet of Surrealism, but he was personally prudish. Most of the other surrealists, like the dadas before them, liked naked women, painters' models, each others' wives and mistresses,

orgies, bordellos, strip clubs, and sex with strangers. Breton wrote a literary sexual mystery that was part *vérité*: the account of his pursuit of "Nadja" is an account that might qualify as a classic harassment tale, though he called it a "novel." Nadja is a street-person, maybe a prostitute, a simple person whom the perverse poet toys with, then abandons. Surrealist erotics had their apotheosis in George Bataille's *Story of the Eye*, a book now regularly assigned by humanities professors to their students. The protagonists, a young couple, make love on the lawn of the mental hospital where their other love, a young woman, is confined and able to participate in their sex only by flying a piss-stained sheet out her window while masturbating. Later, the couple travels to Spain where they murder a priest on the altar of his church, scoop out one of his eyes, which the girl inserts in her vagina; when the boy enters her, the priest's eye makes contact with the head of his penis, and, in that moment, they contact their lover in the madhouse, who has since died. This was not ordinary Surrealist fare, but it brought the genre to a place of limit where literary virtuality met nearly unfettered language-play: the homonyms of "eye" and "I" in the English title have their equivalents in plays between *oeil* and *oeuf* (eye and egg) in French. Breton's difficulties with women, which he passed on to his more literal-minded (or his more homosexual) followers, did not get any easier after his non-encounter with Sigmund Freud,

who enjoyed the adoration of psychoanalysis
lavished on him by the young French poet,
but failed to appreciate (or authorize) the
theory and art that went with it. Since the
father was no help, Breton had, of necessity,
to seek the attention of the feminine. He did
so, grumpily, and with ill effects on his wives.
After his prolonged cohabitation with the
goofy dadaists, and his rejection by Freud,
André Breton decided to experiment with
hypnosis and the occult in order to mine
other worlds for poetic inspiration. As a result,
a period of suicide and vampirism entered
into the already-anxious souls of his acolytes.
Surrealist art and poetry were collaborative,
erotic, spermatic, and perverse, and while
women were, in principle, the holders of
all the metaphors of the unconscious, i.e.,
penetration, surrender, the moon, etc.,
they were physically not welcomed to the
Surrealists' séances. (Possibly because some
of them, especially the Americans, didn't take
the boys' "trances" seriously enough; that
is not to say that, from Madame Blavatsky
and before and after, there were not enough
gullible and superstitious women in art circles
to satisfy even the most serious "explorers";
in fact, women drove the occult business,
and how many of them were fakes, only their
hairdressers knew for sure.) To the dadaists,
gender, synonymous with genre, did not
matter at all. In Zurich they pursued their
affairs discreetly and considered themselves
androgynous to some extent. During the Swiss

period they were a pretty inhibited bunch, which was probably just as well, given Swiss reserve. Huelsenbeck recalls in his memoirs his desperate pursuit of an ordinary Swiss girl who slept with him (unsuccessfully) on the condition that he meet her family. The sexual encounter was a disaster, and the experience may have been traumatic enough to make him undertake the study of psychoanalysis. Emmy Hennings used her meager silhouette to suggest something sexual to the drunk mobs who frequented Cabaret Voltaire, but, for all her worldliness, she remained virginal and religious, a condition that seems to have agreed with Hugo Ball. The sexually adventurous dada work that finally blurred gender distinctions came from Marcel Duchamp, who was sometimes Rrose Selavie (*eros c'est la vie*), and from the sex-loving Mina Loy and the bisexual Baroness Elsa von Freytag-Loringhoven. The arrival of the Surrealists in New York set back the gender issue for the dadaists, whose inspiration for pansexuality came from 18th- and 19th-century France and Italy, purveyors to the modern imagination of a vast store of libidinal images from Rabelais and Casanova. There was something stubbornly creepy about the Surrealist insistence on the connection between "perverse" sexuality and art, which might have been Breton's homophobia (and attraction to men) and some holdover from the Spanish Inquisition, an institution that the truly perverse Salvador Dalí worshipped. A

bit of prudishness may have attached also to the German dadas, who went to great lengths to prove it was otherwise, as seen in the work of George Gross. On the other hand, both Max Ernst's and Hans Arp's images are playful and light, closer to Giacomo Casanova than to Goethe. The scary creatures of Goethe's *Faust, Part Two* are not related to Ernst's Loplop bird, but they did appear on the stage of Cabaret Voltaire, as those oddly costumed, eerily musical, "negro"-obsessed masques, who could have been of Balkan origin as well, and thus purely lascivious and not in the least demonic. In the early German films, sex is often connected with vampirism, and so it remains, after its migration to America until today. Nosferatu is the daddy of modern American sex. German sex has two daddies: Freud and Nosferatu. Nosferatu is some kind of Egyptian–Eastern European, and Freud is a Jew. The Romanians, French by adoption, were even more sex-crazed than the French. The unabashed priest of Eros was the Romanian Surrealist Gherasim Luca, who had proclaimed it a Surrealist imperative to "eroticize the proletariat," during the late 1940s when an alliance between the surrealists and the communists still seemed a possibility (mostly to the surrealists). By that time, the Second World War had ended, and Surrealism was on its last legs as a movement. Luca's attempt to reconnect it via Eros was a marvelous gesture in the desert. All the seats in the Paris cafés were occupied by Existentialists.

foreboding: In 1916 when Dada was born, there was no MOMA. Had Dada's "virgin microbe" mission succeeded completely, there would have been no MOMA. The destruction of jails for art was a chief mission of Dada, and its utter failure in this regard testifies to the triumph of its own self-destructive impulse. Dada erases not just its products, but also its intentions. To its credit, however, there is no known vaccine or cure for the "virgin microbe," and it continues to rise untroubled in the young minds of every generation. There is a kabbalistic reason, wholly contained in the word DADA, and a revolutionary reason, which is the necessity to sweep clean the imperative of the past to create injustice and boredom. An artist (i.e., a self-proclaimed janitor) must be possessed, at all times, by a sense of foreboding. "Dada is against the future. Dada is dead" (T. Tzara).

hugo, ball: Hugo Ball had good reasons for leaving the dangerous militant opposition in Berlin. In Berlin, socialism was threatening to upset the social order, and artists were doing their best to keep up, writing, drawing, and painting to shock the complacent bourgeoisie, and to fire up the German workers, torn between socialism and nationalism. He could have been drafted and arrested, but there was something else: he needed to think. The prewar "whys" that had so unsettled intellectuals ever since the "order of things" had proved not to be immutable

were silenced by the boom of cannons. The din had no room for questions, only for loud assertions or noises not belonging to cannons or bombs, but loud enough to be heard. In Italy, Marinetti and his Futurist fellows were working to synchronize their artistic expression with the engines of war, airplanes, tanks, bombs, gunfire. Thanks to centuries of opera, the Italians' voices were being heard in the artistic circles of Europe. In Germany, antiwar demonstrations by tens of thousands of people gave way to tens of thousands of corpses who had obviously changed their minds. The remaining antiwar demonstrators had to shout very loudly to be heard, and when they were heard, they were shipped to the front (if they were poor) or allowed to emigrate to Switzerland (if they had connections). German philosophy, in the business of asking questions for two centuries, was silent. Russian artists gave themselves over to constructing Constructivism, an intensely loud activity, even though the materials they used were language and paint, not (yet) cement and iron. Constructivism had two immediate purposes: 1. to do away with representation (Kandinsky) and 2. to employ the inner ear, which unlike the outer ear (deafened by bombs) is the true listener. Naturally, Constructivists did not ask questions: they answered them. Loudly. The only Russian asking a question, insistently and incessantly, was Vladimir Ilych Lenin, the exile, whose question was

"What Is to Be Done?"—a question asked by Chernishevski for a previous generation that had failed one revolution. This time, Lenin had analyzed every move made by the previous revolutionaries and thought that *this time* he had the answer. This Revolution would not fail, because it was the Revolution of the Proletariat. After the Revolution of the Proletariat, which was going to take place in an industrially developed western country, Germany most likely, there would be new questions to ask. Hugo Ball's own questions were spiritual, though he didn't yet know it. He still looked for intellectual answers and was writing *Zur Kritik der deutschen Intelligenz*, a philosophical work about German thought, even as he founded Cabaret Voltaire in Zurich. His memoir about the period, published in 1927, *Flight Out of Time*,[55] gives great insight into the spiritual quest of Dada and does away (for anyone who actually reads it) with the reflexive smirk that even now accompanies mention of Dada. The rolling-of-the-eyes-cum-smirk started with Breton's pompous squad of Surrealist enforcers and was perpetuated by smug Anglo-American "mongrels" (as per Mina Loy's great poem "Anglo-American Mongrels")—I mean, of course, "modernists." American professors who religiously produce tons of yearly piddle on the "modernists" cringe with terror at the mere mention of Dada, which is certain proof that Dada is very much alive. Reading *Flight Out of Time* would take the smirk out,

but then what would the professors do? Kill themselves? Yes. DaDa. When Hugo Ball left Dada, he became a Catholic saint, a sad fate for such a great man, but then Tzara became a communist (though not for long). For Hugo Ball's saint period, see **emmy, hennings.**

human, posthuman, transhuman: "The mind is alive with a new range of possibilities: to centralise them, to collect them under a lens that is neither material nor delimited—what is popularly called: the soul. The ways of expressing them, of transmuting them: the means. Bright as a flash of gold—the increasing beauty of expanding wings . . . Under the bark of felled trees, I seek the image to come, of vigor, and in underground tunnels the obscurity of iron and coal may already be heavy with light." (Hopeful Human, Still Hung Up on the Industrial Age, Tristan Tzara, 1919)[56]

"If it were possible to trace a genealogy of virtual religions on the Internet, it would probably begin with Discordianism. According to the tradition recorded in multiple editions of the *Principia Discordia*, the Discordian religion began in 1957 when two friends, sipping coffee in a bowling alley in Southern California, experienced a dramatic break in the space-time continuum, causing them to realize that chaos is the underlying principle of everything. This realization was reinforced by a vision of the ancient Greek

goddess Eris, goddess of discord, conflict, and chaos, who revealed herself as the source not only of chaos, but of the 'happy anarchy' of freedom, creativity, and laughter." (Early posthuman considerations by David Chidester in *Authentic Fakes: Religion and American Popular Culture*, 2005)[57]

"As a result of a thousand million years of evolution, the universe is becoming conscious of itself, able to understand something of its past history and its possible future. This cosmic self-awareness is being realized in one tiny fragment of the universe—in a few of us human beings. Perhaps it has been realized elsewhere too, through the evolution of conscious living creatures on the planets of other stars. But on this our planet, it has never happened before. Up till now human life has generally been, as Hobbes described it, 'nasty, brutish and short'; the great majority of human beings (if they have not already died young) have been afflicted with misery in one form or another—poverty, disease, ill-health, over-work, cruelty, or oppression. They have attempted to lighten their misery by means of their hopes and their ideals. The trouble has been that the hopes have generally been unjustified, the ideals have generally failed to correspond with reality. The human species can, if it wishes, transcend itself—not just sporadically, an individual here in one way, an individual there in another way, but in its entirety, as humanity. We need a name for this new belief. Perhaps

transhumanism will serve: man remaining man, but transcending himself, by realizing new possibilities of and for his human nature. 'I believe in transhumanism': once there are enough people who can truly say that, the human species will be on the threshold of a new kind of existence, as different from ours as ours is from that of Pekin man. It will at last be consciously fulfilling its real destiny." (Julian Huxley, the first director of UNESCO and a founding member of the World Wildlife Fund)[58]

internet(s): The electronic communication and information networks that call themselves, grandly, the World Wide Web (WWW) are the current winners of a long battle of webs. At a time when there were fewer humans and they were of necessity more aware of their environment, especially the things that they could eat or that might eat them, there was a well-functioning web of interhuman, interspecies, and interregnum communication maintained by shamans (holy men). The shamans were the servers of the prehistoric world, capable of understanding animals and reading landscape. Human thoughts were communicated long-distance by means of shaman-boosting stations (some of the shamans lived, literally, in trees or on mountaintops for better reception), and the *faith* of all humans in the interconnectedness of mind and habitat was unshakable. This ancient web was destroyed by greedy shamans and charlatans who began charging for

the connection when people began to take their services for granted, that is to say, when their faith became so unshakable it became unconscious. This psychic web that connected all living things functioned well to the end of the neolithic, when questions about the servers arose. Why was the evident interconnectedness metered by a class of crazed bums who didn't do anything more than pass on messages through the atmosphere? Did they not get freely fed from the community stores? The first "revolution" must have been the establishment of a set of rules for shamans, the first of which was "purity." The shamans had to stay incorruptible, ascetic if possible, before they could be overcome by greed. Tough gig. Not long after, there arose a priestly class that not only metered intercommunication, which must have seemed to most Stone Age people like charging for breathing the air, but put actual impediments in place, making it impossible for your average hunter to have a quick conversation with his guardian-spirit without offering some absurdly expensive sacrifice. The advent of private property, and the desirability of hilltops and the consequent development of an army to guard them, made it imperative for the priestly class of web-servers to make the three-tiered alliance that held through several millennia, namely, royalty, the military, and the shamans. These last actually grew in importance since they arrogated to themselves not only planetary

and cosmic intercommunication, but also the disposition of matter into the afterlife. Neolithic man would have laughed like an animal, which herm was, if the shamans of herm day had attempted such a power grab. Various webs functioned after the free, original version, in forms that were restricted mostly to the social networks of the three-tiered power structure, though the technology of access became more and more complex: gods, oracles, prayers, expensive pilgrimages, rituals, and, eventually, religions and religious wars. Numerous cultures with a good knowledge of interconnectivity survived outside the empires and held on to their knowledge through the use of plant-teachers, but they had to keep their servers hidden and couch their technology in language that obscured it. The imperial civilizations that wrote history were shaken up by intermittent revolutions that demanded the instant return of planetary and interplanetary communication to the people. The European Renaissance produced a shift in perspective that led to the creation of a new internet based on memory. Giordano Bruno's "Theater of Memory" was an attempt to classify and hold all the world's knowledge in one's own head by means of an architectural image, a theater. A single person would be able to know everything possible by placing the memories of everything one had learned within various levels, loges, and areas of a grand imaginary theater that could be visualized in detail with

a little practice. The placement of so much knowledge in a single image did not exactly solve the problem of how to connect all those discrete bundles in their allotted places, without creating a lot of confusion. Bruno's Memory Theater (based on older Greek and Roman models of the same idea, and on countless treatises on *Ars Memoria* since) does not answer another obvious question: what play is going on onstage while all these memories sit in their seats? Or is the stage the place where they come to interconnect, which *is* the performance? After Giordano Bruno, who was also an alchemist, who intuited the changeability of elements and the existence of as-yet-undescribed energies, the question of interconnectivity and networking became more and more concerned with the disposition and classification of knowledge. It occurred to a few people that the vast and quickly accumulating quantity of what is still called "knowledge" in some circles was only a mountain (or sea) of storage devices for the description of the world by people: tablets, books, mathematical and chemical formulas.

Means of organizing this "knowledge," such as taxonomies and grammars, were greeted with howls of delight by the custodians of institutions charged with storing all the information. Interconnectivity, which used to be a matter of cosmic understanding and telepathic transmission, applied for at least three centuries only to connecting recorded

information. The sentimental and social life of people still asking about God, nature, and the cosmos went unaddressed by the new priests of science. Mystics and philosophers stumbled occasionally on some part of the old Web and inferred from that the existence of a much vaster and older network. Teillhard de Chardin, a Christian philosopher, posited the existence of the "noosphere" (from the Greek for mind, *nous*), a thought sphere that connected all people for the purposes of helping divinity evolve, giving shape to *Le Christ-Evoluteur*. Others, like Madame Blavatsky, a theosophist, simply traveled back and forth between virtual worlds, like a hot-air balloon without a navigation system. Still, neither mystics nor philosophers could correct the great misunderstanding beginning to take root in Europe after the Enlightenment: scientists were beginning to, literally, mistake their mountains of description for the world, to substitute descriptive virtuality for reality. This was the hubris at the start of the "communication" revolution. In 1934, a Belgian eccentric named Paul Otlet "sketched out plans for a global network of computers (or 'electric telescopes,' as he called them) that would allow people to search and browse through millions of interlinked documents, images, audio and video files. He described how people would use the devices to send messages to one another, share files and even congregate in online social networks. He called the whole thing a 'réseau,' which might

be translated as 'network'—or arguably, 'web.'"[59] Paul Otlet's project, called "the Mundaneum," collected an extraordinary number of documents and images, but was forgotten after the nazis occupied Belgium and destroyed most of his work. Ahead of the discoverers of the present-day internet by Americans like Ted Nelson and Tim Berners-Lee, who released the first Web browser in 1991, Otlet envisioned not only the information highway, but also the hyperlink, by means of which, he wrote, "anyone in his armchair would be able to contemplate the whole of creation." Otlet, like the creators of the World Wide Web, solved the problem of what to do with the accumulated records of humanity. In a very short time, the advent of the modern internet made it possible for individuals to communicate with one another in a pretty fair simulacrum of the original interconnectivity of the Neolithic. The modern internet is, however, only a simulacrum, no matter how fast or efficient it gets, and no matter how quickly we *internalize* it (which is only a matter of seconds). So what's the problem? The problem, said Tristan Tzara in his essay "Francis Picabia, pensées sans langage," is that "The philosophical myriapoda have broken some wooden or metal legs, and even some wings, between the stations Truth-Reality. There was always something that could not be grasped: LIFE."[60] Indeed. The question is: can anyone enclosed in and in debt to a network still experience

LIFE? Or is our new interconnectivity the actual parenthesis or quotes around life, a.k.a. nature? Has the time come to stop communicating and start *looking*? Someone born before the internet, like myself, is experiencing as *excess* of communication, but this is surely just a result of fatigue and the big learning curve. Or is it? My students, to whom the internet is second nature, feel *liberated* by their ability to go anywhere for a description. The problem, exactly. Even if total immersion becomes possible, virtuality will only lead its resident to another virtuality. Let's say a flesh-and-blood networker meets another virtually-conditioned real human over the network and, let's say, they have sex, they make a baby, they live in an automated house and society, they have a seamless web of a life . . . until. Until Catastrophe. Storms, marauding dadas, bored speed freaks . . . something unvirtual breaks upon them. Then what? What happens then is that their social network *cuts them off*. Real victims do not exist in the virtual world. In the virtual world there are only happy endings: there is no room for either Catastrophe or Miracle. The internet will be (if it isn't already) just another (re) distribution of power among social networks that have the fatal weakness of being virtual. Happily. Happily, virtuality is the fatal weakness of virtual communities and their members. Why happily? Because we are artists, that's why. We have no taste, but a stubborn desire to make you taste *something else*. We

will not perform virtual theater because it's redundant. We like contradictory warm-blooded people who have a thing for rocks and animals. Not a thing about *knowing* things about rocks and animals, but a thing for the actual real rocks and animals. Do we have an epistemological problem? Yes, we do. Take a dada to bed and see me in the morning. We are in a very strange place in the new euphoric world of interactivity in which, as I said before, *everyone is an artist*. That means the following: any signal articulated by anyone into the World Wide Web becomes instantly linked to everyone else's, making it not only possible, but *mandatory*, to be other people. If theater in the past involved the rather time-consuming arts of costuming, from inventing and playing the character to making herm clothes, the Web assembles the dramatis persona on the spot, returns herm to the sender and to herm's potential audience without delay; the audience feedback is instant; from conception to feedback and back and then back and back again through an infinite hall of (re)invention and feedback, any *original* intention can be turned into a surprising *objet*. In effect, the *objet* hardly matters, except to people who like to collect things (i.e., stop the process at some more-or-less solid stage), because the conceptual machine set in motion by anyone's desire, or any desire at all, will run on forever. The Dada job now would consist of the disruption of networks, an incredible effort of the

imagination at a time when social networks are proliferating at the speed of light, literally abolishing time. My Face, My Space, My Body, My Soul, My Idea, etc., are really everybody's face, body, soul, ideas, and will eventually pixelate and automate its members, unless the virgin microbe confuses them. Why should it? Because an actor in the past could step out of herm costume and get drunk in the demimonde, while the morphing hyperlinked entity can no longer disengage. Networking now is like superglue: look at all the flies trying to get their feet out of the screen! Try to remember what your name was before you signed on. Can't? Try "No One." We are now art whether we like it or not, making the revolt *against* art more urgent than ever, which is exactly what Tzara meant when he said, speaking of Tristan Corbière: "Words no longer seemed to him anything more than derisory or criminal instruments. But Corbière himself, who everywhere discovered signs which remained pure in primitive cultures and in folklore, would obviously never have thought about it if he hadn't first loved these people for themselves, people who in their popular expressions have nothing but themselves to give."[61] Lucky Corbière! There were still primitives about, filled with the freshness of expression that still carried something of the ancient web about it. Are they still about? One could make a case for religious fundamentalists as the exponents of the last romantic revolt against the

promiscuity of information, but this is hardly the case. Religious guerrillas today are fighting for control of state power, like the bolsheviks; the texts that legitimize their leaders for the ignorant are read no more literally than Lenin read Marx. The Dada (missionary) position on this is that the genuine work now would be to return individuals to themselves with time to germinate in the dark, without being part of everyone else in the world. Is this even possible? It certainly isn't desirable from any reasonable point of view, except the absolutely negative opinion that a vast extortion of human energies is at work, for purposes not clearly understood. Today's internet is an impersonator of the ancient web and is still in the hands of techno-shamans who still charge for the air. I am Dada-bound to suspect the enterprise of demonism. A dada must battle the obvious, especially if it's inevitable. Futility tastes like (insert innocence-metaphor here) mother's milk, first taste of peach, an unusually long and salty word spoken late in the night outside a shady bar. To *love* singular people with primitive connections to the divine, and expressions that are still unmediated (or only humanly mediated) in an intensely e-mediated world, involves, first of all, stripping yourself down, getting rid of all your screen-names and personae, and then finding other people unmediating themselves while living in trees they won't allow to be cut, like my hero, Julia Butterfly.[62] This is the opposite of seeing your reflections in My Space. Making yourself up for fun, which was the old

Dada, has now come up against the new Dada, which is the necessity to strip down to whatever self you once had, and become a tree.

james, joyce: In the café crowd is James Joyce, also a habitué of Café de La Terrasse, who knows both Tzara and Lenin, and will end up knowing them better than he might have actually known them, in *Travesties*, a 1974 play by Tom Stoppard. Joyce, unlike the intent players, or the absentminded kibbitzers, has other matters on his mind, namely, women and money. Chess doesn't interest him because it does not attract young women and it isn't being played for real money. There is an element of chance in the game, but it isn't as random as dice or cards. What's worse, the game is bound by the absurd ideas of winning and losing, ideas that Joyce doesn't care for in the least. He is writing an odyssey, a forward-looking story of surprises obtained by unveiling the explosion of events contained in every single moment, all moments heading, along with the hero, toward something unknown. Known elements bore Joyce. He believes in neither learning nor chaos. The journey of discovery depends on everything, but is chiefly dependent on women for inspiration and money for subsistence. Chess has too many *rules*, but this is the opinion of a novice, because to cognoscenti, the rules of chess are known as *laws*. Joyce is interested in laws, as is nearly everyone in this motley, stale, mostly unwashed, smoke-cloud-enveloped mob at La Terrasse on October 8, 1916. The

laws matter, because everybody is here by the grace of laws either breaking down or working in their favor thanks to Switzerland's neatly functioning little democracy. Laws matter because everyone who is not a Swiss citizen lives perilously close to their edges. Many of them, Tzara and Lenin among them, inhabit fictional identities. The laws that apply to their fictions may not apply to their prefictional identities.

jews: "The revolutionary avantgarde of the 20th century was in large measure the work of provincial East-European Jews." I'm quoting myself here,[63] but this radical statement needs another look. The shtetls of the Pale, a vaguely defined region stretching through parts of Russia, Poland, Ukraine, and Moldova, were peasant villages occupied with subsistence farming and animal husbandry, but concerned with preserving their communities through learning and spiritual life. They nurtured scholars bent on study of the Torah who brought about a religious revival in the early 18th century, a mystical reform known as Chassidut in Hebrew, the Hassid movement. Rabbi Israel ben Eliezer, a.k.a. the Ba'al Shem Tov, which means "Master of the Good Name," was its founder, who traveled through the poor Jewish villages teaching and healing. The Ba'al Shem Tov taught that every Jew, not just the learned ones, could obtain unmediated knowledge of God by following the commandments and reading the Torah. The nearly-forgotten mystical Kabbalah, an

esoteric reading of the Bible, came back into use in everyday life. Trying to infuse life with spirituality in even the commonest action caught on very rapidly among the simple Jews. The ostensible reason for such renewed faith was the imminent arrival of the Messiah. The Jews prepared feverishly for it: being ready meant surrendering to inexplicable ecstasy. Thousands upon thousands of Eastern European Jews flocked to the Hassidic movement and developed its lore in a short time: wise tales, fables, plays, music, dance, and rituals for every important occasion. The once-depressed communities of the shtetls were filled suddenly with joy as life became more animated through divine and personal radiance. Surrounded by antisemites and in constant danger of being killed, the deeply poor Jews of the shtetls rediscovered the simple belief that everyone was personally connected to the divinity, and that the verses of the Torah, used in combination with the math of the Kabbalah, could work practical magic. A folk figure of the Middle Ages gained great currency among the Hassidim, namely, the Golem, a robot created by Rabbi Loew in Prague in the 17th century. The Golem was a powerful creature brought to life through kabbalistic means to defend the Jews. Rabbi Loew animated the Golem by writing the secret name of G-d on his forehead. The Golem did a creditable job until he fell in love with the rabbi's daughter (in one version) and went on a rampage when he was denied. He had to be destroyed by having the Word

erased from his forehead by the only person he trusted, the rabbi's daughter, after which he disintegrated. His ashes and some bits of bone are still kept under lock and key in the New Synagogue in Prague. The creation of the Golem through belief in the magical power of letters proved prophetic. The four letters of the DNA alphabet can now be manipulated to create human beings. In their mystical isolation, the shtetl hassidim intuited the superbrain of creation, a kabbalistic supercomputer. Not only were the Jews the oldest humans to maintain community through the use of a portable religion, the Book, they projected their literal insights into the future as well. (Ronald Sukenick saw Jews as simultaneously "proto-human" and "post-human," a model of humanity evolving through reading and writing, by means of the Alphabet.) After the Emancipation that resulted from Napoleon's dissemination of the French Revolution in conquered Europe, the Jewish supercomputer entered the secular world. Much more sophisticated golems were put into play, leading to various dialectics, the simplest of which is the perennial subject of science fiction from Mary Shelley's *Frankenstein* to the television series *Battlestar Galactica*. In *Battlestar Galactica*, humans created robots (the Cylons) who revolted by destroying Earth, but are now attempting a hybrid merger with the human race by launching endless humanlike clones who mate with actual humans and give birth to baby messiahs who'll lead the new race to the lost

planet Earth. For the moment, both humans and Cylons live on self-sustaining spaceship biospheres. The truth is that Earth is itself a spaceship biosphere traveling fast through the middle of the universe as part of a rapid cosmic river. Our home planet was *preserved*, not destroyed by robots, hence our dada dreams. Humanity's saving robots were Dada creations.

Both politics and art became available to Jews after Emancipation, and their Torah-honed and Messiahward-looking intellects found a huge playing field in new arenas where they began pleading their case for equality and justice. With centuries-long experience of directed study and self-directed humor, as well as a quick grasp of the social and cultural forms created by seemingly immutable outside hierarchies, some shtetl escapees were quick to see the possibility of revolution. Finding great numbers of Jews in revolutionary vanguards makes sense, but the revolutions of the 20th century were by no means their work alone. The abused of society were myriad.

The subsequent roll call of the Romanian avantgarde contains an impressive number of Jews, but just as many non-Jews. Early in the century, young Romanians from the cities (Bucharest above all) assaulted the traditional forms of autochthonic literature and its pastoral stock of images, attempting to join european literatures and claim a place of distinction alongside the French poets

they worshipped and imitated. The Jewish contribution to this enterprise was catalytic and tonic, bringing an effervescent joie de vivre and thirst for secular life to Romanian aspirations. Outside of literature, there were writers concerned with society, whose work was meant to inspire people to action, and among them one found Jewish social revolutionaries inspired by marxism, and a nascent Zionist movement. The cultural and social revolutionaries were quite distinct, but they often shared with the poets a common longing for utopia. A messianic streak drove many Jews from deep within. To cultural and political conservatives, the results were equally damnable. After the First World War, the Romanian fascist Nicolae Roșu wrote: "Dadaism and French Surrealism exploit the moral and spiritual exhaustion of a war-torn society: the aggressive revolutionary currents in art seem to be an explosion of primal instincts detached from reason; postwar German socialism, largely developed by Jews, uses the opportunity of defeat to dictate the Weimar constitution (written by a Jew), and then, through spartakism, to install bolshevism. In the end, in ideology and practice, Russian bolshevism is the work of Jewish activists. Both Tristan Tzara and Pablo Picasso, the promoters of Dadaism and Cubism, are Jews."[64] Picasso wasn't Jewish, but never mind. If the facts don't fit the theory, damn the facts. Antisemites are, of course, good at finding Jews wherever they are needed.

Lenin was one-quarter Jewish, but when this quarter was revealed, it gave antisemites a lot more than a quarter, it became for them the *whole* bolshevist impulse. During Romania's national-bolshevist era, when antisemitism was officially prohibited, an antisemitism in reverse was practiced: Jews were *not* mentioned, under any circumstances; by their omission they were implied and implicated, sometimes with a wink and a nod, sometimes with a coded reference to "finance" or "speculation," or "cosmopolitanism." To imply Jews without naming them was a practice that survived communism into the age of political correctness: imagine a book entitled *Pioneers of Modernism: Modernist Architecture in Romania 1920–1940*,[65] published in 1999, that devotes a whole chapter to Marcel Janco–built modern buildings but does not mention that Marcel Janco was Jewish. This is Janco the dadaist, cocreator of Dada, who post-Dada gave parts of Bucharest the distinctively modern style that the tourism ministry is rightly proud of. Janco emigrated to Israel later and created the national Israeli design style. It is an interesting connection that a smart promoter of Romanian culture, in these days when Romania finally and officially belongs in Europe, might seize on as resounding to the country's benefit. But there is still an awkwardness, an embarrassment, and a silence about Romanian Jews. There is also denial: three hundred thousand Jews were deported and murdered under

Romanian administration between 1941 and 1944. Three hundred thousand (including the mother of the author of this book) survived. The official Romanian view is that it saved 300,000 Jews from the nazi death camps. The other 300,000 go unmentioned. Presently, one wonders what is the difference between insisting that someone is Jewish and deliberately not mentioning it? In the context of modernist architecture in Bucharest, the antisemitic nonmention replays subtly the fierce battle that raged in the 1930s between the early modernists like Janco, who promoted simplicity and equality, and their heirs, the deco-decorative fascist architects of the late 1930s and 1940s who abandoned simplicity for pompous nationalism. Speaking only of style, there is no doubt that Jews had a greater thirst for justice after centuries of oppression, and an open, light arrangement of surfaces and cubes spoke eloquently against opulent disguise and baroque intrigue. Tristan Tzara told Ribemont-Dessaignes, "Dada was born from moral exigency, from an implacable moral will. Dada proposed to liberate man from all servitude, whatever the origin, intellectual, moral, or religious." Lenin might have said the same thing, but in a different order of priorities, one that might have included "political" at the top of the list. For Tzara, the notion of a deliberately political artist was absurd because an artist pursued moral imperatives through artistic means of discovery, not through propaganda, but the source of both urges to revolution

was the thirst for liberation and justice. The representative of the art revolution is playing chess with the tactician of the social revolution, and both are agreed on the laws of the game. What separates them and makes them compete is the solution to the problems both of them understand. They may not yet know it, but the winner will determine the century's priorities.

kibbitzers: The two protagonists intent on their chess game ignore the crowd of kibbitzers that usually gather around players. The kibbitzers are only half paying attention anyway: they are here to get away from the blustery cold and whipping snow outside. In La Terrasse, the international crowd looks for comfort in each other's foreignness, an escape from the cold precision and well-ordered life and buildings of Zurich. There are thousands of refugees from the war here: draft-dodgers, deserters, pacifists, socialists, anarchists, spies from every state in the war, starving artists, prostitutes, criminals wanted in warring countries. They hustle, they mooch, they kibbitz, but mostly they wait. They wait for the end of the war, and for what they imagine lies beyond the war: revolution, peace, business, opportunities. Some of them wait for the fulfillment of prophecies that mystics, theosophists, seers, fortune-tellers, and scam artists have been spewing into the air since the 19th century, a wind of utopian or dystopian portents that rattles the equally numerous ideologies and political ideas born

of conversation and tension. Visions and anxieties go hand in hand with the crassest hustles. The state of exile is a nation with its own laws and aspirations. Pacifists, mystics, and revolutionaries breathe the same air. One thing is for sure: nothing will be the same after the war, after the two chess-players rise from this table to go their different ways: Tristan Tzara to Cabaret Voltaire where the nightly Dada performance is unraveling centuries of certitudes about art, Lenin to a secret meeting with an envoy of the German ambassador Romberg, who will eventually convince the German General Staff to provide Lenin and his list of carefully chosen comrades safe passage to Russia where the Tsar has just abdicated. Deep down the kibbitzers know that they are lucky to be here, warm and cozy, watching these two hardly-better-than-mediocre players push about chess pieces originating in a soon-to-be obsolete history. War no longer has any room for spectators. Even the American Civil War, the bloodiest war in history until the current one, made allowances for certain sketch-artists, battlefield photographers, bourgeois with spyglasses, and anxious young wives, who could watch from the hills as the combatants systematically murdered each other. Matthew Brady, photographer of the Civil War, was allowed to train his camera on the battlefield, but every conflict since has involved everyone, including noncombatants. The presence of spectators has been greatly reduced since the American

Civil War, leaving only war journalists at the front. Beginning with this so-called First World War, not only are noncombatants excluded, but a whole slew of metaphors is going down with them. Witnesses to history? Don't make me laugh. Documentarians? Strictly for propaganda. Everyone else, shoot them. Scribes, transcribers, chroniclers? Necessary only until our history, the one we make, begins to write itself. It's only a matter of time. And technology. Even if nobody here thinks of the American Civil War, many of them, including Lenin, think about America. Deep down the kibbitzers know that they are obsolete. They can make no appeal to virtue, morality, or function. They certainly do not matter to the players. On this point, Lenin and Tzara are in agreement. If anything, they will do their best to eliminate witnesses. The audience is obsolete; there can't be any spectators in a revolution; there is no room for bystanders. Anyone who does not participate will be destroyed, either physically (not quite yet) or by neglect (soon enough). Each of the players is alone with this thought, but for Lenin the loneliness extends to his network. He had "gradually found himself almost isolated—betrayed and deserted—while all manner of unifiers and disarmers, liquidators and defeatists, chauvinists and anti-statists, trashy scribblers and mangy time-serving petit-bourgeois riffraff had gathered elsewhere . . . Sometimes he was reduced to such a small minority that nobody at all remained at his

side, as in 1908, the year of loneliness and misery after all his defeats, and most dreadful, the hardest year of his life—also spent in Switzerland."[66]

As for Tzara, he has already begun taking action against the audience. Each night, at Cabaret Voltaire, the audience is assaulted, ridiculed, attacked, made to feel stupid and useless. In the beginning, quite a few drunkards objected to having their ears assaulted by the loud, obnoxious noises of drums and improvised instruments, being sworn at in several languages, baffled by simultaneous readings, and jarred by mock explosions. Even some of the sober spectators, such as they were, occasionally rose in fury against the dadaist assault of obscenity, blasphemy, and flaunting of sexual propriety. But as Cabaret Voltaire and Dada began to develop a creed and issue printed manifestos, the reaction died down somewhat, to Tzara's disappointment, and it was becoming harder to provoke. Now there were curious young people in the audience, quiet as lambs and too poor to buy many drinks, regarding the nightly Dada spectacle as if it had been created to entertain them, to somehow . . . express (horrors!) their own feelings. The players (us) are surrounded by Monday-morning quarterbacks, art critics, museum curators, money-forgers making a living out of complete sentences. Beware of this crowd, invisible as it may seem to you

at the beginning of your Dada life! They are always there. They peddle conjunctions: psst! Pssst! How about an AND? Or a nice BUT? Remember: AND is DNA backwards, and BUT is TUB. *Conjunctio oppositorum*. Never buy conjunctions without turning them backwards first.

language crystal: dybbuk = d y book, or the coauthor of this book, Rapper Da Y-Book. Here is a challenge for the reader of *this* book: *The Language Crystal* is the title of a self-published book by a dyslexic author who had the uncanny ability of seeing predictions inside every word or sentence in the news. His ability to turn letters around in his mind-crystal allowed him to look into the utterances of news-makers and phrases published or spoken during the Reagan era, and to discover hidden prophecies describing things to come. In many cases, he was spookily right. He attributed the ability to mentally rearrange words to yield secret meanings to his dyslexia. In the introduction, he wrote about the suffering he had endured until he realized that he had a gift, not a disease. The occult text hidden in everyday text is an esoteric preoccupation quite common these days through the use of computers to scramble, collage, cut up, rearrange words and sentences. Unfortunately, I don't remember the name of the author. A Google search revealed that an English scholar named David Crystal has written over a hundred books about the

English language, about the use of language on the internet, and about . . . dyslexia. There are thousands of entries about David Crystal's work. I wondered if the book I'd read years ago was an offhand exercise of the distinguished David Crystal, but I dismissed the thought. *The Language Crystal* I read is a brave, but touchingly naive, effort by a man who discovered that his brain had a marvelous power. My author could not be googled. Can you identify him?[67] New York poet Hannah Weiner (1928–1997),[68] whose first name is a palindrome, had the gift of seeing words on people's faces, words that she transcribed in her journal. Hannah was pretty unsettling when she looked intensely at your face during some banal conversation, while you knew all the time that she read you, literally, like a book. Some of her titles are *Seen Words* (1989), *Visions* and *Silent Musicians* (1992), and *We Speak Silent* (1993–1994). Hannah Weiner had a direct physical connection to language that opened a world invisible to the rest of us. She was naturally Dada. After the publication of Umberto Eco's *The Name of the Rose* (1995) and Dan Brown's *The Da Vinci Code* in (2006), the world experienced a rash of decodings. Prophetic and esoteric text became suddenly visible under every "sacred" text and, practically, under any text. People began reading for "hidden meaning," not for what used to be called conventionally "meaning." With a sound of gusting wind in the branches of the language trees of Babel,

the words gave way like leaves, and every
reader glimpsed another reality hidden in
the foliage. A reader is a priori a suspicious
and gullible soul who believes both in the
literalness of what herm reads and that texts
hold hidden meanings. How is it possible to
believe both? Simply by dada, by not obeying
logic. For those still skeptical of secret codes,
computer scientists in Israel submitted the
Old Testament in Hebrew to computers that
promptly spewed back combinations that were
nothing short of prophetic: everything from
the future of humanity to the next mayor
of Jerusalem could be found encoded in the
old verses. My Israeli nephew is a linguist
who works for the Mossad: he swears by the
Kabbalah. In 1990 I was told under hypnosis
to experience a past life: I was a scribe in
the marketplace in medieval Toledo, Spain,
writing letters for illiterate lovers and travelers;
under the pile of parchments there was a stone
that I was secretly inscribing in cuneiform
script while writing these letters. My hypnotist
asked me to read the stone. I did. On waking,
I remembered nothing. The babble I taped
sounded like babble. William Burroughs left a
tape-recorder on while he slept: listening to it,
he heard babble. Then he listened again, and
again. He then heard, distinctly rising from
the babble, a voice giving practical advice. The
text hidden in the text, or the hidden phrases
hidden in white noise, have long been detected
by mystics and schizophrenics, but few, with
the exception of dadaists, felt free to cut them

up or break them down over and over to make them yield more and more occult material. The average reader can easily become a dadaist for the purpose of decoding things, simply by rereading them over and over. Try it with the sentence above. If one is algebraically inclined, one can skip rereading and go directly to formulas. For ex: tzara + land, the feminine of Tsar (tsar-ina), so tsar + tzara (king + land = dada + lenin = daddy + baby toy).

For Tzara, Dada works very much like the Language Crystal, its deconstruction of language becoming "a kind of alphabet . . . a self-shaping material within which the nonhierarchical order corresponds to the . . . reality outside language."[69]

lenin: on most book covers of new biographies from "recently opened" Soviet archives, Lenin looks like a bald eagle photographed by Marion Ettlinger, reflected in Monsieur Tzara's monocle. We derive from this observation, 1. the necessity of being photographed by Marion Ettlinger in order to make a stylish writerly impression, and 2. the reflections of what we will look like in the future will depend on "newly opened archives," even if we are not Lenin. There is a bit of Lenin in all of us, as the reader of a screenplay for this book will doubtless tell his Hollywood agent. We will rely on opening archives we didn't know we had. From the very beginning of the Bolshevik success in Russia, there have been more

than thirty-six ways to look at Lenin. W. T. Goode interviewed Lenin for the *Guardian* on October 21, 1919, and while his editors headlined the article "An interview with Lenin: His Cold, Clear Brain," W. T. Goode was careful to begin with a *disclaimer*: "A small wooden office beyond the bridge, where a civilian grants passes, and a few soldiers, ordinary Russian soldiers, were all there was to be seen at this entrance. It is always being said that Lenin is guarded by Chinese. There were no Chinese here." Already, one way to look at Lenin (as always guarded by the Chinese) is put to rest. W. T. Goode was not in the mood to pass on more prejudice about supposed Chinese fanaticism or Lenin's "oriental" roots. He really, really talked with the real guy, a difficult matter "not because he is unapproachable—he goes about with as little external trappings or precautions as myself— but because his time is so precious. He, even more than the other Commissaries, is always at work." There, the working man's idol works. Arthur Ransome, another English journalist in Russia in 1919, said, after his interview with Lenin: "More than ever, Lenin struck me as a happy man. Walking home from the Kremlin, I tried to think of any other man of his calibre who had had a similar joyous temperament. I could think of none. This little, bald-headed, wrinkled man, who tilts his chair this way and that, laughing over one thing or another, ready any minute to give serious advice to any who interrupt him to ask for it, advice so well reasoned that it is to his followers far more

compelling than any command, every one
of his wrinkles is a wrinkle of laughter, not
of worry. I think the reason must be that he
is the first great leader who utterly discounts
the value of his own personality. He is quite
without personal ambition." Lenin a joyous
man? Who laughed? That is certainly not the
Lenin of Solzhenitsyn's *Lenin in Zurich*, who
is a dour, overwrought, frowning, anxious
micromanager who becomes apoplectic and
enraged over small details, and has no time
for shared pleasure, unless it is sharing a
mean joke with his co-conspirators, a joke
that moreover advances the cause of the
Revolution. Chess, yes, that was a means of
thinking while relaxing. Leon Trotsky gives
us another Lenin, just before the revolution:
"I was at the editorial office of Pravda two
or three times at the most critical moments
before the July days. At these first meetings,
Lenin gave the impression of intense
concentration and formidable self-possession
beneath the mask of 'prosaic' simplicity and
calm. His speeches at the first Congress of
Soviets aroused anxiety and enmity among
the Social Revolutionary Menshevist majority.
They felt dimly that this man was aiming far
ahead, but they did not see the goal itself.
And the revolutionary little citizens asked
themselves: Who is he? What is he? Is he
simply a madman? Or a projectile of history
of range as yet unknown? It was a suggestion
of what was coming that all felt for a moment
as they followed with bewildered looks this
so commonplace and so enigmatic man. Who

is he? What is he? Did not Plechanof in his newspaper call Lenin's first speech on the revolutionary soil of Petersburg a fantasia of fever? Did not Lenin's position among the Bolsheviki themselves at first arouse violent dissatisfaction? . . . What was Lenin's mood at this time? If one wants to characterize it in a few words one must say that it was a mood of restrained impatience and deep anxiety." Trotsky's tense, tightly wound Lenin is closer to the one Solzhenitsyn describes, and he is also "enigmatic" (more "oriental," hint, hint) and wears a mask of "prosaic simplicity." Not a poetic dada mask of complexity, which is, after all, the complexity of simpletons, but the dead-man mask of the intense concentration of the one who knows what's right. When the mask cracks long enough for the mouth to open and speak, the words that pour forth are the opposite of nonsense; they are filled with the red-hot iron of anger: "You fools, babblers, and idiots, do you believe that history is made in the salons, where highborn democrats fraternize with titled liberals, where miserable provincial advocates of yesterday very soon learn to kiss illustrious little hands? Fools! Babblers! Idiots! History is made in the trenches where under the foolish pressure of war-madness the soldier thrusts his bayonet into the officer's body and escapes to his home village to set fire to the manor house. Doesn't this barbarity please you? Don't get excited, history answers you: just put up with it all. Those are merely the consequences of all that has gone before. You imagine that

history is made in your contact commissions? Nonsense! Talk! Fancy! Cretinism! History—may that be shown—this time has chosen the palace of Kchesinskaja the dancer, the former mistress of the former czar, as its preparation laboratory. And from there, from this building, symbolic for old Russia, she prepares the liquidation of our entire Petersburg-czaristic, bureaucratic-noble, junker-bourgeois corruption and shamelessness. Here, to the palace of the former imperial ballerina, are coming in streams the Russian delegates of the factories, with the gray, scarred, and lousy messengers from the trenches, and from here new prophetic words will spread over the land."[70]

Isaiah applauds. This is the implacable language that it will take Dada the better part of the century to cut up, scramble, decode, and toss off. For anyone still harboring the illusion, like the British journalists, that there was a joyful human behind the leninist mask, there are garbage heaps of propaganda as high as the Himalayas to promote postmortem the "human Lenin." Lenin himself can be heard speaking and providing a view of himself in a propaganda documentary now available at HTTP://WWW.YOUTUBE.COM/WATCH?V= 1GE6T3SRNAS&FEATURE=RELATED, with music (revolutionary). In 1924 when he died, Lenin was embalmed and displayed in a monumental but relatively petite granite structure reminiscent of the Step Pyramid and the Tomb of Cyrus the Great. There he

remained until 1930 when the popularity of his cadaver shot through the roof, and the decision was made to exchange the modest mausoleum with one made of marble, porphyry, granite, and labradorite. In 1973, sculptor Nikolai Tomsky designed a new sarcophagus. By that time, masses of people had filed past the lifelike Lenin in his glass case from which he was only removed briefly in October 1941 and evacuated to Tyumen, in Siberia, when it appeared that Moscow might be in imminent danger of falling to the nazis. After the war, it was returned and the tomb reopened. Joseph Stalin's embalmed body snuck in next to Lenin's at the time of his death in 1953, until he was removed and buried within the Kremlin Wall by order of Khrushchev in 1961. Boris Yeltsin, with the support of the Russian Orthodox Church, intended to close Lenin's tomb and bury him in the wall also, but he didn't succeed. The tomb is open every day except Mondays and Fridays from 10:00 to 13:00. There is normally a long line to see Lenin. No photos or video are allowed. Altogether, millions of people viewed the corpses of Lenin and Stalin who, between them, dispatched millions of others to mass graves: Bykivnia, containing an estimated 120,000–225,000 corpses; Kurapaty, where estimations range from 30,000 to 200,000 bodies; Butovo, more than 20,000 confirmed killed; Sandarmokh, more than 9,000 bodies discovered. To mention a few. No tourists mob those places. Soviet necrophilia was not confined to dead bodies: one May Day

Parade, a very dead Brezhnev, saluting stiffly, stood on the reviewing stand in Red Square, propped up by two Politburo members, as intercontinental ballistic missiles rolled below.

lenin, philosophical formation: The questions of Russian philosophy and literature (often indistinguishable) have always been "What makes a good man?" "What is the right way to live?" The majority of Russian thinkers resorted to Christianity or German idealism, or a combination of both, to answer those questions in as practical a way as possible, in order to change Russian society. *Philosophie pour la philosophie*, like *l'art pour l'art*, was of no interest to them. "Russia's experience of philosophy has curiously anticipated a breakdown of Western trust in reason. This is why it's possible to take a new look at the Russian phenomenon through postmodern eyes."[71] This is also why it is possible to write a guide to posthumans, and the reason we borrowed Lenin for this enterprise. God, and we don't invoke God lightly here, save us from the ethical questions of Russian philosophy! Or any philosophy! Lord, if you love humans, posthumans, and the dadaists who think of nothing but Joy and the Joy of Not Knowing You (or anything else!), please save us from the ethical questions of philosophers! Let Dada answer: 1. there is no right way to live, just follow your nose, and 2. a good man is one who lets others live as they please (even as he shocks them into Joy). Now seriously, posthumans do not need

a philosophy of culture that obliges human
beings to certain modes of comportment,
even if they are horribly inconvenient. We
do not like murderers, we hate machines
that suck our vitality, we despise equally the
orphanage, the police, and the sadist, but
save us from ideology! Please. Dada knows,
if Dada knows anything, that anything
articulated in the form of a finished sentence
means the exact opposite of what it says. The
overdetermined Lenin and the firmly set
jaws of philosophers are the exact opposite
of what they once appeared to be: in the 21st
century Lenin is non-Lenin; determined jaws
are weak chins; philosophy is piddle. "To be
a culture without reason is to be a mammal
without a backbone."[72] We Dada mammals
are ready to surrender our backbones! What is
meant by "reason" in 19th- and 20th-century
Europe is simply the murder of innocents
by sharpened (to a steel point) beard hairs.
Who has the most beard? Statues. Blow up
the statues. Tzara was clean-shaven, he looked
like a banker. There was a moment there,
about 1916, let's say, when beards and thought
separated. Until that date, to think was to have
a beard. This was no mere fashion: women
have no facial hair. Monks do. Scholars do.
They are men. The *practice* of thought, of
gravity, was the prerogative of the bearded.
The threat of the modern was multiple: it
threatened manhood, what was understood by
"thinking," and it allowed women to practice.
The beards of the "great" thinkers, Marx,
etc., thinned out into the goatees of Freud

and Lenin, as philosophy transitioned to modernity. Hair is not frivolous, as the British court still understands. Hair *is* philosophy. The fact that both men and women have it, in a manner domesticated by "civilization" (which is only the manufacture of hair-islands), means that a strict division of labor had to be established when the bourgeoisie distributed commodities: thought was produced by face-hair, psychology by womanish long hair. Bankers and Jews (identical in the mid-18th to late 19th centuries) were compelled to shave clean to show that they were producers neither of thought nor of reproduction. In an age when artists masqueraded as thinkers (see beards and hair of Impressionists) Tzara's clean-shaven mug proclaimed its solidarity with abstraction, i.e., money and relativity. Until Wassily Kandinsky and Roman Jakobson, unbearded Russian philosophers were inconceivable: abstraction was born in Russia only when the clergy shaved.

masses, the: Keep them busy. When intellectuals get bored, they incite the masses to murder.

michaux, henri: well-traveled French poet who ingested mescaline in Mexico and wrote and drew the fantastic journey of his mind in *Miserable Miracle*,[73] a harrowing account of a (brilliant) French mind in the Land of Unreason. The existence of a vast unconscious fenced off by a reasonable fear of dark (engineered by the illuminists) was

thus proven experimentally, and so the dadas and the surrealists became the doorkeepers (and greeters) at the Doors of Perception (Aldous Huxley), or the Gates of Hell, for the following generations of explorers. Eventually, the Gates of Hell were located in a town called Sunnydale, California, where Buffy the Vampire Slayer, working with academic textualists, works both to stem the tide of escapees from those dark regions and to keep the young from going in. Buffy does this forever on cable TV ("Wherever there is cable, there I am," Grampa Munster [Al Lewis] to me, in Havana, 1996). Buffy works for the Department of Postmodern Sanity produced by the postmodern state (of nausea and amusement). Henri Michaux is on the curriculum of the dada mind, along with later travelers, such as Malinowski (Polish anthropologist, possibly the first Westerner in Shaman-Land), Huxley, Timothy Leary, and the Anonymous Millions of the Sixties. The mind-adventures of Michaux were preceded by Romanian mescaline experiments as early as the end of the 19th century, when the poet Al. Macedonski concluded after his use of the psychotropic that all senses must be involved in the reception of poetry; hence colors, scents, and touch should translate on multicolored pages in various inks. Dr. Nicolae Leon wrote in 1903 about "witches' medicine," and in 1929 he produced and ingested some himself, from a recipe learned from a "gipsy-witch."[74] During the experience, the witch appeared to the doctor and told

him that had he taken the drug thirty years earlier, he'd have been led to a world of beautiful women, but at his age he must go down a long slippery tunnel back to his birth. Dr. Leon's experiences were reprised fictionally by Mircea Eliade, in his story "At the Gypsy Women." Eliade's writings on myth and ritual were immensely popular in the psychedelic age of the Sixties. The Bucharest avantgarde was familiar with psychotropic plants, particularly mescaline, a drug studied by doctors who experimented specifically with artists because the powerful visions, the disappearance of time, and the sensual penetration of objects were thought to be amenable to their powers of description. Here, however, the connection with Dada remained tenuous until Romanian scholar Andrei Oişteanu uncovered a wealth of material about the dadaists', and Tzara's particular, use of drugs. "Romanian avantgardist texts are rife with references to hallucinogenic agents. The psychedelic mushroom, Amanita muscaria, for example, is invoked in the Manifesto published in *unu* in 1928 by Sasha Pană . . . a programmatic text that begins by prompting the reader to 'Delouse your brain!,' a phrase quoted from Ilarie Voronca's 1924 Surrealist Manifesto."[75] Going back in time, we find the young Bucharest avantgardists interested in mental illness and drugs, a preoccupation that started with "mescaline drinking binges" under the supervision of Dr. Nicolae Leon and neurologist Gheorghe Marinescu. In the "atmosphere of libertinage"[76] in Berlin,

Tzara enjoyed opium and cocaine, and later in Paris he smoked opium with Cocteau, but in Oişteanu's opinion, his drug of choice was cocaine, which makes perfect sense given the state of constant excitation and sleeplessness of the restless dadas. The psychedelic state might have been known to Tzara in another form, from his childhood: the intense concentration on the letters of the Kabbalah by mystics led to insights into the nature of time and space similar to those induced by psychogenics; it is possible that the absurd world of Urmuz, and the joy with which the young avantgardists of Bucharest greeted the relativity of "reality," were connected to both ascetic mysticism and folk hallucinogens.

money & art: Tzara ominously wrote in the 1918 Dada Manifesto: "We have had enough of Cubist and Futurist academics! Is the goal of art to earn money and to fondle the nice bourgeois? Rhymes jingle the same sound as coins, and inflexions slide along the profile of the belly. Every group of artists has finally arrived, astride various comets, at the bank, the door opened to the possibility of wallowing in cushions and rich food."

In the humanities era, making some money somehow was never far from the minds of young bohemians who needed to pay rent, drink, and sometimes eat, but none of them could conceive of more money than that. The avantgarde needed cheap rent, inexpensive food, and time. None of

those things are available now, which *could* mean that the avantgarde is finished, that nothing but its ghost remains, and that the only hope for it is Catastrophe, which always happens. An artist who does not conceive of hermself as a complete negation has no choice but to turn hermself into a product; herm begins by *making* products, then turns herm entire body/self into an assembly line, like a dead pig that begins at the start of the rubegoldbergesque meat-processor and arrives, through a series of blades and slicers, as a variety of processed meats on a shelf at the Museum of Modern Art. I mean, wall.

In the posthuman, dada era, the same process pertains, only in reverse. The already sliced, preproduced art-meats of previous ages are sucked back out of museums and reassembled into simple human form. This process has been stealthily emptying the museums and is continually being recycled via the internet. We the people want to reassemble (collage) ourselves from the remains of an artifact-choked civilization into undifferentiated primal energy. The Centrifuges Vs. the Centripets! Tonight! At the corner of Melville & Frisbee!

negergedichte (negro chants): 1915 hip-hop poetry revealed unto Richard Huelsenbeck, first performed in a 1915 "Expressionist evening" in the Harmoniumsaal in Berlin. Kandinsky and Paul Klee are the best-known

Expressionists of the Blue Rider group (Blaue Reiter), an art movement that made possible German Dada, and the irruptions of Hugo Ball, Richard Huelsenbeck, and George Gross. The thick primary soup from which Zurich Dada emerged was composed of art and literature trends fermenting violently since the French Symbolists, early 20th-century Cubism, Futurism, Constructivism, and Kandinsky's abstract art. Picasso's love for African art opened a path to what turned out to be the Europeans' future road back to the original ritual uses of art. Huelsenbeck's *negergedichte* were the chants of his unconscious rhyming with Picasso's insight. The Dadaists and abstract artists found the sacred again with an end run around the Renaissance, back to Byzantium, Moorish Spain, and Côte d'Ivoire. Huelsenbeck was brimming with health and arrogance as he chanted these "negerdichte" at Cabaret Voltaire, and his "umba umba" could be easily read as neocolonialist parody, a kind of blackface comedy that had the drunken Swiss crowd roaring with laughter. Projecting ahead into the century, the chants lose their innocence even more, as colonialism, nazism, wars for independence, Surrealism, and the advent of the true Négritude poets (Senghor, Césaire) restore the warrior potency of Africa to art. After Négritude, the Harlem Renaissance, the Black Power movement, Franz Fanon, Malcolm X, and Amiri Baraka, the approaches and borrowings from Africa

become more circumspect, and "umba umba" becomes as offensive as a German tourist on a safari (the benign version of the anthropologist with a gun). Huelsenbeck's *negergedichte* were not without challenges in their day: the owner of the building where Cabaret Voltaire perpetrated its outrages, Jan Ephraim, an old Dutch seaman, tried to teach him the actual sound of negro chanting, as he remembered it from his travels. Huelsenbeck incorporated some of the words in the Dutchman's memory, but he never renounced "umba umba," which, Ephraim pointed out, was pure nonsense. Pure nonsense was, of course, what Dada sought and found here and there, unaware that this nonsense would become precious matter. The Guide recommends fifteen minutes of "pure nonsense" a day, but since it is doubtful that anyone (meaning any reader of this) is capable of such a long exercise of "nonsense," I advise valuing the "nonsense" one attempts by the going price of minutes at the time of reading. As a rule of thumb, 1 NM (Nonsense Minute) should be worth between $1000 and $5,000 early 21st-century dollars, a range that takes into account future institutions of the MOMA type and the increasing recognition of art as currency. Huelsenbeck became an intrepid traveler as he visited Africa, Haiti, Cuba, China, Japan, Burma, Formosa, and Sumatra as a ship's doctor. Arriving penniless in New York in 1936, with the help of Albert Einstein, he performed his *negergedichte* only

in the context of lectures and reminiscences about the history of Dada. For the purposes of our guide, it pays to know the Albert Einstein of your time, and it is worth considering the possibility that one might grow up. (Given a brutal zeitgeist.)

new year's resolutions by my poetry students, 2008: Fuck more strangers because of reading Kathy Acker. Read all ellipses. Shave cat. Write fortune cookies. Birch the willowy. Collaborate with everybody/everything. Do not employ a Life Narrator (Banneker) or a Delivery Room Grammarian. These mostly positive resolutions, with the exception of the last two, are very dada. Certainly, Kathy Acker (required reading) was, and she'll certainly smile if she reads this in the ethernet. Andrew Banneker wrote about a service where one goes to hire a Life Narrator: the "creative" types all rush to hire famous Life Narrators, like Marcel Proust, Ernest Hemingway, and, woe betide, André Breton. Once engaged, these narrators are always . . . narrating! All minutiae of their lives are being narrated by these eminences in the styles that made them famous! The purchasers soon get sick of the constant background narration and begin snapping at their Life Narrators, mildly at first, then in real anger, but try as they might, they cannot remove their voices from inside their heads, thus illuminating the genuine pathos of a literary education. This pitiful condition, not generally listed among the major sorrows,

is nonetheless real as the overinformed
citizens of the present place their intact
human enthusiasm in overpublicized models.
A drop of dada can cure this condition, and
even a cursory inventory of the store of Life
Narrators makes it evident that neither Tzara,
Duchamp, Loy, Elsa, or Picabia are among
the available models. If they were, they would
drive their purchaser mad much quicker,
before the cement of "style" might set. This
is what I think, anyway. The last of the New
Year's resolutions involves not employing a
Delivery Room Grammarian. This figure will
have to remain mysterious until the next,
revised, edition of this Guide.

nonsense: what sensical people find
unacceptable, illogical, ridiculous, useless;
an insult; a creature from the unconscious
that surrounds, underlies, and fills all that
isn't commonly understood. Poetry, in its
purest form, made out of material obtained
by conscious forays in the unconscious;
certain types of folklore; self-mocking; the
avantgarde™. Used by dadaists in two senses:
1. products of the unconscious (good), 2.
society and idea-systems (bad). The "sense"
in "nonsense" changes with the direction
of one's gaze: inward it brings up poetry,
somnambulist sounds, ur-speech, and animal
speech; outward, it covers with withering
scorn-manure all that is "comprehensible"
and "sensible." Literary giants of nonsense:
Lewis Carroll, Tristan Tzara, and elliptical
poets like Paul Celan and Edmond Jabès, who

suffered from holes of silence where words were erased by pain. Serious nonsense comes from great depth like clear springs. On the upper layers of blah-blah everything makes sense, unfortunately, and the din sucks all the oxygen.

professional revolutionary: What is a professional? In 1916, barristers, accountants, government clerks, bank clerks, and many other types of clerks began to form closely knit professional associations, heralding an era of quickly growing worldwide bureaucracy. The management of colonies by the Western powers accounted for well over one hundred types of professionals trained for specific tasks. The *professional* revolutionary practiced both a european occupation as well established as any postmedieval guild, and a newer type of bureaucratic expertise. Lenin saw his occupation as analogous to that of a printer, a historian, or a lawyer. The history of revolutions and revolts, all the movements for social change since the invention of movable type by Gutenberg, were the well-crafted work of professional revolutionaries. Luther, Calvin, Erasmus, and Zwingli set Northern Europe and the bourgeoisie squarely against the corruption of the Catholic Church. Lenin knew in detail every dash and comma in every sentence in every paragraph of every social rebellion beginning with the Reformation. He knew also the history of empires and slave and serf revolts, and knew that if read in the correct order, these events were ineluctible,

inevitable, and logical, like the pages of a book telling a story that proceeded inexorably to the end. History is a spiral that moves from thesis and antithesis to a new thesis and antithesis, rising each time a bit higher in its hegelian effort to transcend. Karl Marx projected the end of spiraling history into a utopian ending called "communism," and Lenin had no doubt that such a thing was in the offing, though for now the dialectical struggle had to be pursued relentlessly, without any concession to human frailty, without the distractions of sentiment or superstition. Rigorous logic must accompany each move, especially now, when all the conditions are right for the revolution. It is his time to move. The dadaist monocle inspects him far too closely. Could the Romanian poet be a Russian spy? The powers of Europe are hopelessly stalemated in a slaughter without foreseeable end, in which millions have already been killed. Tsarism was overthrown in Russia and Lenin must do everything he can to prevent Russia from becoming another weak, hesistant Western liberal bourgeois democracy that will end, inevitably, in another, worse, world war. His professional caution and training tell him that there can be no doubt now: the time has come. Time is growing shorter and it will soon run out of sand and close the door to opportunity. Lenin loves chess. He has one move left and he needs to make it. Tzara studies him closely, feeling what his opponent feels: a crisis of time. Chess is a drug and its high is caused by time: "Time trouble is an

addiction, perhaps even a physical addiction to the opium-like substances secreted by a chess player's brain during the time trouble phase."[77]

The addiction to chess is genetic for both men, but while the craving infuses them with an urge to action because of a crisis of time, their respective views of the time-crisis differ. Chess is by no means an institutional simulacrum to either one of them; it is not a miniaturized Switzerland or the quaint chess town of Strobeck, Germany. No, it goes much deeper than that. Each chess piece is an investment of ideas and life-experiences, an abstracted and compacted little bomb composed of personal and impersonal history resolved into a shape, into something *believable*. These two people do not agree to society's rules, yet they obey the laws of chess! Perhaps it's just a game, but something more than amused consent is taking place: the urge to play carries forward a purpose. Chess is subversive: below its agreed-upon surfaces and motions there roils an acting out of a demonic force, an opposition to *language*. Chess-players don't use words to communicate: if they talk, it is only to befuddle the adversary, to wound him with words. Language emitted by kibbitzers around chess-players is a kind of fog, a smoky atmosphere. Words never penetrate the dark space where the antilingual force uncoils. Neither Tzara nor Lenin talks, but each one knows that the other is a talker, a *great* talker, and they fear each other's words. In order to

prevent words from escaping the other player, each of them constructs a mental picture of the other. Tzara thinks that if one slices thin the balding professional revolutionary before him, one will find pages from: 1. the Bible, 2. every book. Outwardly, a professional revolutionary is dressed in newspapers and smells like nitroglycerine. His occupation and form itself wouldn't be possible without: 1. print, 2. explosives, 3. logic. The purpose of the professional revolutionary is to create a new text out of all the books that he has read, and to this purpose he employs the angry scissors of rage in bursts of cut-up frenzy. Lenin's fury against idealist philosophers is boundless, but it is text that employs him, forcing him to unmoor it from the logic of grammar and reference. When Text realizes its impotence, because, even in the hands of the most practiced pamphleteer, it has only given birth to another referential system, it abandons the revolutionary, leaving behind an empty rhetorical shell that dissolves itself. Here is where Tzara steps in, with a tougher set of scissors forged in the steel of a first language, an *ur-sprach* yet unbabeled. Lenin is a golem animated by languages: take away languages and the rag doll collapses. Pre-Babel *ur-sprach* is available to Tzara from a mysterious force. Still, it will be a long time, a long game, before the prelanguage overcomes the splintered languages of action to win by synchronizing humans to the creative force. Lenin's brain, sliced thin by Soviet scientists,

will become a book that awaits the furthering of knowledge to be read by the future. His empty head, stuffed with newspapers, rests atop the body displayed for tourists in the Red Square mausoleum. Lenin is an exceptional manipulator of sense, and Tzara's scissors are nearly dull from the effort. If this is difficult for Lenin, think of the predicament of the *average* professional revolutionary, animated by analysis, logic, a seemingly cooperative zeitgeist, and a following of quasi-golems animated by his rhetoric. Does such a someone even have the energy for meeting a wordless future? Tzara chuckles to himself, already convinced that Lenin's next move will be straight out of a book. Brain-fever is all Lenin can hope for, and Lenin, like his father, dies of it young. Tzara doesn't know this yet, of course, but neither does he intuit the depth of contempt Lenin holds him in: he is nothing but a bourgeois worm who has crawled out of feudal Europe to spread confusion within the working class by distributing nonsense, by perverting the art of print into recipes for idiocy. Using language to torpedo the welfare of the proletariat! Lenin feels for artists what he feels for dogs: they are useful only when they bark to warn of an intruder. Dogs who don't bark should be eaten, and the owners of dogs who don't bark should work in sewers. Nonbarking dogs are potentially dangerous because: 1. they are cute like babies, 2. they are considered well-behaved, like house servants, and 3. they don't complain, like obedient serfs.

To think that such a dog could conceive of its dogness as *autonomous* is beyond laughable. It's treason, punishable by death.

richard, huelsenbeck (a.k.a. Dr. Charles R. Hulbeck, from 1936): "Dada Drummer," famous for loud, invented negro chants ending in "Umba! Umba!," born in 1892 in Frankenau, Germany, son of the town pharmacist; met Hugo Ball in Berlin's post-Expressionist circles in 1912; followed Ball to Zurich to participate in the activities of Cabaret Voltaire. Huelsenbeck was a man of prodigious energy, who studied medicine in Zurich by day, drummed, chanted, and recited at Cabaret Voltaire by night, and wrote manifestos, poetry, essays, plays, and novels, before giving up Dada and Europe for good, emigrating to New York in 1936, becoming the practicing psychoanalyst Charles R. Hulbeck, under the tutelage of Karen Horney, as the reader already knows, but speaking of horny, he was a libidinous man (like all the dadaists), and the word "prodigious" is here used in all its senses, including its precise 19th-century form found on the house in Withingham, Vermont, where Brigham Young, polygamist leader of the Mormons, was born, a man of "prodigious endowment," who fathered hundreds of children, a true 19th-century Dada. Richard Huelsenbeck's memoir, *Memoirs of a Dada Drummer*, is written with charming simplicity. These are the qualities instrumental to living a dada life: prodigality, horniness, charming

simplicity, and contention over the birth of
one's phonetic religion. Dr. Hulbeck founded
the Ontoanalytic Association in New York, a
phenomenological and Existentialist society,
related to, but not as funny (or as serious) as,
the Pataphysical Academy founded by Alfred
Jarry, or the Paleo-Cybernetic Foundation
of Detroit. Heidegger and Sartre became
honorary titular deities of the Ontoanalytic
Association, which, as its name implies,
meant to talk its members back to their
birth (which is the same as dying). Freud's
"seriousness" could not be maintained in
America without the addition of energy, i.e., a
phenomenological stream of translation from
"experience" mitigated only by the gravity
of "nothingness." Sartre's public profile has
dimmed since the mid-20th century, partly
because his fame and politics reduced him
to a caricature. As the Fugs' Tuli Kupferberg
put it in a 1967 song, "Jean-Paul Sartre /
that old fartre." In 1967 when the Fugs sang
Sartre out of relevance, Sartre was already a
Maoist, while the hippies were just starting
their dada existence in America. Sartre was so
black-and-white by 1967 that one mentioned
his name only if followed by a brief snort.
The Ontoanalytic Association, like all
psychoanalysis-derived streams of talk, also
ceased being relevant after the ingestion of the
first doses of LSD by the young. The first LSD
experience erased freudianism as completely
as Gutenberg's movable type erased the
incunabulum. Hugo Ball believed that Freud
had rediscovered the Devil. For guidance

purposes, any reader still awed by any "names" in the description-of-reality biz needs to take acid. The Devil question is still open though, because the Devil is a creature, and creatures resistant to description *do* show up on acid.

tristan, tzara (1896–1963) (ab initio, margins of the margin): Tristan Tzara, born Samuel Rosenstock in Moineşti, Romania, on April 16, 1896, changed his name to Tristan Tzara while still in his teens, and wrote, "life is sad, but it's a garden still." Tristan Tzara means *trist în tzara* in Romanian, meaning "sad in the country." The "country" may have been Moineşti, which was no bigger than a village, or Bucharest, or Romania, or the Balkans, a place, in any case, at the margins of Europe, surrounded by Russia, just freed from Turkish domination, and uncertain of its identity.

Within the culturally marginal provincial kingdom of Romania, Tzara's birthplace, Moineşti, was so marginal that besides causing Samuel Rosenstock's sadness, it was barely mentioned in official histories. The Rosenstocks were Jews in an antisemitic town that to this day (2007) does not list on its website the founder of Dada among notables born here. Yet Moineşti, in its vast marginality, is at the center of the modern world, not only because of Tristan Tzara's invention of Dada, but because its Jews were among the first Zionists, and Moineşti itself was the starting point of a famous exodus of its people on foot

from here to the land of dreams, E'retz Israel. The expression "from Moineşti . . ." resounds strongly in Israel, where the Jews of Moineşti are still reverently remembered. Sammy's father owned a sawmill, and his grandfather lived on a large wooded estate, but his family roots were sunk deeply into the mud of the shtetl, a Jewish world turned deeply inward. The community nourished mystics who stared at the illuminated Sephiroth in a carefully preserved hand-copied Kabbalah. Generations of scholars had seen the splendor of a secret world where outsiders saw only mud. The brains ignited by the fiery letters of the holy books were much bigger than anything their physical bodies were capable of. The Jews of the shtetls in the Pale were forced to remain rooted like trees in place until the inevitable expulsion and attendant pogroms. Many Russian Jews settled in Romanian Moldova after pogroms, where they lived as guests of the local Jews, who were not Romanian citizens either, but who had made progress toward it. The emancipation of the Jews after independence from the Ottoman Empire was a condition set by the Western powers for independence, but it did not include Romanian citizenship, which became possible for Jews only after the First World War in 1919, as another condition for peace set by Western powers. By the time of Samuel's birth in 1896, powerful currents of unrest were felt within the traditional Jewish community of Moineşti. The questions of identity, place, and

belonging, which had been asked innumerable times by Jewish history, needed answers again, 20th-century answers. The daddy of Dada was welcomed at his bar mitzvah in 1910 into the patriarchal hassidic community of Moineşti-Bacău by the renowned rabbi Bezalel Zeev Safran, the father of the great Chief Rabbi Alexandre Safran, who saw the Jews of Romania through their darkest hour, during the fascist regime and the Second World War.[78] Sammy Rosenstock's grandfather was the rabbi of Chernowitz, the birthplace of many brilliant Jewish writers, including Paul Celan and Elie Weisel. The Romanian critic Radu Cernătescu sees in Tzara's earliest poetry the mystical filigree: "The Jewish cemetery and the belief that one's piety can revive one's dear departed, and prayer seen as an element capable of re-creating the world, are recurrent motifs in the poetry Tzara wrote at the tender age of sixteen: 'I look for you everywhere, Lord / but you know that it isn't enough,' and 'Clasp your hands in prayer, beloved / Listen how the end of the world reverberates in your ears / . . . in the cemetery of night / Where iron birds fly / Love is silently torn from the gravestone of a shy lilly.'"[79] Cernătescu discerns the hassid in the later dada theorist, too, in the formulation "It is so dark, only the words illuminate," a mystical belief developed by Rabbi Israel Ba'al Shem Tov who lived near Moineşti before he died in 1760. Further dada researches into language and its distinctly vibratory and luminous letters

may be inspired by the commentaries of other famous kabbalists, like Rabbi Eliahu Cohen Itamari of Smyrna, who believed that the Bible was composed of an "incoherent mix of letters" on which order was imposed gradually by divine will according to various material phenomena, without any direct influence by the scribe or the copier. Any terrestrial phenomenon was capable of rearranging the cosmic alphabet toward cosmic harmony. A disciple of the Smyrna rabbi wrote, ""If the believer keeps repeating daily, even one verse, he may obtain salvation because each day the order of the letters changes according to the state and importance of each moment" (Cernătescu). After Dada, after Surrealism, after fighting against fascists in the Spanish Civil War, after the Second World War, after the Holocaust, after membership in the French Communist Party, Tzara returned to the Kabbalah. He studied and wrote about the secrets of the language of Villon and Rabelais, in whose works he discerned the mystical workings of the kabbalistic Language Crystal. The only avantgardist poet who received Tzara's blessing in the 1960s was Isidore Isou, who called his literary practice "lettrisme," a poetry based on the power emanating from each letter of the alphabet. Isidore Isou, also a Romanian of Jewish origin who lived in Paris, saw his work branch into the international "concrete poetry" movement. A young Allen Ginsberg, seated at a Parisian café in 1961, saw a sober-looking, suited Tzara hurrying by,

carrying a briefcase. Ginsberg called to him, "Hey, Tzara!" but Tzara didn't so much as look at him, unsympathetic to the unkempt young Americans invading Paris again for cultural nourishment. It is too bad: the daddy of Dada failed to connect with the daddy of a vast youth movement that would revive, refine, and renew Dada in the New World. Tristan Tzara died in 1963. He is buried in the Montparnasse cemetery in Paris, near Baudelaire, Dreyfus, Huysmans, Desnos, Ionesco, Porfirio Díaz, Duras, Brâncuşi, Cortazar, Kiki, Brasaï, and Vallejo (who declared the poet a small God), the crème de la crème of the 20th century and then some, not a bad party to spend eternity with.

Many geniuses of poetry and revolution were born in provincial towns and villages at the end of the 19th century, and they headed as soon as they could for the Paris of Mallarmé, Verlaine, and Baudelaire, for the Germany of Hegel, Schopenhauer, and Nietzsche, the Vienna of Freud, Einstein, and Schoenberg, the London of Marx and Engels, the Prague of Art Nouveau and Kafka. No wonder Sammy was sad in the country and couldn't wait to leave. When he did, he took with him in his luggage, unbeknownst perhaps even to himself, an ancient mystical tradition that he put to use in ways so novel, it took decades to see its esoteric qualities. The Zurich Dada insurrection acted primarily against the idea of treating words as serfs of thought. "Thinking is made in the mouth," Tzara

(1920). One can find the same denial of the dialectic of words, and the effort to treat them autonomously, in the work of the sage Ba'al Shem Tov, who taught that the world is a mystery hidden by and in words. The world (*olam*) is a mystery (*helem*), words related to the Name (*hashem*), the unpronounceable name. An old midrashic commentary holds that repeating every day even the most seemingly insignificant verse of the Torah has the effect of spreading the light of divinity (consciousness) as much as any other verse, even the ones held as most "important," because each word of the Law participates in the creation of a "sound-world," superior to the material one, which it directs and organizes. This "sound-world" is higher on the Sephiroth (the tree of life that connects the worlds of humans with God), closer to the unnameable, being illuminated by the divine. One doesn't need to reach far to see that the belief in an autonomous antiworld made out of words is pure Dada. In Tzara's words, "the light of a magic hard to seize and to address." The Dada poem? Take scissors, cut up the words, take them out at random. Meaning will attach to them in a different order. William Burroughs, speaking about cut-up (the same dada technique, but taken a technological step higher, to tape-recorders), claims even more magic for the operation: "The simplest tape-recorder cut-up is made by recording some material and then cutting in passages at random—of course the words are wiped off the tape where these cut-ins occur—and

you get very interesting juxtapositions
... I would say that the most interesting
experience with the earlier techniques was
the realization that when you make cut-ups
you do not get simply random juxtapositions
of words, that they do mean something, and
often that these meanings refer to a future
event. I've made many cut-ups and then
later recognized that the cut-up referred to
something that I read later in a newspaper
or in a book, or something that happened
... Perhaps events are pre-written and pre-
recorded and when you cut word lines the
future leaks out. I have seen enough examples
to convince me that cut-ups are a basic key to
the nature and function of words."[80] From the
perspective of this prophetic, *other* power of
words (besides propaganda, persuasion, and
communication), "dadaism is revealed as the
most violent mystical movement in the arts."[81]
"Dada existe depuis toujours. La Sainte Vierge
déjà fut dadaïste."[82]

Tzara and the Iancu brothers departed
Bucharest for Zurich, the city of Carl Jung,
in neutral Switzerland, to the relief of their
parents, who did not want to see them
drafted and sent to war. In Zurich, the exiled
intellectual aristocracy of Europe, unwilling
to die for the idiotic blunders of their
governments, brought along, wrapped in
refugee bundles, the inheritance of centuries
of "otherness." Tzara himself, in addition to
the mystical knowledge in his heritage, carried
more recent memories of a beautiful land

from which his family took trees to make logs from. The secular Jews of his parents' generation were capitalists whose practical materialism horrified Samuel. The French Resistance to the nazis was, of course, the reason he later joined the Communist Party, but there was also an oedipal reason for his joining the communists: as a mystic, he was viscerally opposed to capitalism. He had to kill his father. Tzara left the Party in 1956 when the Soviets quelled in blood the Hungarian revolt.

waking up: A dadaist does not wake up in herm bed or in herm body. This does not mean that a dadaist wakes up necessarily next to or in someone else. The bed could be any bed that is not herms, and the body can be any number of bodies that a dadaist keeps in herm own closet or borrows from others. The dada ease in entering or leaving the body is a technique developed through the use of masks and dreams, or directed defections that can run from pure promiscuity to ascetic desire. This operation jettisons familiarity, a dull ache in a dada shoe. The strange bed or other body can even be composed consciously in dreams, if not simply drawn on a wall. Neither patience nor simplicity affects the rush of waking up in a place one doesn't remember. Practiced on a large scale, this vagabond style is a path to the realization of creolization, a Dada goal.

war: The War is not going well for anybody. There is a stalemate.

word, the power of: "We killed a quarter of a century, we killed several centuries for the sake of what is to come. You can call it what you like: surgery, kleptomania, calligraphy; for all we can say is: We are, we have worked some—revolution, reaction, extra! Extra! We are—we are—Dada first and foremost—first and foremost a word, whose fantasticness is incomprehensible."[83]

zurich: Zwingli, Luther, and Erasmus, the three musketeers of the Reform, find late medieval Europe and the church as ripe for change as an aged Swiss cheese. The Zurich Reform introduced by Zwingli in 1519 is, in fact, a real revolution, maybe not bloody enough for Lenin, but what would you call a movement that does away with the sacraments, shuts the monasteries, and turns the prideful stone churches into libraries? And when, in 1798, Zurich is invaded for the first time and is fought over by French, Austrian, German, and Russian armies, its ancient democracy triumphs, but there is not yet quite enough of it, so in 1830 there is another revolution, and by that time the craftsmen and traders read the Bible in their own languages and every citizen votes. And Switzerland declares itself neutral, telling Europe to fuck off, but in a reserved, dignified sort of way, so that the combatants will respect her and stash their valuables in her banks, certain that they will be there when the wars end. Swiss neutrality is indulged

because of the rectitude of bankers, and
also because large warring countries need a
place for their spies, to negotiate and trade
without interference. The First World War is
the greatest Swiss test yet, not only because it
is hard for the great powers to overlook such
a tasty morsel, but because revolution is in
the air. The Reform and Revolution of 1830
have been well regulated drains of excess, but
there are socialists in the government and
reds in Zurich. The Swiss police is pulling
double-shifts. Murmuring kibbitzers, world
war. At the dead center of the din is the island
of silence where Tzara and Lenin still play
chess in Café de La Terrasse, October 8, 1916.
They've been playing since the beginning
of this book, stopped like figures on a stuck
DVD. Lenin's hand is out (Lenin's hand is
always out, either pointing at the future
from the German locomotive arriving in St.
Petersburg, or pointing at the class enemy)
clutching a knight (Cossack). He is going to
kill the Tsar with it. But this Tsara won't fall
for it, he's ready, he's laughing already. Behind
him a chorus line of Warhol girls linked
cancan-syle point their toes up. A Futurist
automobile driven by Marinetti flies past the
café, leaving behind exhaust and the laughter
of an adolescent girl, Mina Loy, who is
amused by men making history. Mayakovsky
recites to a huge crowd of workers ordered by
the Soviet to attend the poetry mass-meeting
for educational purposes. They don't know
why the giant man (over 7 ft. tall) is shouting
about clouds in trousers and roses shooting

steam, but they are afraid of him and tired. In the old Petrograd before the Soviets, a man worked his twelve hours, then washed off the grime and drowned his gut in beer and vodka until the borscht was ready and Nadia sent one of the eight snotty brats to bring him home. Now, after twelve hours, there are classes, readings from Lenin and Gorky, and compulsory meetings to hear the Futurists. Even Mayakovsky is tired: he has performed at twelve mass-meetings and has been drinking steadily from a flask, but it's all gone now and he feels nothing but impatience for the proletariat. He needs a woman, a bourgeois poetess who smells good, to pour a full glass from a crystal decanter, rub his shoulders, and then snuggle under his arm. His friend Sergey Yesenin has committed suicide rather than write with capital letters, and now Lenin has ordered Mayakovsky to write a poem against suicide. Suicide is counterrevolutionary, decadent, rotten, hateful, the cowardice of hyenas eating a corpse, etc. Mayakovsky thinks that Lenin is tired too. He's said it all before, the hyenas, the corpse, the counter . . . etc. The giant writes the poem and reads it at the mass-meeting at the ironworks factory. A deadly silence greets the recitation: every man and woman feels in herm bones the weariness of life, they could think of nothing better than sleep, the more eternal the better. In 1924 Lenin dies, and the poet writes an elegy lamenting the passing. In 1930, Mayakovsky reads both his elegy to Lenin and the poem against suicide at the ironworks factory, and

is greeted with an even deadlier silence. After the failed performance, Mayakovsky goes to his room and shoots himself. His suicide note reads, in part: "The love boat has crashed against the daily routine. You and I, we are quits, and there is no point in listing mutual pains, sorrows, and hurts." The "you" referred to may be a woman, may be communism, may be life itself. *The Love Boat* is a popular American television show in the 1970s. In 1916, Lenin's hand, unfrozen by the narrator, moves the knight in position to check the King. Tzara moves his King behind the Queen, hiding behind her skirts, safe in the knowledge that Mina Loy will return, without Marinetti, and, without saying a word, will take a long drag from his cigarette, sigh, close her eyes, and let the future kiss her ass.

NOTES

1. A longer discussion on borders and aesthetics may be in order here: I refer the reader to my two earlier texts *The Disappearance of the Outside* (Reading, MA: Addison-Wesley, 1999) and "before the storm: geographers in new orleans," a discussion of anarchist geography published in the book *Jealous Witness* (Minneapolis: Coffee House Press, 2008). For now, suffice it to say that the notion of "privately constructed borders" is an extension of the Republican impulse to privatize everything, from health care to prisons. Borders today *are* largely imaginary: the Mexican-American border, for instance, runs through every major American city, wherever illegal immigrants go for work. The "border" is a metaphor that separates the so-called legal entity from the "paperless" one. In this sense, constructing borders will eventually be a full-time occupation for anyone involved in proving herm (see n. 4 below) legality, while the aesthetics will be simply the manner in which the entity constructs the argument. Anyone who wants to be "legal" will eventually want to be "legally elegant," that is, as aesthetically concise as the law itself. As for "pocket nukes," these will

most certainly be available to the public under the Second Amendment, because they are already in the U.S. arsenal. In the matter of "art student" squads searching people for illegal nukes, the author hopes that he's being ironic, but not really sure. He is most definitely not ironic about the zones of "medicated liberty" or about medications of any sort. In fact, he is going to swallow a pill right now in order to continue the utopian enterprise of typing.

2. Hippies were often misconstrued as being antimaterialistic and Zen inclined, a misconception aided by poets Gary Snyder, Joanne Kyger, Diane di Prima, and Philip Whalen, who were Zen trained. In fact, the baroque imagination of LSD led most young counterculturists away from emptiness and toward fulsome teeming matters like instant communication, better bodies, cosmetics, immortality, and youth potions, all of which translated two decades later into the internet and biotech.

3. *The Dada Painters and Poets*, an anthology edited by Robert Motherwell (New York: Wittenborn, Schultz, 1951). From the introduction by Jack Flamm, p. 56.

4. Pronoun problem solved in favor of "herm" as opposed to s/he or he/her, because the word is the first part of "hermaphrodite," which, as will be seen, is both a Dada desideratum and an affirmation of totality.

5. This text discusses two answers to the question What is that motor?

6. "Dada Manifesto of 1918," from *Seven Dada Manifestoes and Lampisteries*, with illustrations by Francis Picabia, trans. Barbara Wright (London: John Calder; New York: Riverrun Press, 1981).

7. *Essential Works of Lenin, What Is to Be Done? and Other Writings*, ed. Henry M. Christman (New York: Bantam Books, 1966). Lenin wrote the essay we quoted from in Zurich, early in 1916; it appeared in St. Petersburg in September 1917 as "Imperialism, the Highest Stage of Capitalism."

8. "To My Reader" by Charles Baudelaire, translated by Robert Lowell, in *The Flowers of Evil*, ed. Jackson Mathews (New York: New Directions, 1955).

9. It has been noted that "Marx's *Economic and Philosophical Manuscripts of 1844*, which do present this utterly brilliant analysis of the alienation (*Entfremdung* in the original) of workers under capitalism . . . were completely unknown until they were first published in 1932 by the Marx-Engels Institute in Moscow. The first English translation only appeared in 1959. They have been absolutely central to the emergence of a critical (i.e., non-Stalinist, non-SPD-like) Marxism from the 1960s onward, but were completely unknown to Lenin. I'm not even sure *Entfremdung* appears in any of Marx's later writings, as he himself turned more to the economic analysis of capitalism and away from the more philosophical (and Hegel-influenced) critique of his early years." This may be so, but here we take the Dada approach of assuming that even if Lenin had read those notes by Marx, he would have had neither the time nor the inclination to follow

the implications that seduced neomarxists in the 1960s.

10. "Monsieur AA The Antiphilosopher Sends Us This Manifesto," in *Seven Dada Manifestoes and Lampisteries*, p. 27.

11. *The Dada Painters and Poets.* From the introduction by Jack Flamm, p. 56.

12. Ahuva Belkin, "Low Culture in the Purimshpil," HTTP://WWW.JEWISH-THEATER.COM/ VISITOR/ARTICLE_DISPLAY.ASPX?ARTICLEID=1760:

> In the ever-popular Purim shpiel about Mordechai, Esther, the fair queen from the Megillah, is introduced by Mordechai, who compares her to an ugly frog, short, fat and green, and calls her the daughter of a whore. She is played by a man sloppily dressed as a woman; together with the king who, in the best Midrashic tradition, is drunk all the time, they create a comic double act . . . In Weissenberg's *Dos purimshpil*, Mordechai introduces the bride:
>
> *Hoer ze, kindrig, ich hob vin deinetwegen a Mejdel*
> *Is sie asoi groiss, wie a baerischer Wejde!*
> *A zing mit a Pur Lippen*
> *Chotsch in der Erd aranstipen;*
> *Haklal sie is schejn*
> *Mit oigesarzte Zejn;*
> *Hur mit a stern,*
> *Me konn dem ganzen Msrk oiskehren;*
> *Mit a blechen Harz,*
> *Mit a kipernem Bauch.*
> *In a Pipek wie a Makrete . . .* (356–367)

(Look here, little one, I've found you a girl
Tiny as a bear's tail
She has a tongue, and lips
And all you have to do is lay her down
She is prettier than pretty
With holes in her teeth, a brow and thick hair
Good to sweep the market with
Her heart is made of tin, her belly is enormous
and her navel—
What a surface . . .)

And if this was not enough to shock the spectators,
he adds:

Noch a Male hot sie, darft di wissen,
As alle Naechet thit sie sech bapischen. (370–371)

(And another quality, I'll have you know:
Every night she wets her bed.)

13. *Goldfaden's Legacy*, a Radu Gabrea Film
(Bucharest: Total TV, 2004).

14. Emmy Hennings, *Ruf und Echo: Mein Leben
mit Hugo Ball* (Einsiedeln: Benziger, 1953).

15. Here is an example; there are numerous
unfortunate English translations: "Die Trichter//
Zwei Trichter wandeln durch die Nacht.//Durch
ihres Rumpfs verengten Schacht//fließt weißes
Mondlich//still und heiter//auf ihren//Waldweg//
u. s.//w."

16. Much of this description comes from *Dada
East: The Romanians of Cabaret Voltaire*, by Tom
Sandqvist (Cambridge: MIT Press, 2005).

17. HHTP:WWW.LYRICSMANIA.COM/, The full text of
"A la villette":

> Il avait pas encor' vingt ans,
> I' connaissait pas ses parents,
> On l'appelait Toto Laripette,
> A la Villette.//Il était un peu sans façon,
> Mais c'était un joli garçon :
> C'était l'pus beau, c'était l'pus chouette,
> A la Villette.//Il était pas c'qui a d'mieux mis,
> Il avait pas des beaux habits,
> I' s'rattrapait su' sa casquette,
> A la Villette.//Il avait des p'tits yeux d'souris,
> Il avait deux p'tits favoris,
> Surmontés d'eun' fin' rouflaquette,
> A la Villette.//Y en avait pas deux comm' lui pour
> Vous parler d'sentiment, d'amour;
> Y avait qu'lui pour vous fair' risette,
> A la Villette.//Il avait un gros chien d'bouvier
> Qu'avait eun' gross' gueul' de terrier,
> On peut pas avoir eun' levette,
> A la Villette.//Quand i' m'avait foutu des coups,
> I' m'demandait pardon, à g'noux,
> I' m'appelait sa p'tit' gigolette,
> A la Villette.//De son métier I' faisait rien,
> Dans l' jour i' balladait son chien,
> La nuit i' rinçait la cuvette,
> A la Villette.//I' f'sait l'lit qu' i' défaisait pas,
> Mais l'soir, quand je r'tirais mon bas,
> C'est lui qui comptait la galette,
> A la Villette.//Quéqu'fois, quand j'faisait les
> boul'vards,
> I' dégringolait les pochards
> Avec le p'tit homme à Toinette,
> A la Villette.//I' m'aimait autant que j' l'aimais,
> Nous nous aurions quitté jamais
> Si la police était pas faite,

A la Villette.//Y a des nuits où̀sque les sergots
Les ramass'nt, comm' des escargots,
D'la ru' d' Flande à la Chopinette,
A la Villette.//Qu'on l'prenn' grand ou petit, rouge
ou brun,
On peut pas en conserver un:
I' s'en vont tous à la Roquette,//A la Villette.//La
dernièr' fois que je l'ai vu,
Il avait l'torse à moitié nu,
Et le cou pris dans la lunette, A la Roquette.

18. *Memoirs of a Dada Drummer* by Richard Huelsenbeck, ed. Hans J. Kleinschmidt, trans. Joachim Neugroschel (Berkeley and Los Angeles: University of California Press, 1969).

19. *Seven Dada Manifestoes and Lampisteries.*

20. *Ball and Hammer: Hugo Ball's Tenderenda the Fantast*, trans. and with drawings by Jonathan Hammer (New Haven, CT: Yale University Press, 2002).

21. Quoted in *Surreal Lives: The Surrealists 1917–1945*, by Ruth Brandon (New York: Grove Press, 1999).

22. Quoted in ibid., from Louis Aragon, "Tristan Tzara arrive à Paris," in Dachy, ed., *Projet d'histoire littéraire contemporaine.*

23. Marcel Duchamp wrote to Hans Richter in 1962, "This Neo-Dada which they call New Realism, Pop Art, assemblage, etc., is an easy way out, and lives on what Dada did. When I discovered ready-mades I thought to discourage esthetics. In Neo-Dada they have taken my ready-mades and

found esthetic beauty in them. I threw the bottle-rack and the urinal in their faces as a challenge and now they admire them for their esthetic beauty."

24. Tzara's familiar refrain, "I am still charming," came from a note in André Gide's journals where he recalled how "charming" Tzara was when they first met, and how much "more charming" was his young wife. Barbara Wright translates "charming" as "likable" (*Seven Dada Manifestoes and Lampisteries*).

25. *Seven Dada Manifestoes, 1916–1920*, by Tristan Tzara (Paris: Editions Jean Budry, 1924), translated by Ralph Manheim for Motherwell's anthology, *The Dada Painters and Poets*. We will be using also the Barbara Wright translations in *Seven Dada Manifestoes and Lampisteries*.

26. For a discussion of "nudity as art medium," see Gherasm Luca and D. Trost's 1945 manifesto *La Dialectique de la Dialectique* (Bucharest: Editura Negația Negației).

27. "People of the Future," the title of a 1965 Ted Berrigan poem. In its entirety: "People of the future, / While you are reading these poems / Remember / You didn't write them / I did." *Collected Poems*, by Ted Berrigan (Berkeley and Los Angeles: University of California Press, 2006).

28. Sandqvist, *Dada East*, p. 126.

29. This has to do with permission and the future, or with Plato and Socrates. Pound was a Futurist who saw poetry as a field of language capable of taking in (or up) anything: translations from the Japanese, snippets of conversation, funny rhythms,

accents, performative and informal dimensions that would allow future poets to add on to the "field." Eliot bemoaned the great virtues of the past, the Platonic perfection, leaving nothing for the young to build on; if everything great has already happened, then why bother?

30. Julie Schmid, "Mina Loy's Futurist Theatre," *Performing Arts Journal* 52, 18.1 (1996).

31. Georges Hugnet, "The Dada Spirit in Painting" (1932–1934). Reprinted in Motherwell, *The Dada Painters and Poets*, pp. 123–196.

32. *La chute dans le temps*, by E. M. Cioran (Paris: Gallimard, 1978), a notion through which the Romanian-born French philosopher sought to explain the permanent exile of human beings from Paradise as a "fall into time." In this case, I am using the "fall" from time into an eternity of connectiveness.

33. Allen Ginsberg, *Selected Poems 1947–1995* (New York: HarperCollins, 1996). "Who threw potato salad at CCNY lecturers on Dadaism and subsequently presented themselves on the granite steps of the madhouse with shaven heads and harlequin speech of suicide, demanding instant lobotomy" ("Howl," p. 130).

34. *Seven Dada Manifestoes,* no. 7, in Motherwell, *Dada Painters and Poets*.

35. Elizabeth Bayley Seton was the first person born in the United States to become a canonized saint (September 14, 1975); b. August 28, 1774, New York City; d. Emmitsburg, Maryland, January 4, 1821.

36. Gilles Deleuze and Félix Guattari, *Anti-Oedipus: Capitalism and Schizophrenia* (Minneapolis: University of Minnesota Press, 1983).

37. *The Unknown Lenin: From the Secret Archives*, ed. Richard Pipes (New Haven: Yale University Press, 1996).

38. Lenin letter from Zurich to Inessa Armand, 30 December 1916 (in Pipes, *Unknown Lenin*).

39. *Baroness Elsa: Gender, Dada, and Everyday Modernity*, by Irene Gammel (Cambridge: MIT Press, 2002), p. 256.

40. Quoted in Brandon, *Surreal Lives*.

41. Julién Levy, *Memoirs of an Art Gallery*, pp. 42–43. Quoted in Brandon, *Surreal Lives*.

42. Brandon, *Surreal Lives*.

43. Carr, in *Travesties*, by Tom Stoppard (New York: Grove Press, 1974).

44. J. C. Hallman, *The Chess Artist: Genius, Obsession, and the World's Oldest Game* (New York: St. Martin's, 2003).

45. Ibid.

46. *Seven Dada Manifestoes*, no. 8, in Motherwell, *Dada Painters and Poets*.

47. Tristan Tzara, *Simbolul 1*, quoted in Ovid S. Crohmălniceanu, *Evreii în mișcarea de avangardă românească* (Bucharest: Editura Hafeser, 2001).

48. Ibid.

49. Reuters, reporting by Marius Zaharia; editing by Keith Weir.

50. Guillaume Apollinaire, *Les Onze Mille Verges* (London: Peter Owen Modern Classics, 2003).

51. *The Dada Painters and Poets.* From the introduction by Jack Flamm, pp. 101–102.

52. Sandqvist, *Dada East*, pp. 152–155.

53. Huelsenbeck, *Memoirs of a Dada Drummer.*

54. Ibid., p. 50.

55. Hugo Ball, *Die Flucht aus der Zeit* (Diary) (Munich: Duncker & Humblot, 1927).

56. Tristan Tzara, "Note on Poetry," *Dada* 4–5 (Zurich 1919). Translated by Barbara Wright in *Seven Dada Manifestoes and Lampisteries.*

57. David Chidester, *Authentic Fakes: Religion and American Popular Culture* (Berkeley and Los Angeles: University of California Press, 2005), p. 198.

58. World Transhumanist Association, "Explores possibilities for the 'posthuman' future created by increased merging of people and technology via bioengineering, cybernetics, nanotechnologies . . ." WWW.TRANSHUMANISM.ORG. "Transhumanism" by Julian Huxley (1957).

59. Alex Wright, "The Mundaneum in Mons, Belgium," *New York Times*, June 17, 2008.

60. Tristan Tzara, "Francis Picabia, pensées sans langage," translated by Barbara Wright in *Seven Dada Manifestoes and Lampisteries*.

61. Preface by Tristan Tzara to *Les Amours Jaunes* by Tristan Corbière (Paris: Le Club Français du Livre, 1950).

62. "For 738 days Julia Butterfly Hill lived in the canopy of an ancient redwood tree, called Luna, to help make the world aware of the plight of ancient forests. Julia, with the great help of steelworkers and environmentalists, successfully negotiated to permanently protect the 1,000 year-old tree and a nearly three-acre buffer zone. Her two-year vigil informed the public that only 3% of the ancient redwood forests remain and that the Headwaters Forest Agreement, brokered by state and federal agencies and Pacific Lumber/Maxxam Corporation, will not adequately protect forests and species." HTTP://WWW.CIRCLEOFLIFEFOUNDATION.ORG/ INSPIRATION/JULIA/.

63. Codrescu, *Disappearance of the Outside*.

64. Quoted in Crohmălniceanu, *Evreii în mişcarea de avangardă românească*.

65. *Pioneers of Modernism: Modernist Architecture in Romania 1920–1940* by Luminiţa Machedon and Ernie Scoffham (London: MIT Press, 1999).

66. Alexander Solzenitsyn, *Lenin in Zurich* (New York: Farrar, Straus and Giroux, 1976).

67. After all that, I DID find the book in one of my "towers" (my books are stacked in towers fifty feet high around my study, to secure the perimeter):

The Language Crystal was written by Lawrence William Lyons, and it was published by Grammar Publishing, PO Box 2333, New York, NY 10009. Inside the book is a note addressed to me by the author on September 5, 1989, that informs me, among other things, that the book can be purchased directly from the author at 342 East 15th Street, NYC 10003 (my old zip code! I would like to, one day, write an alphabetical whimsy of the admirable people who once inhabited that zip code).

68. Hannah Weiner, HTTP://EPC.BUFFALO.EDU/ AUTHORS/WEINER/.

69. Sandqvist, *Dada East*, p. 149.

70. "This transcription of Leon Trotsky's 1925 Lenin came about through a donation from the personal archives of Asher and Ruth Harer in San Francisco, California. This book is very rare and, to our knowledge, been published only once, by Blue Ribbon Books, a now defunct New York publishing house, in 1925. The translator remains unknown although the title page of the book indicates that this is an 'authorized translation'. By whom, we don't now know. Sections of this book have been republished as pamphlets over the years by the supporters of Leon Trotsky, but this book remained 'out of print', until this electronic version on the Trotsky Internet Archive. Transcription and HTML markup by David Walters in 2001." HTTP://WWW. MARXISTS.ORG/ARCHIVE/TROTSKY/1925/LENIN/ INDEX.HTM.

71. Lesley Chamberlain, *Motherland: A Philosophical History of Russia* (New York: Overlook/Rookery, 2007), p. xii.

72. Ibid., p. xiv.

73. Henri Michaux, *Miserable Miracle*, trans. Louise Varese (San Francisco: City Lights Books, 1963).

74. Andrei Oişteanu, "Scriitorii Români şi Narcoticele: avangardiştii," Article in *Revista* 22, no. 23 (June 3–9, 2008), part of a series on Romanian writers and the use of drugs.

75. Ibid.

76. Ibid.

77. Hand Ree, quoted in Hallman, *The Chess Artist*.

78. *Resisting the Storm: Romania, 1940–1947*, memoirs by Alexandre Safran (Jerusalem: Yad Vashem, 1987).

79. "Mistica dadaismului," by Radu Cernătescu, HTTP://RADU-CERNATESCU.BLOGSPOT.COM/. May 1, 2008. ("te caut pretutindeni Doamne/ dar tu ştii că-i prea puţin[1]; O, iubitul meu, în rugăciune prinde-ţi mâinile/ Ascultă cum zbârnâie sfârşitul în urechi/ . . . / . . . în noaptea cimitirului/ Unde zboară păsări de fier/ Plăpândă dragoste ruptă-n tăcere dintr-o lespede de crin sfios[2]." "[1] T. Tzara, *Primele poeme*, Buc. 1971, p. 35, [2] *idem*, p. 53."

80. *The Job: Interviews with William Burroughs* by Daniel Odier (New York: Grove Press, 1970).

81. Cernătescu, "Mistica dadaismului."

82. Manifestul colectiv, "Dada soulève tout" (1921), in *19:24*, ed. Daniel Stuparu.

83. Huelsenbeck, *Memoirs of a Dada Drummer*.

The Public Square Book Series
PRINCETON UNIVERSITY PRESS

Uncouth Nation:
Why Europe Dislikes America
BY ANDREI S. MARKOVITS

The Politics of the Veil
BY JOAN WALLACH SCOTT

Hidden in Plain Sight: The Tragedy of
Children's Rights from Ben Franklin to
Lionel Tate
BY BARBARA BENNETT WOODHOUSE

With Thanks to the Donors of the Public Square

President William P. Kelly,
the CUNY Graduate Center

President Jeremy Travis,
John Jay College of Criminal Justice

Myron S. Glucksman

Caroline Urvater